SIDEWALK CANVAS

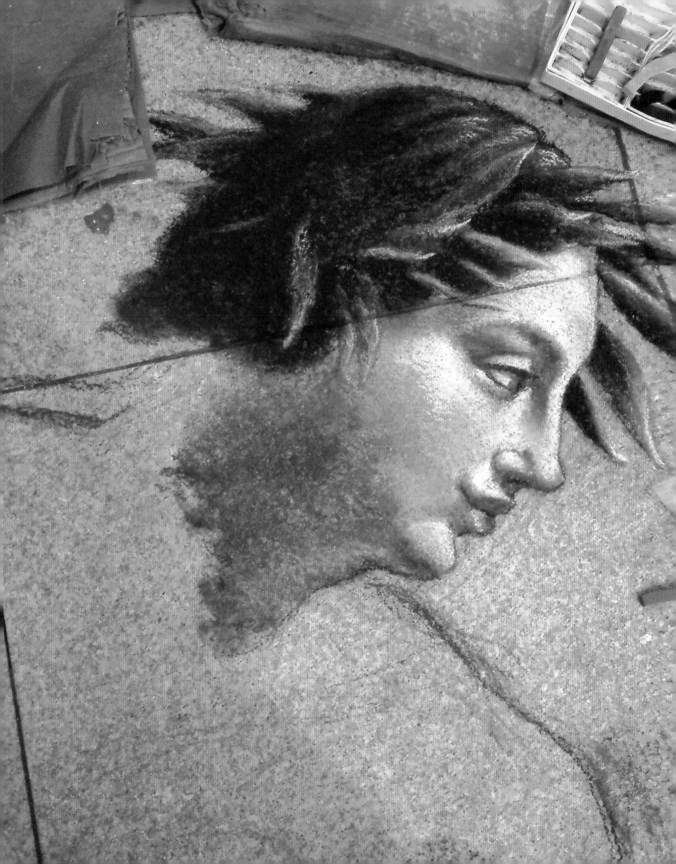

SIDEWALK CANVAS

Chalk Pavement Art at Your Feet

Julie Kirk-Purcell

Fil Rouge Press

To all of those artists who have seen a street painting somewhere
and are wanting to jump into the arena...and to my father - always
my biggest fan, he would have been so excited to see this book come
to fruition

First published in the United Kingdom in 2011 by
Fil Rouge Press, 110 Seddon House, London EC2Y 8BX

Copyright © Fil Rouge Press Ltd 2011

The right of Julie Kirk-Purcell to be identified as the author of this
work has been asserted by her in accordance with the UK Copyright,
Designs and Patents Act 1988.

ISBN 978-0-9564382-2-5

Printed in China by Imago

A CIP catalogue record for this book is available from the
British Library

10 9 8 7 6 5 4 3 2 1

Fil Rouge Press Publisher **Judith More**
Project Editor **Jennifer Latham**
Designer **Simon Goggin**
Editor **Claire Cross**

Fil Rouge Press books are available from all good bookshops.
Alternatively, contact the publisher direct on www.filrougepress.com

CONTENTS

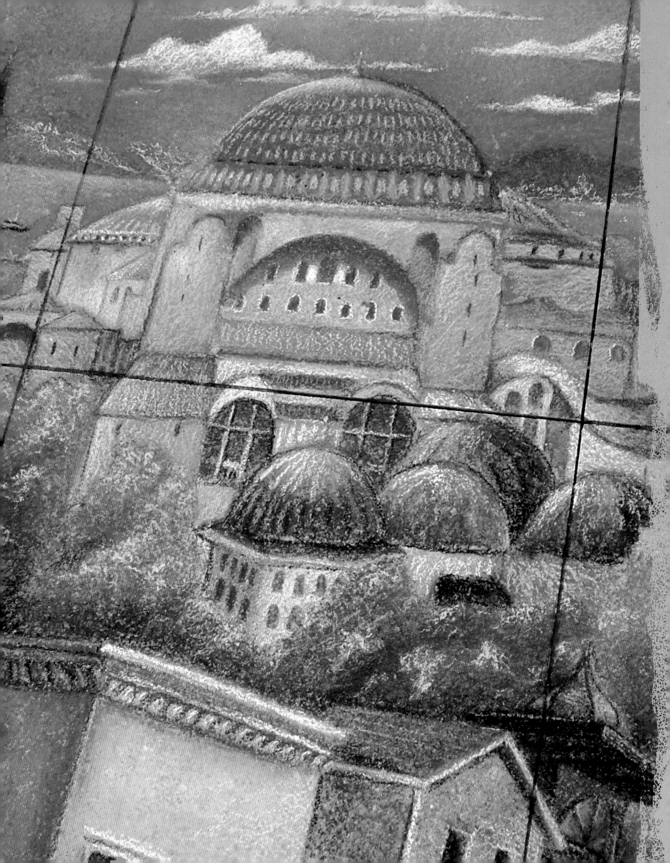

INTRODUCTION

HOW DID IT ALL BEGIN?

LET'S TRAVEL BACK IN TIME 500 YEARS...

It's the early 16th century in Italy, a time of great religious influence, and shortly after the incredible contributions from artists such as Michelangelo, da Vinci, and Raphael. Cathedrals have appeared all over the European continent, monuments to the power the Catholic Church held at the middle of the millennium. Many areas are under constant strife as both the church and local rulers try to expand their base of influence. In the meantime, local people are often struggling to live their lives, surrounded by the art and power of the upper classes and the church, while themselves feeling the weight of poverty. Somewhere around this time, give or take a hundred years, we start finding documentation of a form of art derived from religious icons, which can be documented back to the 3rd century. Rather than the formal setting of a cathedral, though, this art is being executed outside on the ground, where the people have access to it on an everyday level—"street painting."

THE FIRST STREET ARTISTS

The art of completing a painting on the surface of a street or sidewalk—street painting as it has come to be called in recent times—drew its inspiration from the religious imagery of the day and from a sense of community. Although recent years have seen paintings done on rich expanses of asphalt or sidewalk, early artists had nothing more to paint on than rough cobblestone streets or perhaps the beaten earth. Some versions of its history speak of itinerant folk artists moving from town to town in search of bread and perhaps a few coins. They would complete paintings out of almost anything available to them—chalk, charcoal, even colored tile pieces or stones. Often these artists would set up in a location for a few days to paint before moving on to a new town, much like the guitar player of today who sets up shop on a corner at the train station, case opened to collect coins. Some of these artists might even have been ex-soldiers wounded out of service or disabled workers who had fallen on hard times. Others might simply have preferred this nomadic lifestyle, similar to wandering minstrels. Whatever their motivation, all of these artists most likely had one thing in common—the need to earn a living to survive the tumultuous nature of Italy at that time.

ICONS IN STREET ART

During this period, there were several flourishing trends in painting. As well as the older, very formalized, style associated with the painting of religious icons, there

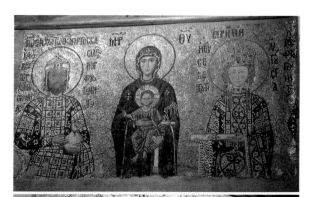

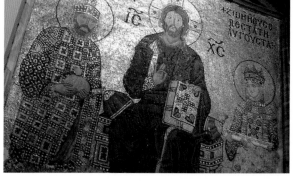

were the newer Renaissance styles, driven by a return to the ideals of humanism, rooted in classical Greece and Rome. This return to classicism during the Renaissance period, largely influenced by the church, eventually evolved into the Mannerist style, seen toward the end of the Renaissance.

While Renaissance art had many themes, street painters had a strong tie to religious iconography—many of the images they painted were religious, and, in particular, icons and images of the Madonna were popular. Painting religious subjects helped the street artist in that the subject matter invoked an almost automatic response of obligation on the part of the viewer to pay homage to the painting in the form of some bread or donated coins. Many street painters did other more permanent work in addition to street painting, especially during the winter months when street painting would be impractical.

THE BIRTH OF MADONNARI

Street painters maintained their tie to iconography and, as trends changed in the artistic world, they often stayed rooted in the formalism of earlier religious images. For many years, icon painting thrived alongside the newer trends of the Renaissance and Mannerism, but eventually street painting became a separate and distinct tradition.

As the church established a strong hold over the country, and attempted to integrate religion into everyday life and break the old ties with pagan beliefs, festivals that dated back to the Etruscan period began to be associated with religious holidays. In this climate, the growing popularity of temporary paintings at outdoor festivals became a way of celebrating the Madonna and Christ, and due to the subject matter, the artists came to be called Madonnari. As a result of this history, religious subject matter has endured and is a big part of the street-painting tradition today.

Previous page: Detail of the exterior of the Hagia Sofia, part of a street painting completed in Istanbul, Turkey.

Left: This original composition combines elements from other paintings, including a portrait of Christ by Guido Reni. Though more dynamic than the traditional icons, the tie to religion is apparent in both the subject matter and some of the design elements. Melanie Stimmell Van Latum in Grazie, Italy, 2006.

Opposite: Examples of traditional icons from the Hagia Sofia in Istanbul, Turkey.

STREET PAINTING TODAY

Today, traditional street painting is associated with the copies of old master paintings, but for centuries the works were original images of the Madonna and Christ, drawing on the formalized design principles of icons. While copying paintings became a bigger part of artistic training by the 19th century, the tradition of copying paintings for street-painting purposes began much later—in the last part of the 20th century, when cheap color reproductions of masterpieces became readily available to copy from.

THE ART OF COPYING

For 19th-century artists, who often turned to the old masters for their subject matter, drawing on the Renaissance and Baroque periods would often result in paintings with a religious theme, and in this way the paintings retained their ties to the earlier icons, even as artistic styles began to change drastically.

These copies served several purposes for the artists who completed them. Generally, they were easily recognizable images that the viewer had some familiarity with, much like the icons of old, so the viewer would relate to the image quickly. The practice of copying great works is a well-regarded tradition in the classical arts, and one that is used still for training students today; so in a sense when an artist made a copy, he or she was being self taught.

As artists would often do several paintings a week, coming up with new, effective designs was difficult to achieve consistently, so it was often better to rely on the tried-and-tested images of the old masters. Lastly, artists who gained mastery at completing copies often finished these paintings more quickly than they would an original design with the same amount of detail, where each new object might have entailed more decision making on how

to handle it. As copies of old masters proved to be very popular and filled the publics' desire to see traditional images, artists were happy to please the public who might happen upon them, enticing them to support the artist.

THE ATTRACTION OF STREET ART

Even now the popularity of old master copies endures and for many of the same reasons. In street painting, the familiarity of these images draws in the crowd—although the viewer might not be acquainted with a particular image, they are familiar with the style and relate it to the classical painters of old. The conservative nature of many of these images makes it easier to appeal to a wide audience, and the teaching aspects of doing copies of well-executed paintings cannot be denied. The entire concept—that of a priceless work of art that should be seen on the walls of a museum, instead being painted on the rough surface of the street—is one that stops people in their tracks. Shock, dismay at the temporary nature of the painting, and appreciation of the talent before them are all expressed in varying degrees to the artist.

It is this ephemeral quality of street painting that often appeals to the street artist. Much art is created to produce a tangible object: a sculpture, a painting, a photograph, a drawing, or a building. In street painting, the creative process is the object the artist seeks. It is the very act itself, the moment that the pastel hits the sidewalk or other surface, that is the point of this work of art. In many ways, street painting is closer to performance art than visual art. Instead of purchasing a completed work, a passer-by might donate money to thank the artist for their effort. With so much art created in the privacy of a studio, the interaction of the artist and viewer is often distant; in street painting, it is immediate and satisfying for both parties involved.

Left: An old master copy with dramatic color and light–quite a bit different from the traditional street paintings! Valentina Sforzini, Grazie, Italy, 2006.

those discovered in the caves of Lascaux, France. There are numerous such drawings to be found from various periods preceding the Madonnari that were made using some of these same materials. In the 16th century, pastels were referred to as crayon or chalk. While the same raw pigments that were accessible to artists at the time who were painting in other media, such as fresco or tempura, were also available for pastels, many historians generally attribute the use of pastels as a painting medium to a later time period.

Previously, pastels were used in a similar way to crayons for drawing, with the focus on line and value. Johann Alexander Thiele (1685–1752) is generally thought to be the first artist to use a full palette of pastels extensively in a painterly style. Thiele and several of his contemporaries used the media for finished work, handled in much the same manner as a painter might use oil paints or other wet media. However, even with the advent of a full palette in pastel, it is thought that many traditional street painters still worked in black and white–even as late as World War II it is known that this was the case, though there is little documentation of the exact methods used in earlier centuries.

Street painting remained popular for centuries, but following the severe upheavals of World War II there was a drastic decrease in the practice. In an effort to preserve and document the art form for future generations, Madonnari in Italy banded together and created the first festival devoted to street painting, Grazie di Curtatone, in 1972 (see pages 164-5). Some of the painters that first performed at this festival were well into their 90s and brought a sense of the original history of the medium with them. The festival has kept its ties to religious iconography and, in order to participate in the competition, all artists still have to include religious imagery in their subject matter.

THE HISTORY OF PASTELS

Contemporary street painting, in full color and very much a finished work of art, is probably quite different from early street paintings. Traditionally, artists in the 16th century worked in limited palettes of black, white, or possibly earth-toned reds and yellows–or perhaps even earth pigments they found around them. These pigments, and the drawing materials made from them, date back to prehistoric times. Early man used raw pigments combined with some sort of binder to hold them together to make marks and drawings, such as

A GROWING MEDIUM

Anamorphic perspective, a type of perspective used to address distorted visual perception when looking at something on an angled plane (see pages 44-51), was first used in paintings during the Renaissance and Baroque periods. When the popular American street painter Kurt Wenner began designing his own works, he developed his own version of this technique, creating compositions that were unique to the genre and which helped to create a wider popularity for the medium. His compositions were inspired by the painted Baroque ceilings in Rome, but used a geometry that Wenner invented to address the specifics of street painting—a geometry that was different from the more formulaic 17th-century Baroque approach to anamorphic perspective. As Wenner traveled internationally to complete these paintings, he brought more attention to the medium of street painting and to events such as the Grazie Festival in Italy, which grew and attracted foreign artists. The popularity of the art form also grew through the proliferation of images on the internet, which have garnered hundreds of thousands of new fans from all corners of the globe.

THE STREET PAINTING COMMUNITY

Today there are more opportunities than ever for street painters to make a living in their chosen media. At the same time, street painting has developed into an art form with an altruistic arm—for example, a number of charitable festivals have cropped up in the US over the last few decades. At the American festivals, hundreds of artists, from school-age children through to hobbyists and professionals, come out to support whichever local charity a festival is sponsoring. Here they can enjoy a weekend of camaraderie with the other painters, as well as experience a short respite from the solitude of working in private.

This development is quite different from the way festivals have evolved in Europe. Here, the artists maintain their ties to the past and the festivals generally attract professional artists who often make their living through the medium. However, even at these more competitive festivals, there is a sense of connection between the artists, partly due to the relative rarity of being a contemporary street painter. The same artists who compete against each other at one festival might very well connect to complete a painting together at another festival.

Both types of festival offer a chance for the public, to some of whom art-making may seem quite foreign, to witness many paintings being created from start to finish. For much of the public, this will be their first time actually seeing a professional artist at work. Furthermore, over the course of a weekend festival, some members of the public build a bond with certain artists and paintings, and are often quite protective of the creation they are witnessing. They return frequently to watch the painting's growth—and even go so far as to bring along food and drink to the artists, have in-depth conversations with them about art, and chide the passer-by who accidentally steps on the painting.

Opposite left: This early painting by Kurt Wenner, called "Muses," shows his use of perspective to create a realistic illusion of depth.

Opposite top right: Hundreds of paintings by local children at a festival in Gilbert, Arizona.

Opposite bottom right: This original design was a composite of various figures from old master paintings to form a larger painting paying tribute to the arts. Provo, Utah, 1999.

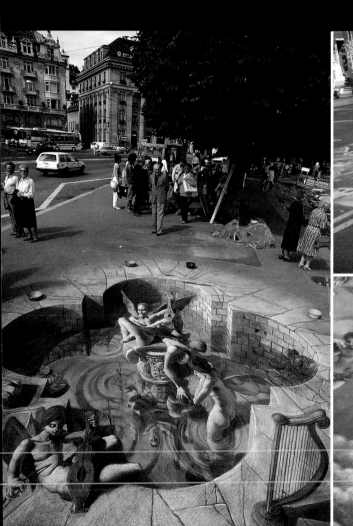

THE ESSENCE OF THE ART

Street painting essentially only exists because of the mutual respect that arises between artist and audience. It is fitting that work is washed away once a festival is completed. Rather than a painting being created as something to keep, it is done with the purpose of drawing people together to witness an event. For many street painters, the most popular question they are asked is: "Doesn't it upset you that it will be washed away?" The response is always an emphatic "No!," since the work was never intended to be permanent. Indeed, there is a sense of magic that comes with being in the moment, and runs as a common vein through artist and public alike. For this is a moment only they will share together, documented only by a camera, which can never capture the sense of experiencing the painting in person. In cases where the painting is preserved and becomes permanent, there is an intangible sense of loss in that permanency. In some respects, it is no longer a street painting, with all of the romanticism that term might conjure up—it is merely a painting.

A TEMPORARY MASTERPIECE

One aspect of street painting that attracts artists is the chance to try out new things and make mistakes—when the painting is washed away, it cleans the street for the next experience. There are numerous types of ephemeral, or temporary, art in existence, and most cultures have some type of such art. One needs only to see the temporary paintings made from flowers and seeds in Central and South America, Europe, and other locales; pigment paintings in India; the sand paintings of Asia and of native Americans; and the sand sculpture competitions found in many warm climates to realize the appeal of ephemeral art.

One reason why painting masterpieces in pastel on the ground may seem like heresy to some is that many of these paintings replicate the million-dollar paintings found in museums. Subconsciously, viewers conditioned to think in materialistic terms may attribute value to them, unaware of the ephemeral tradition of this type of work. A well-executed street painting of any type, whether an original or a copy, is beautiful to behold, and demonstrates a gift that is often highly regarded.

To our way of modern thinking, which is tied to the idea that a material object should be kept or sold, there is something of the rebel in the street painter who throws away a work when through with it. They may be seen as a little anti-establishment, a little classicist, even a little folk artist—whatever the view, street painting attracts artists from all walks of life, from professional painters to teenagers anxious to make their mark, to hobbyists who only paint at one festival a year.

CREATING AN ILLUSION

It is this mix of fringe versus establishment that brings such a wide variety of images and subject matter to the modern-day festival. Old master copies continue to be a prevalent source of imagery, but rather than always being classical in nature, they encompass modern-day techniques and contemporary themes. More and more typical though are the designs based on building a sense of illusion and interactive space between the painting and the viewer.

Opposite top: This painting by Kurt Wenner, called Dies Irae, is one of his earliest and best-known uses of anamorphic perspective. His leanings toward the Mannerist period are very apparent in the figures, whose distortion adds to the drama of the painting.

Opposite middle: An original composition by Melanie Stimmell Van Latum that feels quite removed from the classical old master copy approach. There is a wonderful application of design in this colorful painting.

Opposite bottom: Fun with dragons! I learned a great deal from attempting this painting and in subsequent works felt as though my attempts at creating my own designs benefitted from early trials and errors.

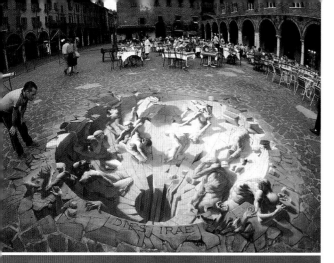

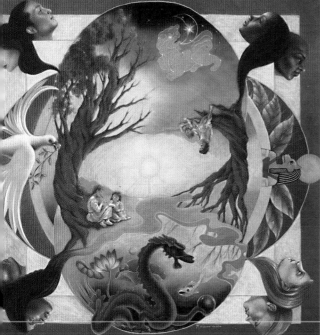

In the last decade, illusionistic street paintings have become enormously popular. Kurt Wenner began street painting in 1982 and, as previously mentioned, is credited with the invention of anamorphic perspective (see pages 44-53) as applied to street painting, using visually distorted perspective to add illusionistic space. Emails also circulate around the globe with images of paintings by several street artists known for this type of work; often these artists use the Baroque approach to perspective, which is more accessible in photographs than in person due to the extreme distortion. Unlike these strict anamorphic paintings, Wenner's paintings are an interactive space in a way not previously envisioned, and at least in part he should be credited with the way that the medium has sky-rocketed in popularity. This has resulted in hundreds of festivals, new artists, and street-wise advertisement campaigns using illusionistic street paintings to reach viewers by arresting the attention of people who would often ignore a normal billboard.

A VARIETY OF STYLES

Commissions for street paintings, along with new festivals cropping up almost weekly, have brought a proliferation of new street painters in the last decade. With these come new ideas, new techniques for designing and painting, and the growth of an internet presence in the form of web blogs, street-painting communities, and websites devoted to the art form. Due to the global nature of the internet, artists can draw on Eastern influences such as Asian prints, as well as Japanese pop art and Manga styles. Indeed, walking through a large festival can yield paintings from a rich variety of sources—a 3-D painting devoted to saving the environment, a portrait and tribute to a dead rock star, a copy of a Japanese woodblock print lying next to a copy of a Rubens, a copy of a Sistine Chapel detail with a humorous political twist, and numerous original designs. By throwing together two hundred artists in one locale, two hundred different ways of thinking take root and flourish for a weekend.

EARNING A LIVING

If festivals are a place for free thinking and gaining experience, the global popularity of street painting means that the once "starving" street artist might now have a way to make some money through their art. And this is not just in the form of a few random coins, since numerous corporations and marketing agencies now seek out street artists. However, even in these modern times, the tradition of street painting as a street art lives on, and artists are still to be found randomly on streets around the world, creating paintings.

Besides professional street painters, there are a number of art students who make a living in the summer doing street paintings. In fact, students can make enough money over these few months and the remaining sunny weekends to cover a good deal of their schooling, continuing their education on the street rather than in the classroom. All that is involved is time, courage to put their work out there in front of the public, and a crowd willing to look at and support the work.

SOURCES OF WORK

Although some artists never realize enough work to earn a living, nonetheless there is now sufficient recognition of street painting that jobs with corporate clients often crop up. Much of this work is commissioned by advertisers, often for companies that prefer a more edgy reputation. The most common images requested are the three-dimensional ones that have become so popular, in part because the best way to grab someone's attention is to get them to interact with the ad image; a three-dimensional image asks the viewer physically to become part of the space. Street painters also get paid as a form of entertainment at amusement parks, shopping malls, and similar venues, in a similar way that a band might be brought in for entertainment.

FESTIVAL WORK

In addition to the more commercial jobs, most charity-driven festivals pay one or more "featured" artists as part of their budget. These featured artists are in place to show what an experienced artist can accomplish—both as a draw to the public who are hoping to view images they've only seen on the internet, as well as an example to local artists starting out, to demonstrate what is possible within the medium. By watching experienced artists and hopefully attending workshops sponsored by the festivals, new artists can progress their skills fairly quickly. Featured artists are often expected to run workshops for local artists, where they might share images and their version of how to street paint. Over time, local artists gain enough experience to apply what they have seen, and in the meantime the experienced featured artist helps to fill in the gaps.

There are numerous competitive street-painting festivals around the world. These are much more prevalent in Europe, where the art form originated and where street painting is recognized as an occupation. Here, artists complete their paintings in the time allotted, sometimes with various parameters in place on theme, size, or materials. In many respects, competitive festivals are a better venue to recognize and appreciate the value of the artist, since many international events offer stipends for all the artists, regardless of their ranking or experience. In contrast, many American charity-driven festivals ask artists to work for free, sometimes with little or no compensation for the expenses the artist might incur.

Either way and in each type of festival there is work for everyone, and no matter what the background of the festival, it is still a meeting place for people who love to make art with people who love to see it.

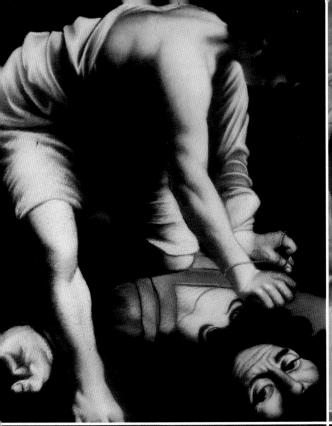

Top: A copy of David and Goliath by Caravaggio, completed at the college I teach at as a demonstration.

Bottom: A traditional old master copy of Caravaggio's Conversion of Mary Magdalene, completed in San Rafael, CA, that offered an education in how to paint drapery—notice at the bottom of the photograph all the many pastel colors that were required to complete the work.

Top: A 3-D painting based on the stories of Narnia by C.S. Lewis. The painting was done on canvas so it could be used as a background for visitors to have their photograph taken. The place to sit for the person who would like to be included in the painting? The tree stump!

Bottom: This painting was completed by one of my students at Irvine Valley College in California. Each spring the painting and life drawing classes get together to do a mini street-painting festival as part of their art education. The students each choose an old master copy and spend a couple of weeks

GALLERY: SACRED IMAGES

The significance of historical religious imagery is still very apparent in today's street paintings, even if the approach is not quite so formalized as in the original icons. A few festivals, such as Grazie in Italy, mandate that the image be religious in nature; however, many artists undertake these types of paintings regardless of the festival preferences for numerous reasons. With some festivals being held at places that seem conducive to religious paintings, such as the festivals held at some of the California missions, the traditional theme is often an obvious choice.

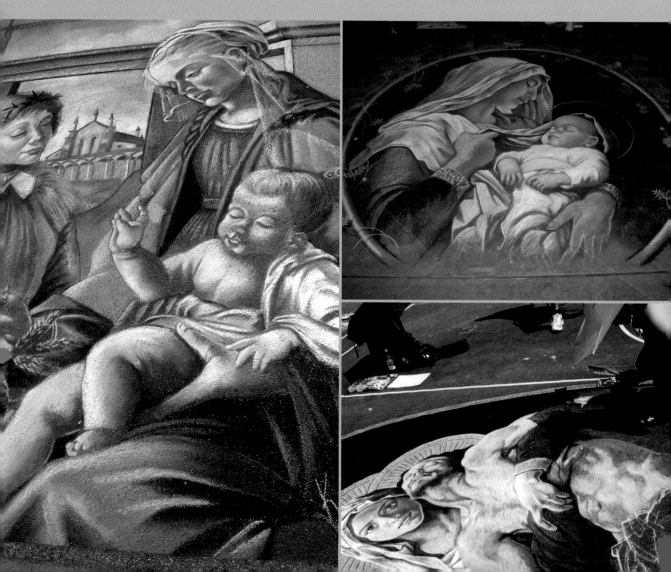

Opposite far left: A copy of Botticelli's Madonna of the Eucharist painted by Ketty Grossi for the festival in Grazie, Italy, 2006.

Opposite top right: Tomoteru Saito added a trompe l'oeil border around this image of the Madonna and Christ by Bouguereau for a Christmas commission.

Opposite bottom right: A copy of Pieta by Bouguereau painted by Tomoteru Saito. His version of the original draws out the poignant expression in the Madonna's face.

Below top left: "Thy Will Be Done" by Ketty Grossi, painted in Grazie, Italy. Not all religious images are copies of old masters–this was a very beautiful original design.

Below bottom left: A copy of Caravaggio's Betrayal of Christ, painted in the Netherlands by a group of artists, including Ketty Grossi, of the C.C.A.M. (Centro Culturale Artisti Madonnari) in Buscoldo, Mantova, Italy.

Below top right: A copy of Madonna and Child by Marianne Stokes that Melanie Stimmell Van Latum painted in Grazie, Italy, 2010, and which won the gold medal in the Maestro division.

Below bottom right: Selica Tripini painted this copy of The Garden of Gethsemane by Carl H. Bloch in Grazie, Italy, in 2009. Selica is currently the president of C.C.A.M. (Centro Culturale Artisti Madonnari), an organization for Madonnari founded in 2000 in Grazie, Italy.

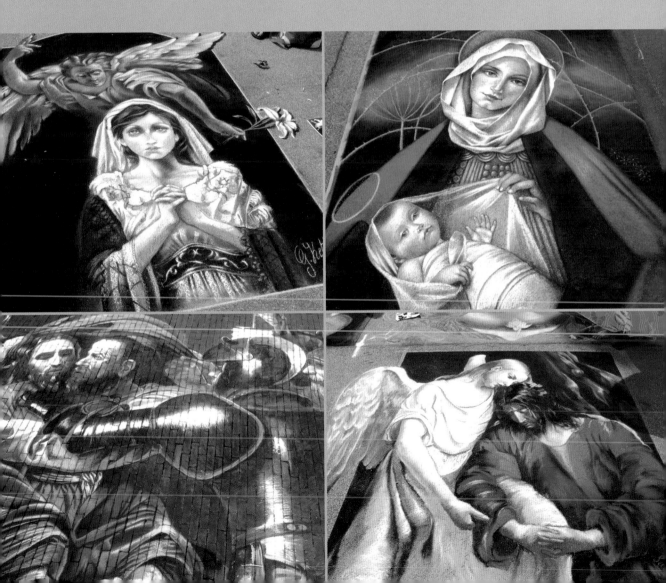

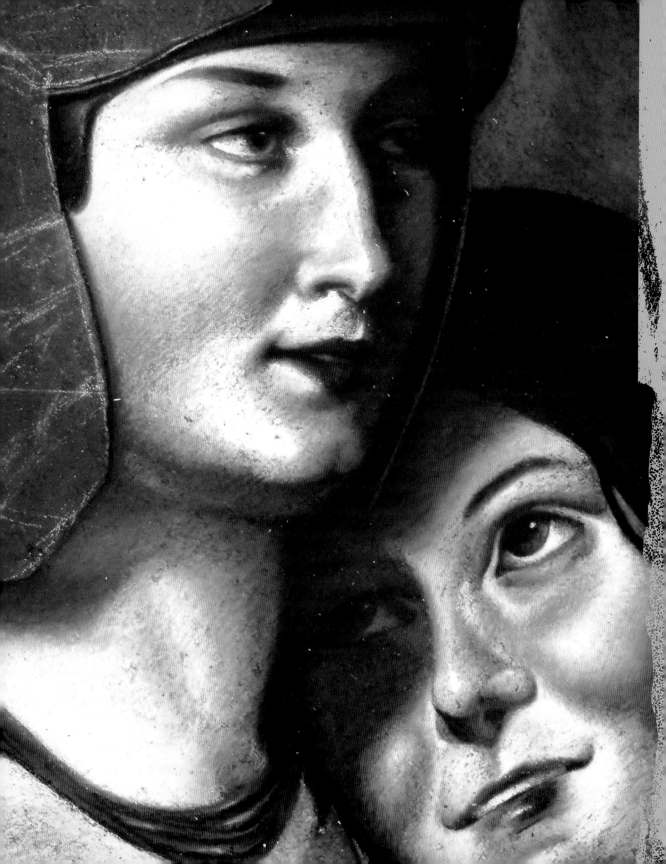

THEMES

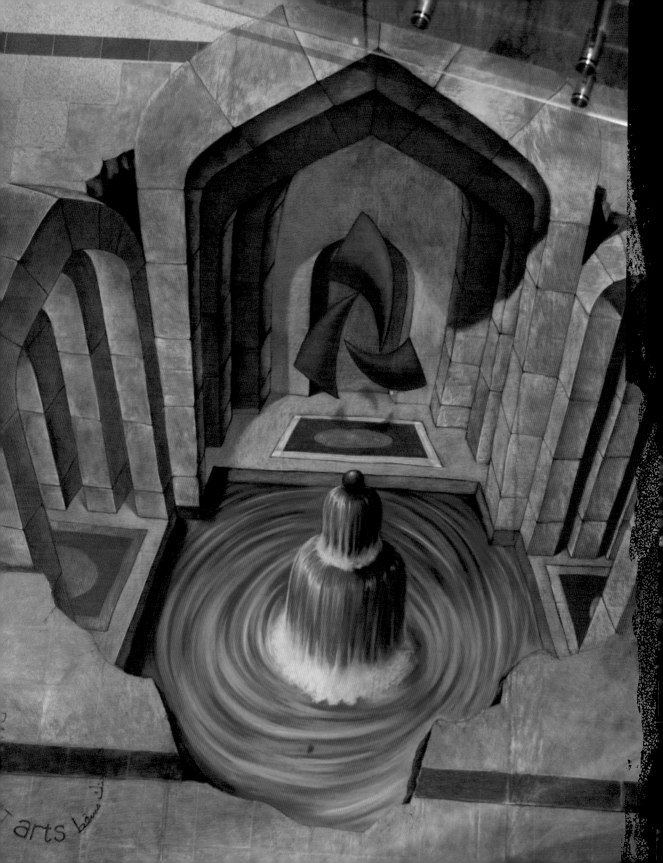

Choosing a theme and composing a painting is often a difficult process. With street painting, there are specific concerns that should be considered, even when copying an old master. Sometimes when viewing paintings at a festival, it becomes apparent that the reason one painting is more striking than another is not that it has been handled better in terms of technique, but rather because the artist painting it wisely chose to work with the strengths of the medium and its surface. While, ideally, you should paint what you would like to paint, part of the momentum that carries you through such a physical painting approach is the response from the crowd. If you choose a painting or adjust your color palette in such a way that you draw a greater response, that momentum is greater, and can help you to be more successful as an artist—not just in the viewer's eyes, but in your own eyes. It's true that we play our best game when we feel good about what we are doing! With street painting, there are numerous ways to consider that game and make it a win-win situation, making the best of the qualities of your painting along the way.

Previous page: The beautiful skin tones of this copy by Melanie Stimmell Van Latum of In the Theater Wardrobe by Friedrich von Amerling are well blended and rich in color. Santa Barbara, CA, 2005.

Opposite: For this 3-D painting completed at BankMuscat in Oman, I used the repeating arch motif found in many Omani mosques. The fountain in the center helps to add perspective while also being a nice splash of color, as does the anamorphically distorted BankMuscat logo which appears within the center arch. Muscat, Oman, 2010.

CHOOSING YOUR THEME

What you choose for your theme can either grab the viewer's attention or divert it, so put some thought into what your painting will be about. I can almost guarantee you that the viewing public will ask questions, so it's good to feel that you made a conscious choice that you can explain. Consider where the festival is being held, who your crowd might be, and how your own desires might influence you. If the festival is attracting a younger audience, I might design an image that is more fantasy driven, with dragons or mermaids. At some of the more traditional festivals in well-to-do areas, you might decide that an old master copy is your best bet. In today's climate, some festivals might not be the best choice for traditional religious images...and just as easily, might be a great choice for traditional religious images. Thinking about your audience, as well as considering your own preferences, can set you up for a successful experience.

The size of the space you have to work in, the amount of time you have to work, and the workability of the surface you're painting on can all be factors in helping you choose just how complicated or simple you would like your painting to be. Thinking through these factors and putting some effort into making good decisions on how to control your composition and design for the best viewing will influence how successful you felt the painting was by the end of the weekend.

SIZE MATTERS

One of the more obvious physical characteristics of street painting—its imposing size—has a huge effect on how the painting is viewed. Too simplistic or overly detailed images are magnified on a larger scale. By choosing compositions that are dynamic, this feeling is increased exponentially on the street. One of my own favorite periods to do old master copies from is the Baroque period, especially of masters such as Caravaggio and Rubens. I've copied paintings from other periods too, but the dynamism of many of the artists during this period appeals to my personal tastes and also works very well for street paintings. The compositions are typically based on diagonals, or diagonals intersected with a strong horizontal or vertical line. On the ground, this translates into a painting that has some interest, even when viewed from angles it is not intended to be viewed from. Another wonderful aspect of many of the paintings from this period is the great emotion often imparted by the figures. This is one of the hallmarks of these painters, and a feature that translates well onto the ground. The drama and emotion expressed in such a composition is greatly multiplied by the immense size of a street painting, where figures often larger than life are now on a stage just a few feet away from the viewer.

There are, of course, numerous paintings from other periods that can be just as effective, but I use these examples to illustrate some of the characteristics that seem to grab the publics' attention. Thinking about the potential sense of dynamism, drama, and emotion when deciding which painting to copy or what to design can make a big difference when that painting is reproduced to at least ten times the size of a picture in a book.

Opposite bottom: Old master copies are a popular way both to hone painting skills as well as paint subjects that are more traditional. This copy of Caravaggio's The Betrayal of Christ was finished in 2000 in California and was 12 x 15 ft (4 x 5 m). It took me three and a half days to paint. The dark, dramatic background and rich coloring is typical of the Baroque period and tends to make a striking street painting.

Left: When working out at Disney's California Adventure Park, I came up with designs that were themed to the park. The designs were completed on tile boards so they could be moved easily and put away when I wasn't working. This Chinese dragon was one of those designs, and proved to be a colorful and quite popular addition to the park while being worked on. The photograph doesn't show it, but additional tiles formed a long tail coming from the dragon, some painted by guests and some painted by myself, and streamed down the walkway as we added to it over several weeks.

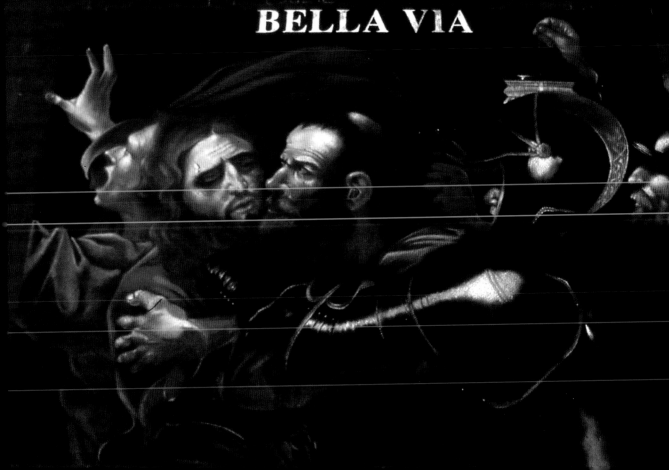

BELLA VIA

THE IMPORTANCE OF COLOR THEORY

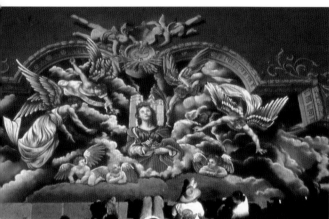

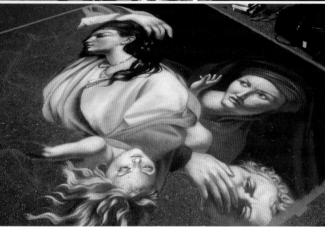

Top: Painted at the Santa Barbara Italian Street Painting Festival, CA, 2000. I designed and won the competition to be the featured artist and had three other artists—Genna Panzarella, Phil Roberts, and Tracy Stum together with Charlene Lanzel—help with completing this 15- x 30-ft (4.5- x 9-m) painting.

Bottom: A copy of a Navez, The Massacre of the Innocents, chosen for the subtle use of color and the dynamic composition of the figures. La Jolla, CA, 2009.

Color palette choices are one way to draw positive attention to a painting, or conversely to obscure the painting by making the wrong choices. This is where good old-fashioned color theory (see pages 142-5) comes into play, as well as an educated understanding of contrast and value (see pages 130-1). A knowledge of how cool and warm colors affect the viewer can be imperative in drawing attention to a street painting, as the size is so large there is no way for someone looking at it to take the image in fully at a glance—they must move around the painting with their eyes, looking for the subject matter.

CREATING AN INTEREST

As the overly large nature of street paintings makes the way the viewer sees the space somewhat abstracted, by concentrating the more vibrant, warmer colors in places in the painting that should have the most interest, you will make it easier for the public to understand what they are looking at. On the other hand, if you put lots of warm, interest-grabbing color in an area of little development or interest, it can be confusing, especially at such a large size. The viewer will be attracted to that specific area, almost pushing out other areas to their peripheral vision.

There have been numerous studies as to how long someone views an image such as a painting before moving onto the next image—it's often a matter of a few seconds. So in those few seconds, you want to grab the viewer's attention and give them something to hold onto. This becomes even more important with a large painting, where too much or too little color, detail, or clarity can make it very difficult to understand what is happening.

MONOCHROMATIC COLOR

Sometimes you may choose not to use any color variations at all. Monochromatic color makes its own impact, and has a special way of capturing the eye. It's essential to be in control of your values—whether subtle and low key or high contrast—for the painting to maintain a sense of being complete and whole. Apply light logic (see pages 126-9)—build your lights slowly, and maintain a composition that will help direct the viewer to your focal point. Most importantly though is to allow yourself the freedom to use your artistic intuition when making your value and palette choices.

THE USE OF VALUE

Along with the way that color affects how a painting is viewed, there is also the overall use of value (see pages 130-1) in the painting to be considered. Again, too much or too little is a problem. When contrasts are very harsh, it can easily scatter the composition, breaking it up into smaller pieces instead of maintaining a continuous whole. Too little contrast can make the huge expanse seem like a giant cloud, in effect making it difficult to read what is happening in the far points of the painting due to its size. This is one of the other reasons I often choose to copy Baroque paintings, or model my original compositions on the lessons learned from those paintings. The idea of using light as a compositional device to focus on certain portions of the painting helps direct the viewer to those points. With patterns of light and shadow helping to build the composition, as well as using the patterns of color in a similar manner, it is easier for me to develop viewer interest in what I am doing.

You also need to consider the value of the surface you are painting on and the way this affects how the painting will be seen. The deeper gray-black of fresh asphalt is a wonderful way to add drama to brighter hues on top. This works similarly when you incorporate black into the background of a painting. The deep background tends to give more depth to the colors, while a light background can result in the colors looking washed out.

Above: La Tomba della Falsità, an original design by Valentina Sforzini completed in Sarasota, FL, 2010. The monochromatic values of the overall painting allowed details such as the green eyes to become strong focal points within the painting.

PERSPECTIVE AND DIRECTION

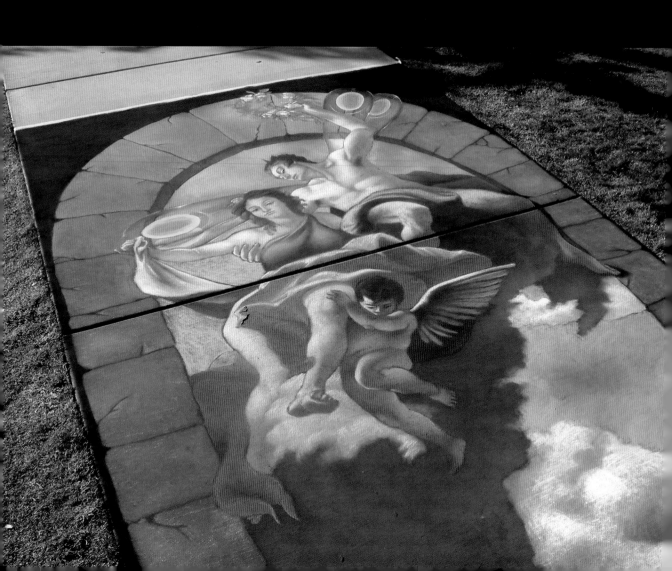

Looking at ways to direct the viewer's interest leads to one of the other effective tools when composing a street painting: The use of trompe l'oeil and perspective effects. The illusion of space and form doesn't have to be a complicated one to grab the viewer's attention. Indeed, simply painting a simple perspective-based tile border, or adding a frame around a traditional painting, with light and shadow added as if it is really there, can be enough to stop the viewer and make them look longer. These are relatively easy tricks that even a beginner can master, and can make a big difference to the final painting looking more finished and thought out.

A FIRST POINT OF INTEREST

Often I think about how I will direct viewer interest when I'm deciding where and how to begin my painting and how it will progress. I always start in the top portion of the painting. Once I've blocked in an overall drawing on the ground, I begin by painting something in that area to grab attention immediately—usually a face, or another high-impact element, such as a tiger or brilliant drapery. If you imagine walking through a festival on the first day and seeing the beginnings of multiple paintings, the ones that are just starting to fill in their background colors, skies, or architecture, are not going to attract attention the way a well-painted portrait will. As portraits, and similar, are detailed elements that require skill to finish well, they become a good starting point for me to move into "painting mode," as well as being a focus point for the viewer. In addition, the momentum gained at the start from successfully painting something difficult helps keep your creative energy flowing through the rest of the day.

As you consider what to paint and decide whether you will choose to copy an image created by someone else or develop a design of your own, it's important to keep these compositional elements in mind. It helps to find images that have some of these compositional devices already, and use these as a basis for designing your own work.

Top: This painting, a copy of Judith and Holofernes by Allori, done at Grazie, Italy, felt much more complete once the frame was added to the piece.

Bottom: A copy of a Ribera, Inspiration of St Jerome, is given a stone border to help relieve some of the space around the figures and add weight to the painting. Santa Barbara, CA, 2004.

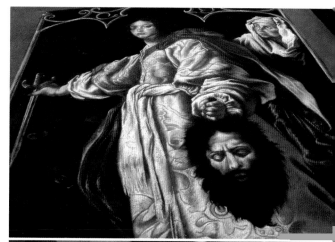

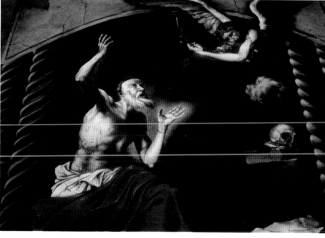

These techniques are an effective way to teach yourself about strong composition. Learning more about all of the facets of a good composition, and combining that knowledge with an understanding of the specifics of street painting in particular, will help you create paintings that leave a lasting impression on those who view them.

GALLERY: THEMES

The common themes of technique and color tend to run through all good street painters' works, as they do here, but at the same time these street painters have developed works that derive new qualities by being a street painting, whether based on an old master copy or on the artist's personal work. The use of composition, as well as color, value, and contrast, can make or break a painting. These qualities tend to draw in viewers and make them want to return to see the finished work!

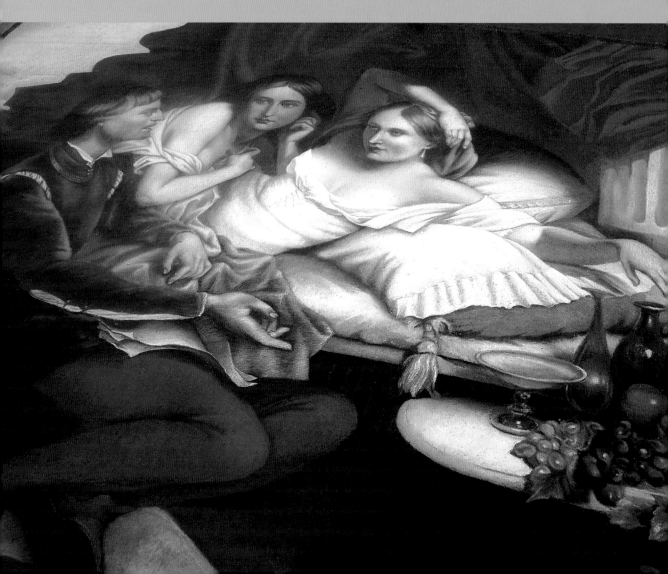

Opposite: A master copy of The Queen of Naples by Gustaf Wappers painted by Melanie Stimmell Van Latum at the Italian Street Painting Festival in San Rafael, CA. Melanie's technique for rich color and the finish of her work make this painting a beautiful and much more dramatic tribute to the original.

Below top left: Ann Hefferman completed this painting, a copy of a work by Martin Johnson Heade, in San Rafael, CA. The more monochromatic background makes the red of the orchid and hummingbirds jump off the pavement. Ann's interest in botanical illustration in her personal work has found a voice in her street paintings in a way that makes her work stand out from all of the other artists.

Below bottom left: Michael Kirby's multi-faceted street painting Catrina, completed in Guadalajara, Mexico in 2011, takes the art form to a different level with its inclusion of dance and music as part of the final painting. The work measured 65½ x 65½ ft (20 x 20 m), and became a "performance" art piece in every sense of the word.

Below top right: Many of Genna Panzarella's paintings incorporate details of an old master combined with animals and other images that form the idea she is creating. This work, "Mother Earth Sends a Messenger," was painted in 2006 at the Santa Barbara I Madonnari Festival, CA.

Below bottom right: Vera Bugatti combines a portrait in this painting with the background image of the church in Grazie, Italy. If you walk inside the church, there is an alligator hanging from the ceiling. Stories tell of the alligator preying on people who walked by the lake side until the faith of the people there made it so the alligator could be caught. In this image Vera has created a painting that is true to the traditions of Grazie while remaining completely her own in theme and technique.

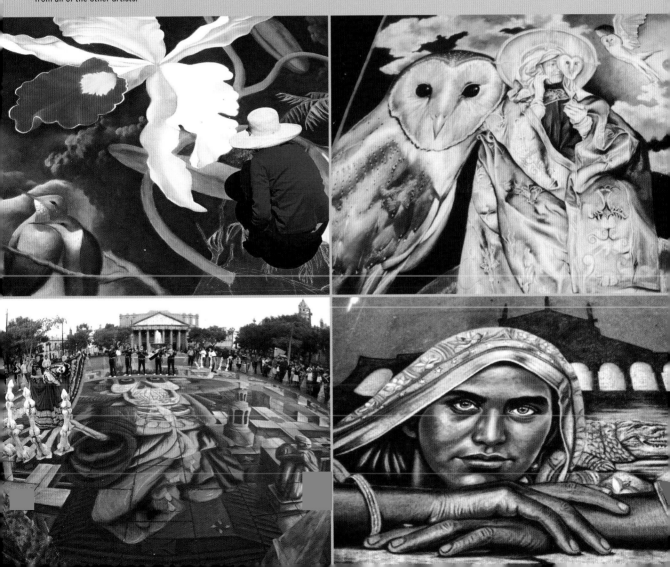

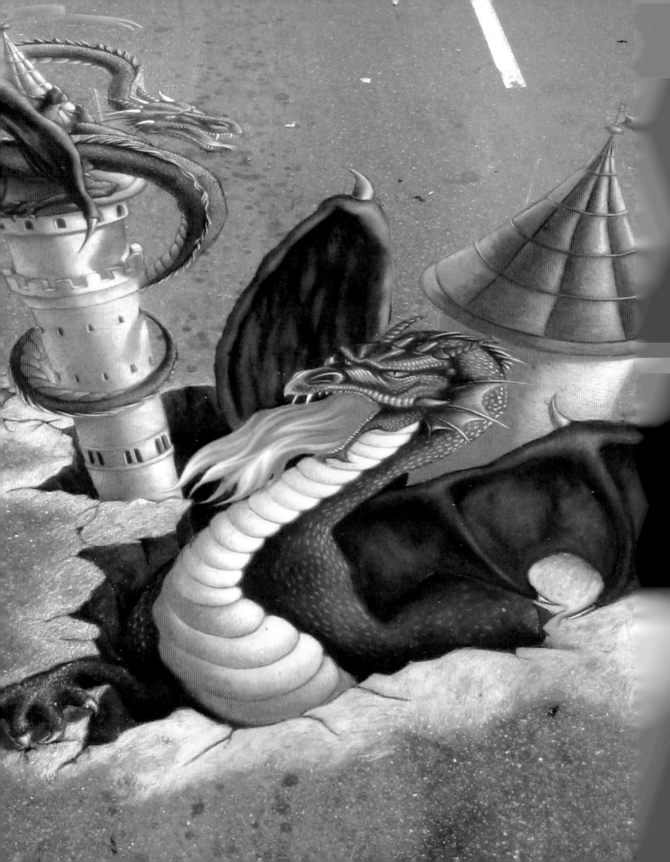

From ancient Greek murals that transformed a room into an underwater fantasy to Renaissance church frescoes, which appeared to be additional rooms or openings to the outside world, mural artists have spent centuries creating illusionistic space as a theme in their work. The term for this type of illusion is "trompe l'oeil," which refers to any painting, or section of a painting, intended to fool the eye into believing that a two-dimensional painting is actually a three-dimensional object or space. This was usually accomplished by painting the object as realistically as possible, using light and shadow to give the illusion of the painted object having convincing volume.

When the Renaissance architect Brunelleschi discovered the process of scientific perspective, he found a way of building convincing depth into a two-dimensional work. The Renaissance masters became so enamored with the process of perspective that they used it in many of their works. This discovery, in combination with trompe l'oeil effects with light and color, allowed these artists even more freedom to manipulate space and create illusions that amazed onlookers.

Street painters have employed the classical tradition of trompe l'oeil and the use of scientific perspective in particular to create work that is entertaining to a public audience—stopping them in their tracks with something that is not only beautifully painted, but which also puts viewers into an interactive environment. These images use various types of perspective—single-point, multiple-point, and anamorphic perspective, as well as a combination of these—to allow the onlooker the immediacy of being involved in the painting in a very real sense.

Opposite: This painting has a single-perspective point located at the bottom, as well as anamorphic distortion in the furthest elements, such as the purple dragon and castle.

THE USE OF ILLUSION

PERSPECTIVE CHOICES

Above left: This painting uses primarily single-point perspective with minimal distortion in the top half of the painting.

Above right: A one-day painting completed in New York City in 2008, which uses a combination of perspective techniques.

Below right: The single-point perspective helps to establish a strong sense of depth here. I wasn't able to have all the space I needed for the intended anamorphic distortion, hence the "squashed" appearance to the top half of the painting.

The basis of scientific perspective is that parallel lines disappearing into space converge to the same vanishing point. This seemingly simple idea becomes significantly more complex as various factors—vertical space versus horizontal space, multiple objects with differing parallel lines, picture planes that no longer stay perpendicular to the viewer, and light and shadow—affect both the number of vanishing points, as well as the eye level. Given enough of these additional factors, even a relatively simple painting can begin to feel as if it has the complexity of a graduate level math course!

CHOOSING PERSPECTIVE TYPE

There are various factors that come into play when an artist is deciding how to build their space to the greatest effect. The size of the work, the vantage point of the viewer, the time available to complete the piece, as well as the function of the final "product"—whether the work is being developed for the public to view, or is being created primarily for photographic or print work—all need to be considered. All of these factors affect the artist's decision as to which type of perspective should be used for the best outcome.

WHY USE SINGLE-POINT PERSPECTIVE?

Many paintings use single-point perspective, which can be very effective in creating a simple sense of depth. Single-point perspective needs little to no additional space to create its illusion, so these images can be completed in whatever space there is available—though the greater the size of the painting, the greater the impact of the depth (and the impact of the painting as a whole) tends to be. However, single-point perspective is simple and, especially in photographed work, does not have the realism that an anamorphically distorted painting might have. On the other hand, single-point perspective paintings are easily readable by the viewing public, and are traditional in the sense that there is no distortion, only the created depth.

ANAMORPHIC PERSPECTIVE

This is the distortion of perspective to compensate for the fact that a work is not parallel to the viewer's picture plane (see pages 44-53). For example, with sidewalk art, the viewer is looking at an image on the ground and at an angle to them, instead of at a flat painting directly in front of them on a wall.

Works that use anamorphic perspective can be problematic in several ways. In anamorphically distorted images, even small items are greatly enlarged as they are painted. So a painting that originally might have been 7–10 ft (2–3 m) in height if painted flat on a wall, when painted on the floor needs to be executed at a size closer to 25–35 ft (8-9 m) to adapt to the differing picture plane. Not only is this factor a space consideration, it is also a time consideration—obviously as the work magnifies in space, the time it will take to complete it also increases. Due to the extreme distortion that happens, images are more difficult for the viewer standing in front of the painting to "see" well. Some viewers find it hard to get their brains and their eyes to agree on how to work together, which can be frustrating and leave them feeling left out of the illusion. Overall, anamorphic images are probably best suited to works that will be viewed primarily in photographs, as the camera does the job of flattening the piece for viewing. There is no denying the popularity of this type of work, especially thanks to its visibility on the internet. As a street professional painter, these images probably account for 90 percent of the work requests I receive, and I'm often in the position of finding a happy medium.

A few artists opt to set up an inexpensive camera in front of their painting to provide an easier way to view the work. However, with larger crowds this can make enjoyment problematic and fleeting at best. The difficulty is that some viewers will feel rushed to enjoy what they are seeing through the camera, while others will not worry that there is a line of people behind them waiting their turn, and will take so much time as possibly to annoy those still waiting!

REFLECTIONS AND STREET PAINTING

Every once in a while, I'll end up at a festival where someone is doing a cylindrical painting around a reflective tube. This type of anamorphic distortion is not specifically a process that has been created for the street-painting medium. The same painting could just as easily be put on a table top, or painted in a variety of mediums. Rather than list all of the specifics of this type of distortion, there are several places on the internet that detail the exact processes for doing a cylindrical reflection. Often, artists generate the drawing through a computer program, or at least a grid that has been distorted, to make the drawing completely accurate. The drawing itself is so distorted that it is almost completely incomprehensible without the help of the reflection.

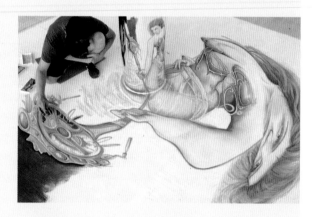

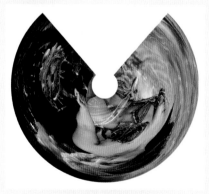

Above: Images showing the computer distortion and final product for a reflective cylindrical painting created by Leon Keer of Planet Streetpainting at FRINGEMK in Milton Keynes, UK, 2010.

THE BEST OF BOTH WORLDS

What some artists choose to do, myself included, is to avoid strict anamorphic painting and instead do works that have a combination of anamorphic perspective and perspective that involves no distortion. Part of that decision is my preference to stay rooted in the ideals of street painting, which involves viewer interaction. Precise anamorphic perspective looks so odd when viewed in real life, since the distortion is quite extreme, especially with images that have vertically tall elements in them. When looking at these images from the side of the painting—which can happen quite a lot at a crowded festival—it is almost impossible to make sense of what you are looking at.

THE HUMAN DIMENSION

For artists who fall in love with the medium of street painting, part of the romance is often the interaction with the viewer who is standing in front of the painting. Photographic images of anamorphic street paintings that are circulated are, in reality, built for the camera and the internet, not for the public viewing them. Due to the scientific aspects of anamorphism, the image almost has a sense of "coldness" to it, or a lost dynamism. In fact, stronger drama can be built into the painting when the artist is less worried about stretching out the image, and spends more time drawing directly and building a unity to the design that is less dependent on mathematics and more dependent on what the eye truly sees. One of the reasons for this is the immediacy of the drawing. In the same way that many artists refuse to work from photographic reference because they feel it flattens the artist's intuition as well as the actual space, the process of strict anamorphic perspective cannot ever account completely for the biological process of sight, including peripheral vision, and the process our brains go through to take the information sent to it by our optic nerves and tell us what we are seeing in a manner that we can comprehend. Often we don't realize just how much our brains are compensating for small visual oddities!

Anamorphic street painter Kurt Wenner's individual use of perspective (see pages 52-3) is specifically done to address these problems. His desire is that his paintings are a drawing demonstration, rather than about a photograph that documents the end product. Although there are several artists who make a good living doing large anamorphic images—and the photographs circulated can be quite amazing—for myself, ultimately, I want to street paint and to live in that moment with my work.

Below left: The close-up (top) shows the distortion of the hand and face; the painting, called La Ruina, reads more strongly for depth in the shots taken from a distance (bottom). The distortion is kept to a minimum, balanced with the desire to achieve the illusionistic effect.

Below right: The cow (bottom) is built on single-point perspective, but she is also distorted somewhat to allow for the viewing angle. The side view shows just how much correction was done (top).

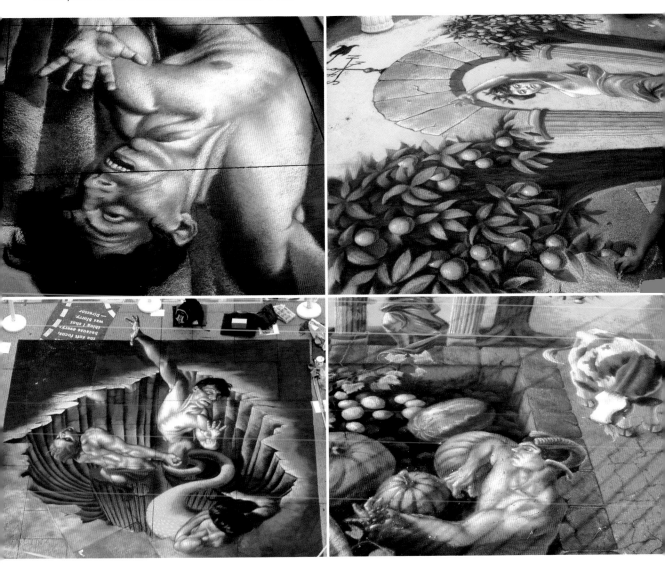

SINGLE-POINT PERSPECTIVE

The basics of single-point perspective—the problems of shadows, archways, steps, and so on—are best learned by purchasing one of the many books that deal with perspective in a general sense. Here, the focus is specifically on how single-point perspective is used within street painting.

LOCATING THE VANISHING POINT

To apply single-point perspective to a street painting you usually use the vanishing point, which is normally located at the bottom of the painting, to help you to determine the center lines of the vertical elements within the work. Generally, if you look at a street painting and think of the top of the painting as being north and the bottom of the painting as being south, the further "south" of the bottom border the vanishing point is placed, the less extreme the sense of depth becomes. As the vanishing point becomes closer to that "south" border, or even is moved into the interior of the painting, the depth becomes more extreme and distorted, and can move away from creating a sense of realistic depth.

For the greatest optical enhancement, the vanishing point for a single-point painting that is designed to be viewed by an average adult would usually be found approximately 5 ft (1.5 m) from the station point—the point where the person who is viewing the painting is standing. Most of the time, you could assume that the person would be standing around 1–2 ft (about 0.5 m) from the center of the bottom border, which would put the vanishing point from which the perspective should be based approximately 6–7 ft (1.8–2 m) south of that border. This vantage point should be used to define the vertical edges of items within the painting.

FURTHERING THE SENSE OF DEPTH

If you wish to further the sense of depth in your finished work, look for ways to include vertical elements throughout the painting during the design stage. The more these vertical elements are used to enhance the overall design, the more that sense of depth enhances the overall theme of the work. These elements might be as simple as the vertical edges of a brick border or cracks disappearing down into the ground, or they might be much more elaborate, such as the approximate center line of figures and animals, architecture, or trees within the painting. Generally speaking, anything vertical might be placed on these perspective lines and used to add to the sense of depth.

Below: The client for this image wanted a 3-D painting, but gave me a relatively short space to build it in. This meant that the depth was small enough in comparison to the width that essentially I didn't do any anamorphic distortion. Instead, I used just a single-perspective point to establish the vanishing point for the outside wall, and then put all of my "characters" in their correct perspective.

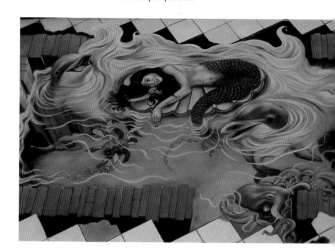

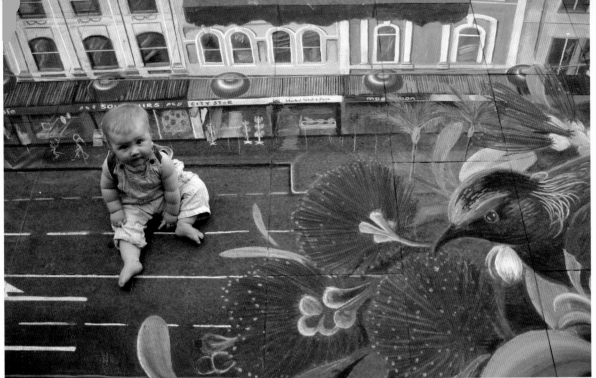

Top: Artist Ulla Taylor placed her daughter in the middle of her single-point perspective painting. All of a sudden, a small baby is a giant! Ulla Taylor, Tui Over the City, Auckland, New Zealand, 2009.

Bottom: The original design for this single perspective painting of a desert fortress and magic carpet was designed for BankMuscat in Oman, 2010.

ESTABLISHING PERSPECTIVE

1. To locate the vanishing point, the artist finds the center of the bottom border of their painting, then measures down an additional 6–7 ft (1.8–2 m) from that point and marks it with a piece of pastel.

Tip: I recommend marking the vanishing point clearly as, over the course of several days, this mark will most likely be stepped on by the public walking by–retaining the mark over several days of painting is important if you want to keep a sense of continuity to your perspective.

2. One of two methods can be used to refer to the vanishing point during the course of creating the work. The artist either lines up a long straight edge with this perspective point, or they can choose to tape the end of a construction chalk line (see page 117) to this point. This then allows the artist to snap down chalk lines quickly to establish the perspective points. The construction chalk line can be left taped in place over the course of the day. (Just be careful that the wandering public doesn't trip over it in their eagerness to view your painting!)

Tip: As the lines are snapped, bear in mind that every few lines the string will need to be rechalked–wound up within the mechanism–and that rewinding it all the way to the beginning of the line will leave unneeded chalk lines all over the bottom of the painting. I recommend rechalking only the last few feet of lines for whatever actual perspective marker is needed.

GALLERY: ILLUSIONS

The images in this gallery use some sort of perspective to create their illusion of space. From figurative and classical themes to the use of environment and commercially based advertisement images, street painting is enjoying a popularity now that means that most people are aware of the art form. This is a far cry from 20 years ago when many people thought street painting meant drawing lines for cars—the street painter of today is much more likely to be painting the car itself on the ground!

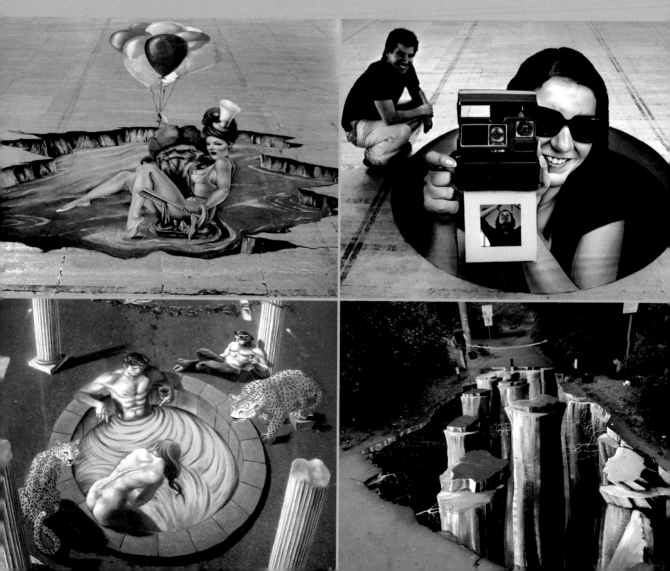

Opposite top left: An anamorphic painting by Melanie Stimmell Van Latum called Special Delivery. FRINGEMK Pavement and Street Art Festival, Milton Keynes, UK, 2010.

Opposite bottom left: Sometimes trial and error ends up needing improvement, but much of the perspective reads well in this 2006 painting done in Denver, CO.

Opposite top right: One of a series of images completed as commissions by Juandres Vera for a new festival in the UK. A mirror was used to put the spectator within the Polaroid, letting the real person become a part of the larger illusion.

Feedback, image from the FRINGEMK 3D and Anamorphic Street and Pavement Art Festival, CMK, UK, 2010.

Opposite bottom right: Notice the post in the middle of the street, mid-painting. It actually helps complete the effect! Gregor Wosik and Marion Ruthardt, Moscow, Russia, 2010.

Below top left: The attention paid to the cast shadows in the foreground helps complete the illusion. Gregor Wosik and Marion Ruthardt, Moscow, Russia, 2010

Below bottom left: Artist Ulla Taylor takes a wild ride on one of the lifeboats from the Titanic. Melbourne Museum, Melbourne, Australia, 2010.

Below top right: Baby Ruby, visiting one of her mother's paintings and also helping to complete the illusion! Ulla Taylor, Tao Philosophy for Babies–Unnecessary Goods Ensnare Human Lives, Geldern, Germany, 2009.

Below bottom right: Artist Ulla Taylor and her daughter Ruby, playing with a blue tongue lizard that appears to be sitting on the pavement.

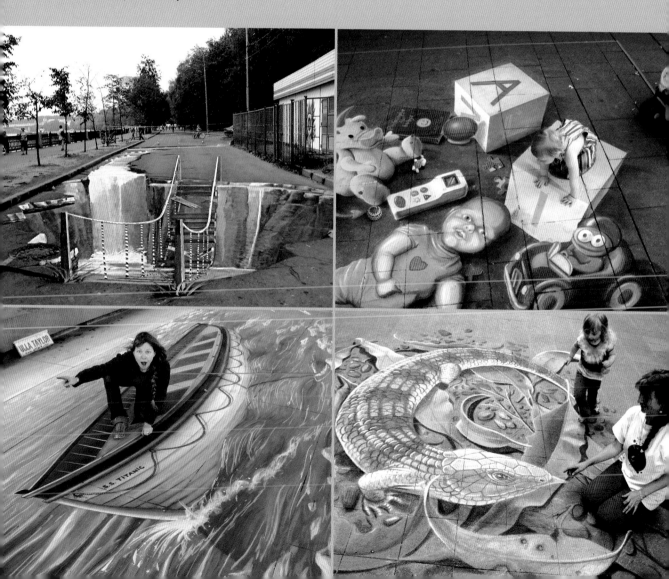

Top left: This work captures a real sense of the moment in time when the jacks are caught and the hand shadows the earth as it catches them. Juandres Vera, Matatena (Jacks), image from the FRINGEMK 3D and Anamorphic Street and Pavement Art Festival, CMK, UK 2010.

Bottom left: This image, called Message in a Bottle, of an octopus crawling around was painted by Rod Tryon at the Italian Street Painting Festival held in San Rafael, CA, 2007.

Top right: The world's largest street painting, completed by Planet Streetpainting in Rijssen, the Netherlands, in 2009. The artists are standing on the outside support beams along the edge of the painting.

Bottom right: View of the painted pool shown opposite right with the artists taking a swim. The illusion in this painting is enhanced by the acting skills of Planet Streetpainting! Alphen aan de Rijn, The Netherlands.

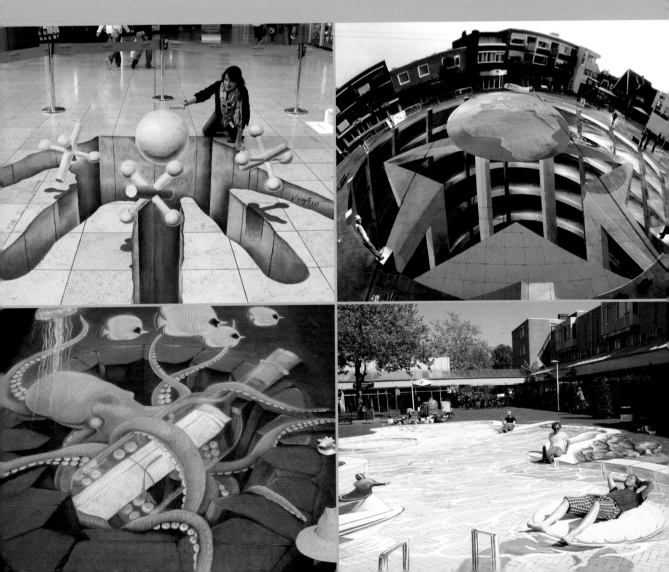

Left: Upside-down view of the swimming pool painted by Planet Streetpainting shown opposite bottom right, to give an idea of the distortion.

Top right: This is one of a number of original designs created for the University of Maryland. It is a surrealistic image that was inspired while the artist was playing soccer. Michael Kirby, 2010.

Bottom right: The Hombre de Fuego (Man of Fire) mural in Guadalajara is an important image in Mexican Art. The artist designed this image based on indigenous points of view, which involves a group of Huichols extinguishing the fire in the image by sitting on it and pouring water. Michael Kirby, Guadalajara, Mexico, 2000.

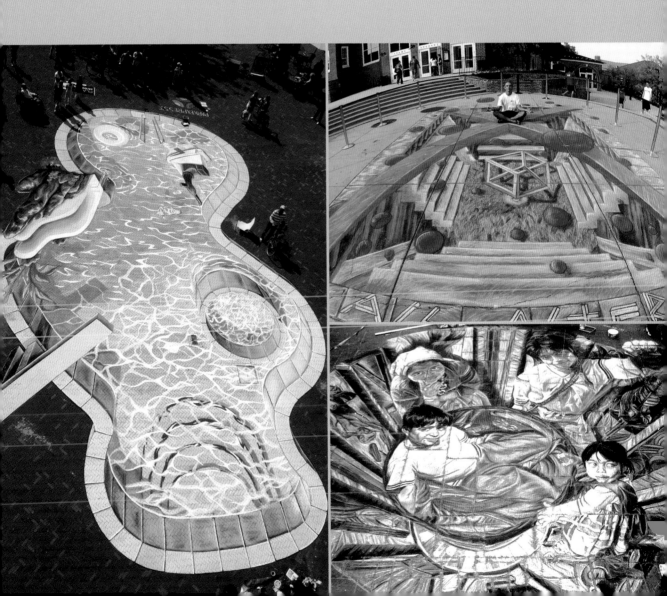

Anamorphic perspective—the use of perspective to make a distorted image that appears correct when viewed from the right vantage point—first showed up in the art of the Renaissance period. In adjusting the perspective, artists could take a wall or other surface that the viewer might be standing to the side of and, by distorting the image they were looking at, make it appear as if the image was flat in front of the viewer, rather than on an angled wall. As the use of perspective became popular with Renaissance painters and muralists, the additional use of distortion almost became a bit of a visual riddle for the viewer to figure out—if they were not standing at the correct vantage point, the distorted image might appear completely incomprehensible. The history of street painting often points to religious icons. As the idea of creating an illusion of space was used commonly within church frescoes and religious works, in applying these same ideas to contemporary street painting, artists such as Kurt Wenner are actually tapping into a historical tradition, though in a much more extreme manner.

Opposite: An image taken while completing an anamorphically distorted painting, Faerie Ring, in Denver, CO, 2008. I was two days into the painting when I came back on the Sunday morning to find that rain had completely washed it away! This photograph was taken on Sunday afternoon as I repainted it and worked to complete the bottom of the image

MORPHIC PERSPECTIVE

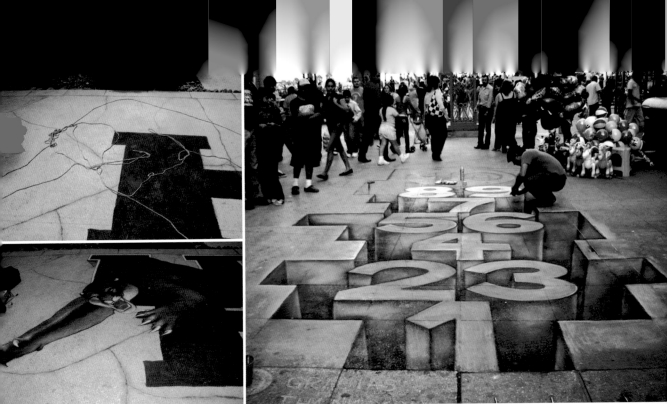

Above: The top photograph of a painting done for University of Houston in 2010 shows the layout for the rope "drawing" of the cougar mascot; the second, the finished painting of this portion.

Top right: Juandres Vera created this hopscotch painting to refer to childhood memories of drawing with chalk. In the game, jumping outside the squares lands you out–in his version, jumping outside the squares lands you off the cliff! The numbers and outside edges are parallel and at the same plane as the ground. This means they were drawn as is. Simple perspective establishes the vertical edges descending down. Plaza Morelos, Monterrey, Mexico, 2010.

Bottom right: This version of the 14th canto in Dante's Inferno was painted in Denver, CO, 2010. The figures are distorted as they are parallel to the ground plane and at the same level; the cliff tops were drawn as is. This has two perspective points–one central one for the rain of fire, and one below

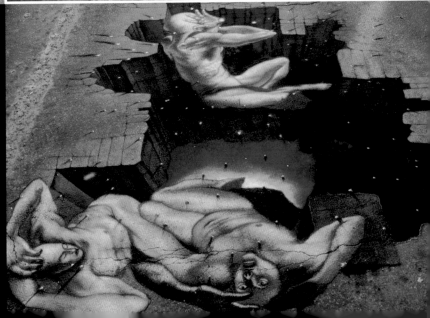

Building a street painting that has correct anamorphic distortion is mostly a matter of geometry—just how amazing the design ends up being is dependent on the artist's creativity as well as their use of composition and technique. However, by understanding a few basic principles, as well as applying the geometry correctly, most painters can complete a successful drawing that is a surprise for viewers to happen upon.

ELEMENTARY RULES

The first thing to watch for is that the portions of the painting that are meant to be at ground level and parallel to the ground, such as a tile border on a pool or the top of a rock ledge on a pit, are drawn without distortion. The items that are the most distorted are the vertical portions of the painting, such as a person rising up, or sinking down, into the ground, or the edges of a cliff going down.

Another principle is that the more vertically tall a form is supposed to be in relation to the viewer—for example, the person rising up out of the pit, rather than sinking into it—the more distorted the painting will be, as for the viewer to read it at the correct height, the image needs to stretch proportionally out, closer to the horizon line. Also be aware that while stretching the image out can approximate anamorphic distortion, it won't create a perfect version. A perfect version is created by building the geometry that projects the viewing point properly.

It should be noted that, other than Kurt Wenner, most of the artists creating street paintings with illusionistic space use a form of anamorphic perspective that originated in 17th-century Baroque painting. However, when Wenner began street painting back in 1982, he created his own geometry for anamorphic perspective, which was specific to the needs of a street painting.

THE "EYE-BALLING" METHOD

There are several ways to arrive at an anamorphic painting. One relatively simple way to create distortion is basically by "eye-balling"—that is, constantly viewing the image through a camera and correcting it bit by bit until the appearance in the camera is correct—a tedious process, which is almost impossible if the image is fairly complicated. However, if the image is simple enough, it can be done this way, which makes a good alternative to the mathematical version (see pages 48–51).

The first step is to set up a camera where you expect people to be viewing and at an average viewing height—probably about 5.5 ft (2 m) high. You then need to figure out a single-point perspective point for the vertical edges. This vanishing point should be located near the bottom of your painting and depends on how extreme you want the illusion to be: The closer to the bottom of the painting, the more extreme the depth; further from the bottom gives a more realistic, though not quite as strong, sense of depth. Once you've set up the camera, you need one person standing in the camera viewing angle to mark out where the painting needs to be and make corrections as directed by the person watching through the camera lens.

USING A ROPE

Probably a slightly easier method is to have a long skein of thin nylon rope that can be laid out on the ground in the shape of the object being drawn. The rope becomes a simple drawing of sorts, allowing you to adjust it until the shape seems correct in its distortion when viewed through the camera. This also frees you, if you're working alone, to step behind the camera, check your "drawing" then move back to the rope to make minor adjustments until it all feels correct when viewed through the lens.

Once you are happy with the rope's position, you can use a piece of pastel to trace the edge of the rope and mark your drawing down, without leaving lines all over the ground as you make your adjustments. A rope also works well when fixed to your vertical vanishing point at the bottom of the painting, as you can stretch it out to each of the corners that need to be vertically correct for perspective, then trace along the rope to establish the perspective of that edge.

MATHEMATIC PRINCIPLES

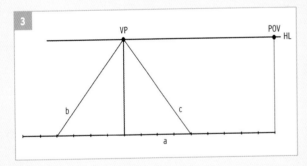

The last method I will cover is the mathematic principle of anamorphism. It can be a little complicated, so follow the steps closely and have the following items handy:
• **Vellum or tracing paper—at least 14 x 17 in (36 x 43 cm), though smaller will do if you can use tape to add on extra sheets as needed • Ruler • Pencil and eraser • Protractor • Compass**

1. The aim is turn this sketch into an anamorphically distorted street painting. We will assume the following: The final size of the street painting is 8 ft (2.4 m) wide by 10 ft (3 m) tall. The viewing height is 5.5 ft (1.6 m) at the center of the painting, with the viewer standing 5 ft (1.5 m) from the bottom of the painting. As you make your scale drawing on paper, one unit equals 1 ft (30 cm), and for your unit measurement on the paper, the unit size will be drawn at 1.5 in (4 cm). So, your scale is 1.5 in (4 cm) = 1 ft (30 cm). Your first step is to make a scale drawing of your chalk area in the correct perspective from where your viewer is standing.

2. Mark out a horizontal line near the bottom third of the paper, which will be eight units long (12 in/31 cm) and represents the bottom edge of the painting (line a). From the center of this line, mark a vertical line that is five units tall (8.25 in/21 cm), which will represent the viewer's eye level. From this point, draw a second horizontal line, parallel to the first, which will represent the eye level or horizon line (HL). The point where this line intersects the vertical line is the vanishing point (VP). From the two ends of your painting edge line (line a), draw lines that connect with the VP (lines b and c). These lines represent the outer edges of the painting going back into perspective.

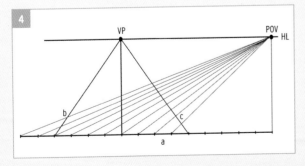

3. Your next step is to build your 1 ft (30 cm) grid for your painting in perspective. Because the height of your painting is 10 ft (3 m), this means it is two units longer than the width. So, continue line (a) for two more units (3 in/8 cm) to the left.

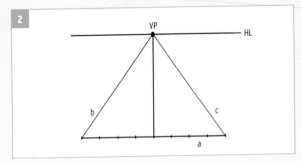

4. As mentioned in step 1, the viewer is standing 5 ft (1.5 m) from the bottom of the painting, so extend line (a) out five units (7.5 in/ 19 cm) to the right. You will use this measurement to help determine your point of view (POV) for the painting by drawing a line up from this point to the horizon line. Where this lines intersects your horizon line is your POV.

You will use your POV to help you establish the foreshortened depth of your grid squares. By lining up each of the unit marks on the bottom of the painting with the POV, you find the intersection points for both your center vertical line as well as the right border edge of your painting (line b). You need to find the depth for 10 units of vertical painting, which explains why you added two additional units on the left side.

5. Using a ruler to connect the intersection points on the vertical line and line (c), draw a horizontal line across the painting edges from line (b) to line (c). Repeat this for all of the intersection points. Once completed you should have 10 new horizontal lines, each parallel to line (a). The top line out of these new lines is the back border of your painting, line (d).

6. Connect each of the remaining original unit marks with the VP, ending them at line (d).

7. You've now created a grid of your 8 x 10 ft (2.4 x 3 m) painting in the correct perspective for a person with a 5.5 ft (1.6 m) viewing height who is standing 5 ft (1.5 m) away.

8. Keep your original grid clean and intact by laying a fresh sheet of tracing paper on top and taping down the corners of the paper so it doesn't shift. Draw the outline of your painting design the way you would like to see it appear to the viewer, fitting your design inside the grid boundaries you've just made. Keep your design lines fairly simple and clear, avoiding any shading or extra mark making: The cleaner the drawing, the easier to complete the next steps (see pages 50–1).

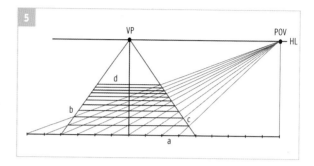

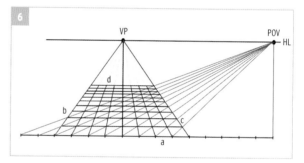

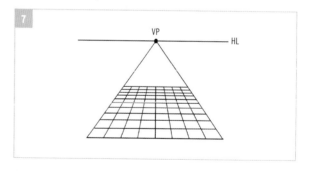

ON A COMPUTER

1. Retrace your perspective grid as neatly as possible onto your drawing.

2. Scan the image and import into Photoshop, or a similar program that will allow you to distort the image.

3. Using the "rulers" option, distort the image, so that in distorting it you bring the perspective grid back into a normal, squared grid no longer seen in the foreshortened distance.

4. Print it out! You now have a print-out of how the painting needs to be distorted when you draw it to a 1 ft (30 cm) square grid marked on the ground (see above). By following the grid closely, your drawing on the ground should appear the way it does in your original design on top of the perspective grid in Step 8, page 49.

BY HAND

1. Place another sheet of tracing paper on top of your drawing and grid, lining up the bottom edge of the paper with line (a) and taping it down along this line.

2. Carefully squaring the grid to the original, mark a grid in your same unit measurement where one unit = 1.5 in (4 cm) and the grid is 10 units tall by 8 units wide. This grid represents the grid you will mark on the ground for the actual painting, where each grid square equals one square foot (30 square centimeters).

3. In the very first step, we decided that the viewer is 5 ft (1.5 m) away from the painting, so we need to find the anamorphic projection point for that spot that will approximate the way your vision would work for viewing the work. Mark a line straight down from the vertical center that is five units (7.5 in /19 cm) long (line e). At a 90º angle, mark a horizontal line (line f) at the bottom that is five units long, centered on line (e).

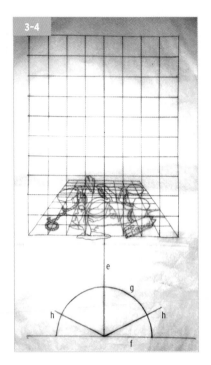

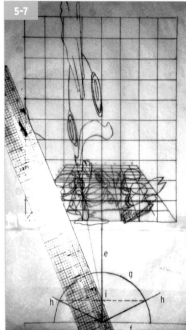

4. Using a compass, draw an arc (g) that is just under 2.5 units in radius.

5. Using a protractor, find the 30º points on arc (g) (points h).

6. Draw a horizontal line across, connecting both points (h). The point where this line crosses line (e) is our anamorphic projection point (point i).

7. Using a ruler, from point (i) connect key reference points from our original drawing onto the squared grid. The closer the grid to the viewer, the less distortion there is, but as the grid moves away from the viewer the distortion grows. Continue to mark these key reference points for all of the elements in the drawing onto the squared grid, using the projection point carefully.

8. Once these key reference points are noted, remove the drawing from behind the grid and continue to finish the details of the drawing, keeping an eye on the overall proportions of each square as you continue to "connect the dots" and finish the distortion. Remember your lessons from perspective. Any elements that are at ground level and parallel to the ground will not need the distortion; the distortion happens to the vertical edges and distance.

9. Double check your drawing. Put the drawing on a flat surface, such as a drawing board, and hold it up to one eye (close the other), approximately five units away and 5.5 units high compared to the drawing. Or, you can photograph it with a digital camera to check.

10. All that's left now is to paint your drawing—make sure that you set up a camera 5 ft (1.5 m) away and at 5.5 ft (1.6 m) high for photographs. It can take a while to get used to painting the distortion, but with a few paintings under your belt, it will get easier!

KURT WENNER

Illusionist street paintings based on anamorphic distortion have been around for over 30 years. While relatively new to the art form, there are images and artists who have become almost iconic in representing this style. American artist Kurt Wenner can arguably be listed as the painter who started the movement–and remains at the top for complexity and technique, as well as dedication to the art form. His strong attachment to Mannerist painters lends itself well to the distortion that happens naturally, and this shows in his rendering of figures and animals, adding to the feeling of fantasy created by 3-D street painting. Two of his paintings, Dies Irae (see page 15) and Muses (top right), have been around for 20–30 years and show up constantly on the internet or in print. Newer paintings, such as Triumph of Puck (bottom right), Spirit of Water (opposite), and Wild Rodeo (left), show the evolution of his painting style into the detailed designs he often paints now.

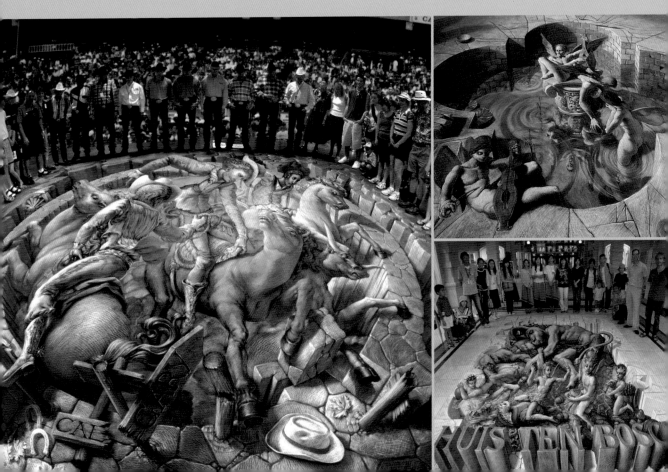

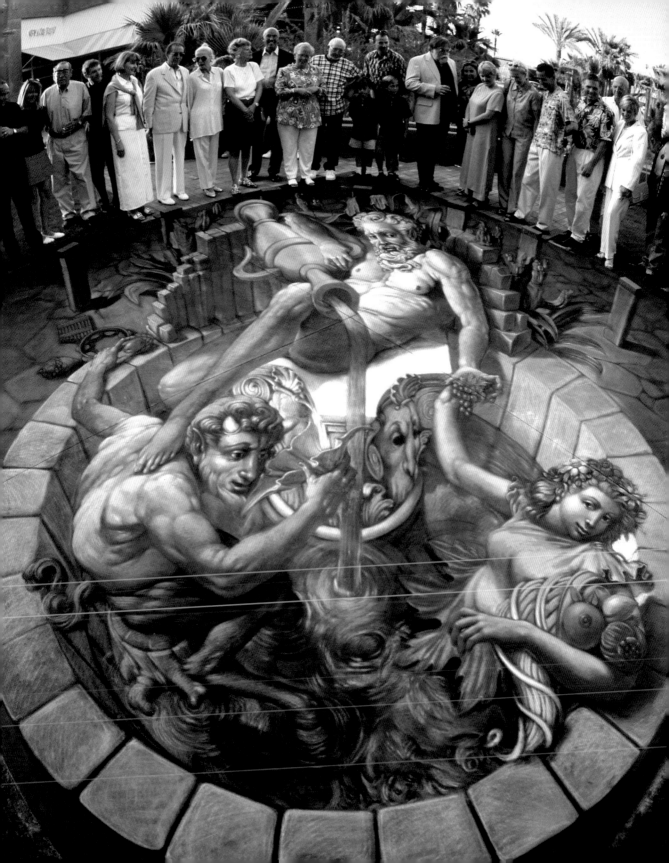

MATERIALS

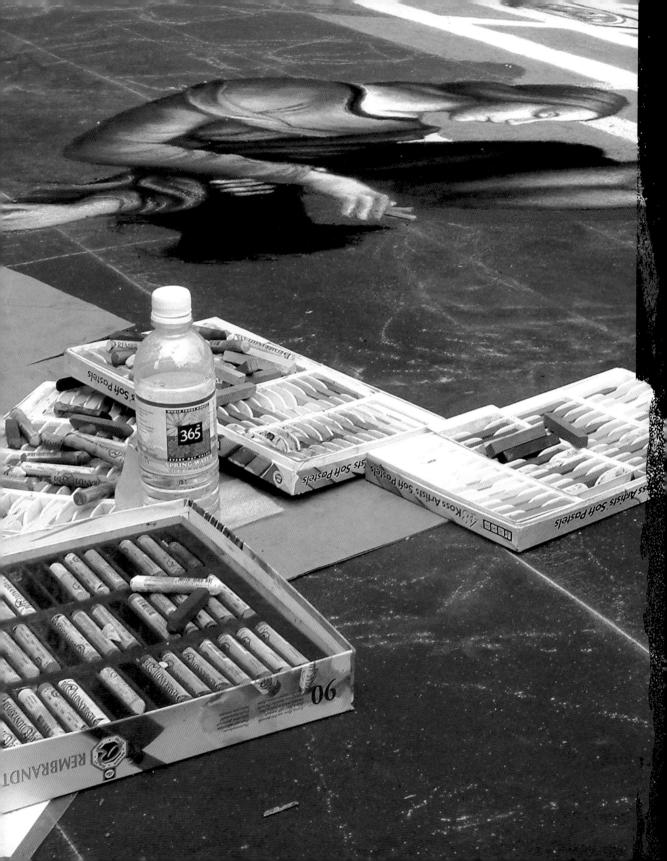

PAINTING MATERIALS

The painting materials used for street painting have stayed fairly consistent over the years, although additional materials occasionally crop up as various artists address the particular need of a current project. Depending on the background and experience of the artist, they might be more likely to work in dry pigments primarily, or pigments emulsified in water and/or egg (similar to egg tempera paint but much thinner), or soft pastels. Most artists use some combination of all of these materials. Some artists have branched off into using acrylic-based mixtures for their street paintings, but this leads toward issues of permanency and away from the traditional art form, so this type of media isn't addressed here.

The primary medium traditionally associated with Italian street painting is soft pastel. There are a variety of soft pastels available commercially, but the quality and price range of these pastels can vary quite a bit. Many street painters rely on their own home-made pastels, the recipes for which can be anything from typical pastel-making recipes to a couple of the "street-painting pastel" recipes floating around. These recipes aim to solve some of the problems specific to street painting, such as dust and the longevity of the painting under the elements, and so have variations on the materials used in their binders to help solve these issues.

Previous page: Detail of a demonstration given at a workshop in St George, Utah, a copy of a face originally painted by Navez.

Opposite: A few of the various materials used in completing this painting in San Rafael, CA, in 2006.

PIGMENTS AND BINDERS

Pigments are the raw, powdered substances used to create the color of a particular paint medium. They can occur naturally, such as in earth minerals or in plants and animal products, or they can be man-made, such as in chemically based pigments, or pigments created as by-products of industrial waste. The creation of some of these man-made pigments obviously came much later in history than the raw earth pigments, which have been available and used for thousands of years. The wide variety of colors that we have available to us now would shock artists of the past, who were used to quite limited palettes in comparison.

USING PIGMENTS DIRECTLY

The use of pigments as a direct street painting material is seen less in North America, but more in some parts of Europe. An artist who has experience handling the dry pigments can make beautiful paintings that are very soft and finely blended, and can fill in large areas quickly. One issue to consider when using straight pigment is the delicate nature of the surface. Pigment has no inherent

binder and, as a form of colored dust, is more likely to be damaged by wind or foot traffic than typical pastels. Dry pigments, therefore, are usually manipulated using paint brushes on the ground, which push the dust around and allow the artist to blend softly and correct the painting.

Pigments can be purchased at many good art stores and through online art suppliers, as well as directly from manufacturers, known as pigment houses. These develop wide ranges of pigments and often multiple varieties of the same pigment, such as ochre or sienna from various locales. The place an earth pigment originates from can result in warmer or cooler variations of the pigment, as well as lighter or darker shades. Some earth pigments have both raw and "burnt" variations, which are exactly what they sound like—the pigment has either been heated or not! Cadmiums are a heavy-metal pigment and come in a variety of yellows, oranges, and reds, as well as greens. There are numerous newer chemically based pigments.

Generally, most of the earth pigments, as well as some lake pigments (an organic dye that is usually combined with metallic salts), have been around for a long time and

Far left: Prussian blue is a deep, but vibrant, classical color that is very useful in the street painter's palette due to its darker value. This image shows a ball of pastel "dough" that has been made by mixing the binder into the finely powdered pigment. This dough can then be formed into pastel sticks.

Left: Burnt sienna, a classical and widely used earth pigment. Here, it's already in the process of being mixed with the binder that will turn it into a dough, which can then be formed into pastel sticks.

in use by artists dating back to prehistoric times. Heavy metal pigments showed up during the industrial age as by-products of the high-heat fires that were then in use. Many more contemporary pigments are derivatives of chemicals that were also invented in our modern age. Most pigments can be made to work for home-made pastels (see pages 62-4 and 176-7), with minor fluctuations in the binder-emulsifier ratio to account for either drier or more naturally binding pigments.

The proper and safe use of pigments is an involved process. The recommendation is to ask the pigment houses questions about safety, read any relevant safety literature, and do experiments to find out what is best suited to your purposes (see also page 67).

Below: A copy of Gerrit van Honthorst's King David Playing the Harp completed on roofing paper (roofing tar paper) in Utrecht, the Netherlands, by artist Gregor Wosik. Much of the underpainting—especially the background—was completed with raw pigments that Gregor worked with a paint brush, and then the final details were completed with actual pastels.

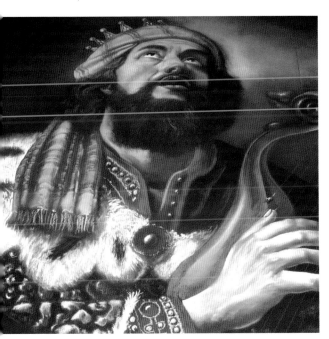

BINDERS

These are what we call the material that "binds" or glues together the dry pigment, turning it into a useful art medium. The same pigments are used across the board, whether the artist is using oil paints, watercolors, acrylics, or street-painting pastels.

Types of binders: The difference in materials is not in the pigment itself, but in the binder used. In oil painting, the binder is typically linseed oil, in acrylic painting it is liquid acrylic, and so on. In street painting, we vary the binder. As mentioned previously, some artists use dry pigment and so there is no binder. Others might emulsify, or dissolve, the pigment into water or water-based binders. Common water-based binders are either simple sugar water or water that has some egg white added to it.

Tempera paint is a water-based paint that has egg white in it for binding purposes—this is a much thicker consistency than paints made from water-based-only binders, which to look at almost resemble water. Tempera paint can be quite useful for street paintings if it is watered down somewhat, the process for which is covered more in the sections about surface preparation (see pages 80-1). The straight form of tempera paint is a bit too thick, and yet too soft once it dries, which makes it difficult to draw finishing effects on top.

Usually, street painters use pigment dissolved into one of the water-based binders as an easy way to fill in large areas within the painting, or to cover difficult surfaces and make the surface more workable. However, there are no exact measurements for any of these binders. You will need to experiment, as the successful ratio of the binder is determined by so many factors, such as the surface, specific pigments (some pigments will dissolve better than others), and what you find most workable with your own technique. The final details and actual painting portion of the work is typically completed with soft pastels.

PASTELS FOR THE STREET

There are hundreds, if not thousands, of commercially prepared pastels to choose from. For street painting, the most commonly used pastels are called soft pastels—to the novice artist, they feel similar to chalk. In some regions, the art form is actually referred to as chalk painting, rather than street painting, which is incorrect. Soft pastels do not normally contain precipitated chalk, and they do have a binder in them—unlike chalk, which is compressed dust with no binder. Due to the white opacity of chalk, it would also tint and wash out any color pigment it was mixed with, so there is no such thing as a colored chalk that is truly dark or a pure hue in value, as it has always been diluted down with white chalk. When you look at the street paintings within this book, or ones that you see in situ, one of the elements that stands out is the rich, vibrant color. This color saturation could never be achieved with chalk as a medium.

SOFT PASTELS

When purchasing pastels for street painting, don't confuse oil pastels or hard pastels with the soft pastels that you actually need. Oil pastels are difficult to remove from the street because of the high oil content, and don't blend well with other pastels; they are also affected by a hot sun beating on them all day. Hard pastels can be useful for fine details, such as the rim of an eyelid, but are much too brittle to be of any use in filling in the large areas required with street painting. Hard pastels have a much higher content of wax in them than soft pastels, which have little to no wax—an exception being the street painting pastel recipes on pages 176-7 (see also pages 63-4)!

The typical binder for soft pastels is called "gum tragacanth." Depending on the pigment and manufacturer, you might also find that there is some sort of filler material used along with the pigment.

Generally, the filler material is meant to stretch out the pigment further, since the pigment is the most expensive ingredient in the pastel. Its effect will be noticed mostly in the darker colors—browns, blues, greens, and purples—as the filler material will naturally lighten the strength of the pigment, resulting in pastels that are never quite as deep in value as you would like them.

PASTEL QUALITY

The issue of value tends to crop up with cheaper pastels rather than the brand pastels sold both in sets and as individual colors. However, there is a lot than can be done with these cheaper sets of pastels. In the United States, there is one brand in particular (see Resources, page 179) that is commonly used by most street painters and at festivals. The boxes are very well priced and the pastels come in handy for filling in the majority of paintings. For most artists, they are more than sufficient for completing a painting. As an artist gains more experience and knowledge, they might choose to purchase individual colors for areas such as skin tones that can enhance the less expensive sets, both widening their color palette as well as the value range.

Most of the more expensive brands sold in art stores are sold as individual sticks as well as in complete sets. If a painting requires a lot of a certain color, buying several individual sticks in that color is usually the best answer. These pastels will tend to spread a bit further due to the higher pigment load in them, and can be used alongside the cheaper pastels to stretch them out even further. Sets of the better-quality pastels are a great complement to have in your palette for certain types of paintings. If you are an artist who works primarily with the figure, buying a good portrait set is almost a necessity, as the limited color range found within the cheap sets will at times feel restrictive.

Top left: Starting at the top, the darkest purple in chalk, a low-quality pastel, and a high-quality pastel. It's easy to see the value difference when looking at the comparable marks each stick makes.

Bottom left: A box of low-quality pastels with a few random colored chalks on top. Many of the chalk colors appear washed out or tinted in comparison to their pastel equivalents. This brand (see page 179) might be lower quality, but is actually very useful for street painting and the brand of choice at the majority of the US festivals. Almost all of the sticks in the box are of middle value or lighter, with only a couple of sticks actually dark in value. However, these pastels are very cost effective, have a good weight to them (which means the pastel will stretch further), and have a good balance of softness, yet sturdiness.

Top right: The darkest blue out of the lower-quality pastels (left) compared to a home-made dark blue (Prussian blue), see right.

Bottom right: A box of one of the higher-quality pastels. Notice the variations in hues that you find in this portrait set, as well as some of the nice darker-valued pastels, which are so helpful for laying in shadows that are rich in color and not muddy, such as black.

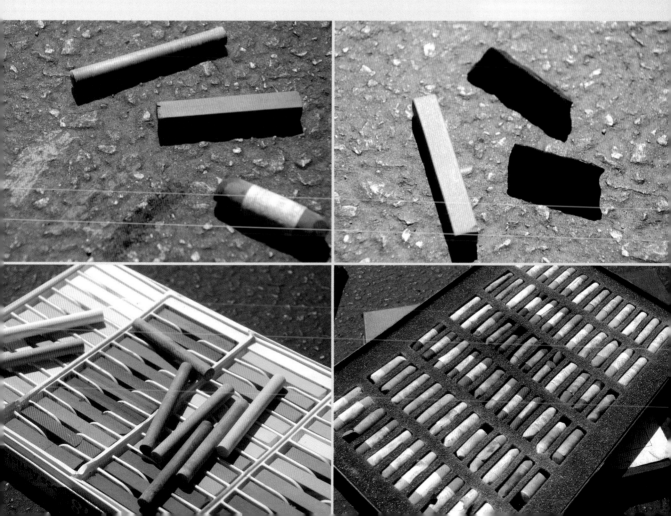

HOME-MADE PASTELS

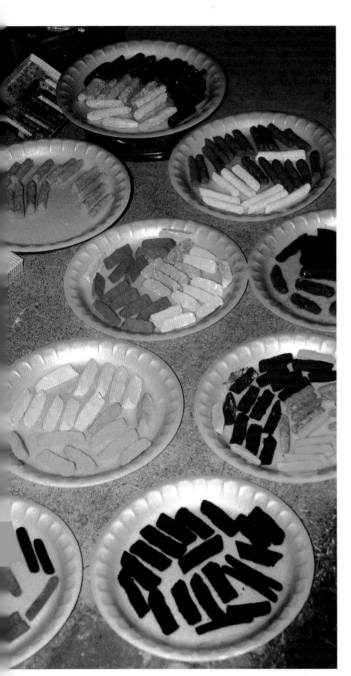

Pastels are not that difficult to make, and home-made pastels definitely have their place in street painting. If the quality is controlled with careful and thorough blending, they can be a much less expensive way to add high pigment colors into your box. There is also the advantage that you can control the shape and size of your sticks, as well as develop certain color mixtures that are best suited to your palette.

MIXING PASTELS

It is important to follow the instructions on the glue and emulsion recipes (see pages 176-7) closely to make the binder. Mix pigments well, grinding out any lumps, don't be afraid to experiment, and most of all—take great notes! It's really helpful to write down anything you discover along the way, since consistency can be hard to maintain if you rely on memory alone. Mixing pastels can take some time, but is actually a satisfying way of attaining your goals. Depending on the heat and humidity, pastel sticks may need a week or two to dry out once made, so be sure to gather your materials and pigments with this in mind. Many artists might even tweak their material mixtures one way or another for their purposes or make new discoveries along the way—this is the nature of street painting! Be on the lookout for other artists who use mediums you're unfamiliar with, and do what you can to learn from them.

Left: Once you have gone through the process of making pastels, you'll see just how simple it really can be and how much more cost effective if you have the time to do so.

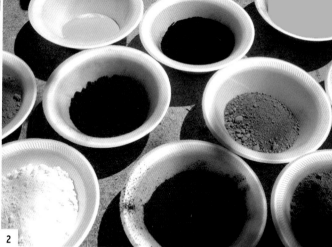

1 2
3 4

5 6
7 8

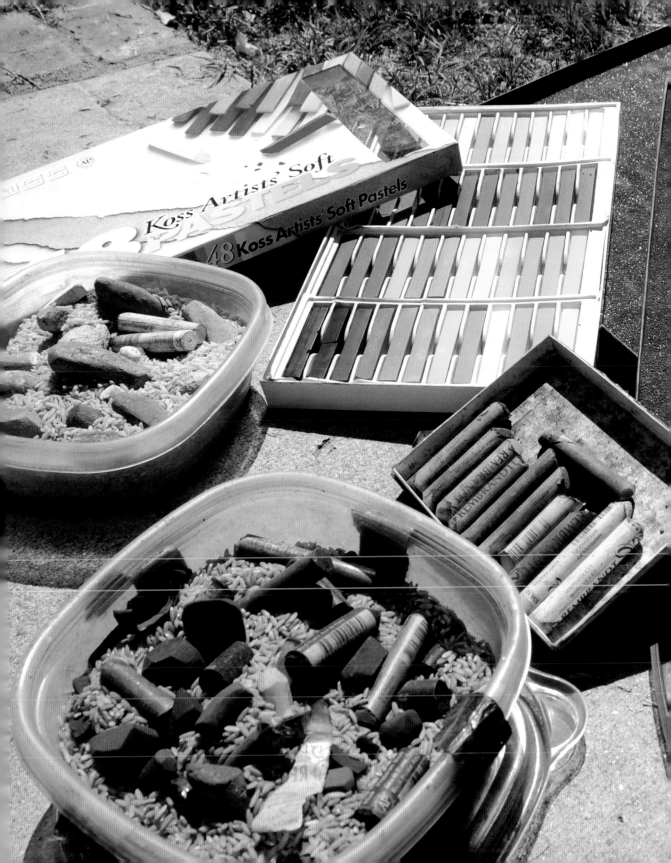

STORAGE AND TRAVELING

Once you have gone through the process of making pastels, you'll see just how simple it can be and how much more cost effective if one has the time to do so. Part of the reasoning behind the higher mark-up for ready-made pastels is that they are difficult to store and ship. Their fragility means that pieces are easily broken, resulting in a high degree of lost product, especially with the finer and softer, high-quality pastels. Like purchased pastels, pastels you make at home are also fragile. There are boxes that can be purchased specifically for storing and traveling with pastels. There are also numerous storage containers that will work just as well.

PROTECTING YOUR PASTELS

Besides the risk of breakage, the other issue with pastels is the dust they create. When stored together, the dust of one color will mix together with other colors and coat all of the pastels, sometimes so badly that it is impossible to tell what color you are holding until you actually draw with it. To combat both the dust issue as well as sticks breaking, you need to use something that pads or protects the sticks. If they are in flat drawers, sometimes simple polystyrene foam sheets will serve well.

One other trick, and one that works well if the pastels are in containers rather than drawers, is to use some cheap rice to store with the pastels. Pour the dry rice into the container so that it is surrounding the pastel sticks. The rice helps to keep the majority of the dust off of the sticks as well as protecting them from breaking. This is especially helpful if you are putting several different types of sticks together, for example home-made and commercial brands. In a flat box or drawer, sticks of different sizes affect each other depending on how well protected they are, but in rice everything is equally protected.

Top: Various soft pastels. Clockwise from top: A higher-end, good-quality pastel portrait set; storage containers of various high-quality and home-made pastels; cost-effective, lower-quality pastels that work quite nicely for street painting.

Bottom: Containers for pastels using rice to protect the pastels from breaking as well as to keep the dust from individual pastels coating others. Notice how the rice begins to take on the pigment color, so it is best to group pastels into similar values or hues when using rice.

The only real down side to the rice is that it will make the containers much heavier to carry, which can be an issue if you are traveling by air where this could potentially put you over the luggage weight limit. As far as possible, keep your pastels in their original boxes when traveling.

TRAVELING WITH PASTELS

When I travel, I tend to keep most of my low-quality, mass-painting sticks in their boxes, and then have a couple of boxes of finer sets for doing portraits and the like. Lastly I take a couple of plastic containers (such as the throw-away storage containers for meals that you can purchase at the market/supermarket) into which I divide my pastels by color/value and then cover them in rice. So, I might have a box that contains all of my dark green, blue, and brown pastels, whether purchased or home-made, and another box that has my home-made whites and creams, and yet another that has my skin-colored individually purchased or home-made pastels. This makes it easier for me to find what I need, as well as containing the dust in each box into a certain value or color range.

When I fly, I tape all of my boxes with a couple of pieces of masking tape to prevent them from falling open and making a mess. Nowadays, security is always an issue, but even though they usually check my case, they soon realize it's harmless—I haven't had any problems with my materials not making it to the other end. If you are moving materials across borders, it helps to make sure that you have with you the MSDS (Material Safety Data Sheets)—pack them in the case with the materials. If there are any remaining questions, these should help to solve them. However, I don't usually worry about this for pastels, but if I'm traveling with tempera paint or gesso, I do try to have this information to hand.

TOXICITY OF PIGMENTS AND PASTELS

One issue I would bring up as a caution if choosing to use actual pigments, making one's pastels at home, or even just using pastels at all is to bear in mind the toxicity of certain pigments as well as some of the dangers of the pastel medium. Some pigments, such as cadmium-based pigments or cobalt violet, can be especially toxic to the artist, as well as to the environment and other people exposed to them. Some manufacturers sell versions of these toxic pigments that are called "washed," where a majority of the toxic elements have been cleansed or bound within the pigments to make them less harmful. However, the issue is still present, and the most dangerous ways to use these pigments—where they can be inhaled or taken directly into the bloodstream—are the ways in which street painters need to use them.

The environment: The other issue is toxicity to the environment. Most of us are aware of the long-term detrimental effects of certain chemicals or heavy metals on the environment, especially when washed down into the water table and oceans. Contributing to these issues is possibly nothing short of irresponsible now that we've witnessed some of the long-term negative effects. Most pigments are not an issue; in fact, a number of pigments are from minerals in the earth that are no more harmful than dirt—since they often are just that. However, using some of the more beautiful, brightly colored pigments should be done with the knowledge and awareness of what one is drawing with.

Safety guidelines: Whether pigments are considered toxic or not, when using dry pigments to mix pastels, it's always a good idea to use a dust mask to avoid inhaling the fine dust, which can be a serious health issue. This same issue can come into play when using the pastels themselves, as constantly breathing in the dust can be a potential cause of respiratory problems. In addition, you are constantly taking pigments and binders directly into your body through breathing in or rubbing them with exposed hands. Wearing gloves can offer some protection, or using tools for blending, rather than your fingertips.

GALLERY: PASTELS

Pastels are a wonderful medium to work in, since they are good for learning painting basics, and one of the best ways to first understand them is to work on an old master copy. The paintings are a chance for you to hone your skills and build your understanding of street painting technique. As you grow more proficient in the medium, you may want to try twisting an old master by adjustments to the color, format, or subject matter to test yourself and grow as an artist, while also tapping into themes and concepts that have meaning to you.

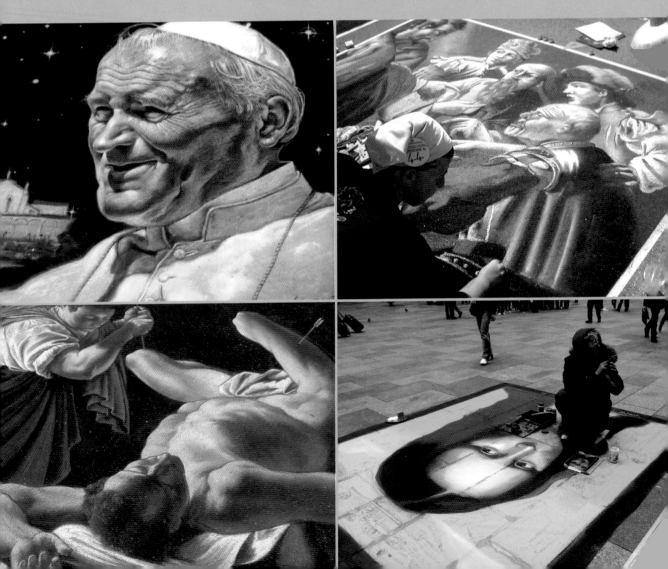

Opposite top left: A wonderful portrait completed of the Pope for the Grazie Festival, Italy, by Tomoteru Saito. Tomoteru's work is very beautifully handled and his portraits have a life-like quality to them that makes them popular with the crowds. This has come from years of working as an artist, often completing old master copies in order to hone his technique.

Opposite bottom left: This copy of a Baroque painting of St Sebastian by Bassetti was one I completed years ago at a time when I was choosing many of my paintings to help me understand the basics of pastel technique as well as anatomy and foreshortening. Denver, CO, 2002.

Opposite top right: Bold color marks this copy of a Baroque painting completed by Ketty Grossi in Grazie, Italy, 1999

Opposite bottom right: Marion Ruthardt completed this copy of da Vinci's Mona Lisa, working in much more saturated color tones than the original painting.

Below top left: This detail of a Jacques-Louis David copy by Marion Ruthardt shows her ability to handle the pastel with a humorous twist.

Below bottom left: This colorful painting, Bella Terra, designed by Italian artist Bruno Fabriani,

was completed in 2010 at San Rafael, CA, where he was one of the featured artists.

Below top right: Vera Bugatti's concept of time being a circle, instead of having a beginning and end, connected these two disparate faces in a way that was intended to be slightly disturbing for the viewer. Valkenburg Festival, The Netherlands, 2008.

Below bottom right: Vera Bugatti often uses photographic references as a starting point to evolve her own themes and designs. Here, she changed the woman in the original image to one who more closely mirrors the concept she wanted to develop. Grazie, Italy, 2008.

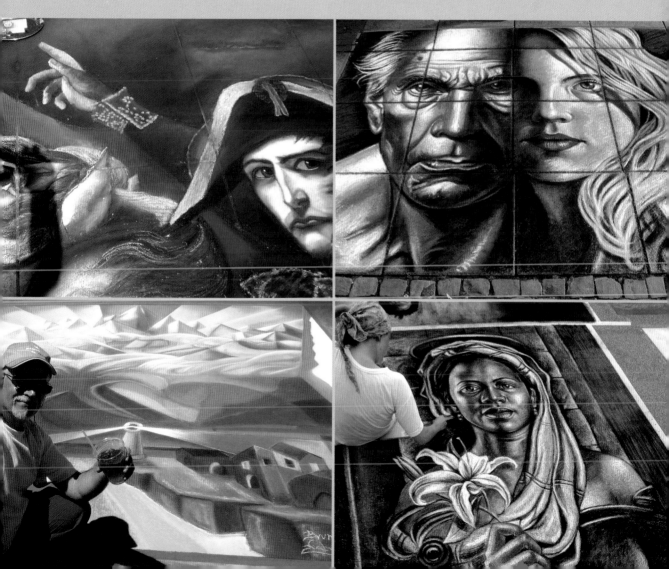

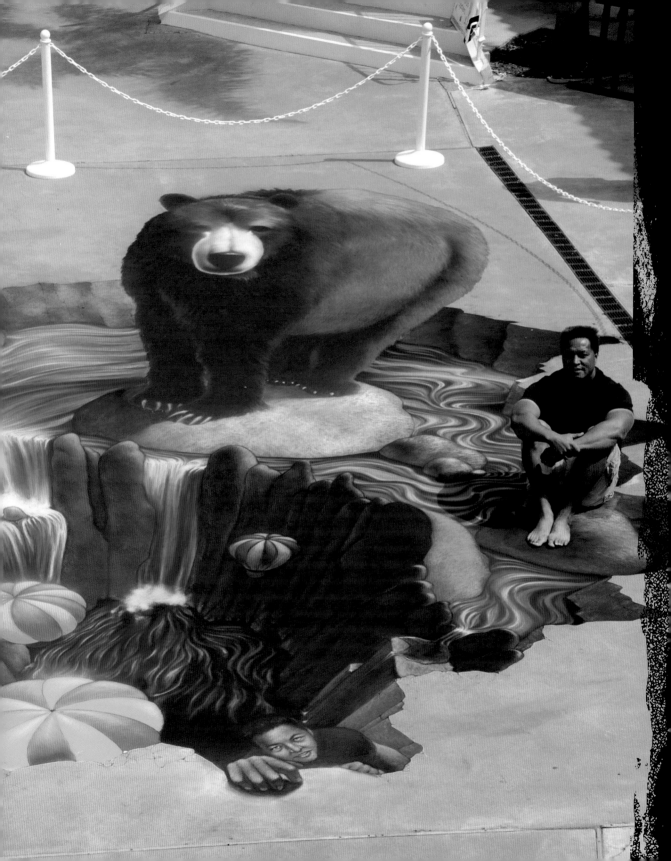

With the rise in popularity of street painting over the last decade, paintings are done on all types of surfaces, from outdoor asphalt to indoor marble, and each surface presents its own issues. If you are concerned with turning out a good-quality painting, it's wise to do some testing in advance and figure out what will help you to work the most effectively. The key factors in how well a surface will work are the roughness or "tooth" of a surface, how hard the surface is, and the value—or lightness or darkness—of a surface. For "tooth" think about sandpaper—if you were to draw with a piece of chalk on fine sandpaper, the smooth yet gritty surface would be ideal for taking the chalk and holding it on the paper. Indeed, fine papers made specifically for pastels are often similar to a very fine, medium-value sandpaper, though a bit more archivally pure than sandpaper!

A smooth, slick surface gives you nothing for the chalk to be grabbed by—drawing with chalk on a glossy piece of marble would leave hardly a mark, let alone anything close to a painting. However, many surfaces can be painted on with some sort of preparation first. For surfaces such as marble or sealed cement, there are solutions that street painters incorporate that give the effect of street painting on a more receptive surface. Some of these paintings can actually be saved into semi-permanent or permanent paintings to be kept—if prepared and then "fixed," or preserved, correctly afterward.

Opposite: A 25- x 35-ft (8- x 11-m) painting completed in 2010 in Corpus Christi, TX. My husband is both the model for the rock climber as well as posing in the painting. This painting was completed on a cement surface, so the surface was painted with tempera paint to prepare it to take the pastel, as well as giving a deeper background to the pastels. The drawing was completed first, then painted in with tempera, retaining the underdrawing by using various colors of paint, and finally completed with pastel on top.

OUTDOOR SURFACES

You might think to yourself, "It's the street, isn't it always outdoors?" Well, the answer to that points to the current popularity of street painting. Now that it is being used by marketing agencies and corporations for brand recognition or for a new "street-wise" way of reaching the public, street painting is found in all types of venues, from amusement parks to conventions to malls and shopping centers. Basically, wherever people are, often so are street paintings. The majority of street paintings are still done outside though, and one of the best surfaces for working on—regular asphalt—is common enough that many artists rarely need to worry about other surfaces. However, if you do work on a different surface, it's always good to know techniques to help overcome some of the problems inherent in a surface.

WORKING WITH THE WEATHER

Another issue to factor in with your surface is weather—and the size of your painting. In some areas rain is a daily occurrence. If that is the case and you are working on a larger painting at a festival, you might need to find a solution that involves working indoors or under cover for most of the project and then moving the painting outdoors for the actual event. In this case, working on an alternative surface, such as canvas or boards (see pages 82-93) might be your answer, despite the fact that the painting will eventually be on a suitable surface. However, if you are outdoors and expecting decent weather for the duration, then the most common surfaces you will find yourself on will be asphalt, cement, and sometimes brick or paving stones.

Above: A close-up shot showing how the bumpy surface of the asphalt picks up the color and yet allows underlying layers to show through.

Top middle: An advertising image done on a brick surface in San Francisco, CA.

Top right: This detail shows just how bumpy life can get when the asphalt is old enough!

Bottom left: A photograph of artist Ulla Taylor's daughter, Ruby, on Ulla's painting done on paving stones.

Bottom right: Notice how the texture of the street actually allows you to pick up the highlights and build a strong sense of accent against the darker background. Detail of a copy of Return of the Prodigal Son by Guercino.

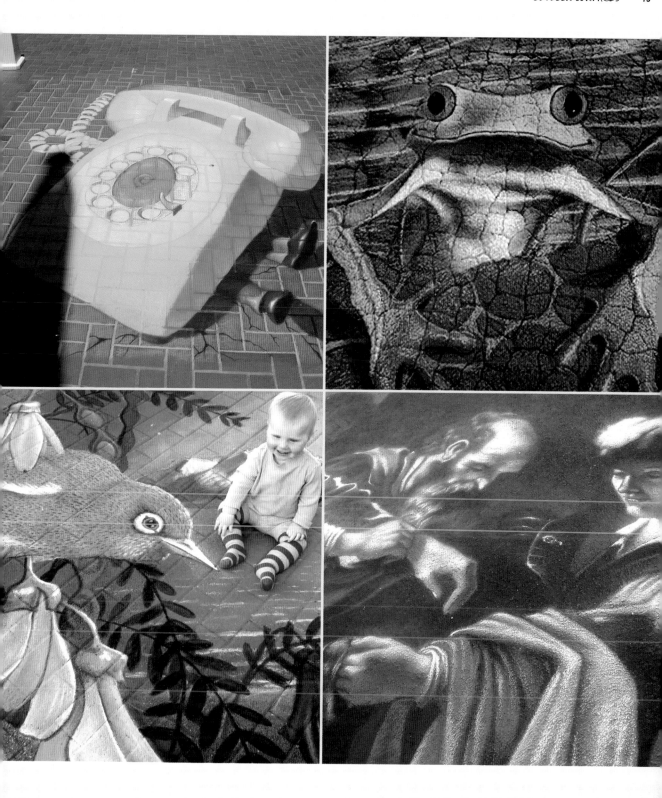

ASPHALT

Newer asphalt is often the ideal painting surface for several reasons. First, it has a smooth, yet toothy, texture that pastel grabs onto. The tar base in asphalt also creates a natural binder of sorts, at least in newer slurried surfaces. This tar binder, combined with the softer smooth-tooth surface, means that the pastel adheres well to it, yet remains workable. Blending and smoothing can be done and the finer details can be drawn in without the rockiness that some surfaces create, which interferes and makes it difficult to draw the finer lines and shades.

WORKING WITH BACKGROUNDS

Another factor that comes into play with asphalt is the dark background—a charcoal, deep gray-black—which shows the pastel to its best advantage. If you think about kitschy black velvet paintings, the effect is similar. No matter how silly those paintings sometimes look, it can be a little seductive looking at a bright color on the black background. The deeper background also shows colors on top to their best advantage as it deepens them, making them appear more vibrant, rather than lightening them and washing them out as a white background would do.

PROBLEMS WITH ASPHALT

When working outside, it helps to take whatever surface you are working on and try to bring some of the qualities of good-condition asphalt to it if it doesn't already have them. Problem surfaces include older asphalt, which can be much rockier, lighter in color, and has probably lost much of the tooth and binding qualities of the tar, since that tar has worn out over time. Newer asphalt needs little to no preparation, and the majority of the time street painters work directly onto it without doing much more than sweeping away the dirt.

Older asphalt, especially where it is rocky and beginning to break apart, can be a difficult surface to work on because of the texture more than anything else. Try to avoid it if it is too broken up. Although a little bit of cracking can actually enhance the feeling of history in a painting, too much cracking makes it difficult to draw on and chews up pastel in large amounts. If you really don't have a choice, you can try preparing the surface in a similar way to cement (see opposite), using a good sweeping/cleaning to remove as much debris as possible, and then painting a layer of tempera paint on it.

Left: A street painting completed in New York City on what was possibly the worst asphalt I'd ever seen! My team and I chewed through a lot of pastel, but the paintings turned out better than expected—they took on a bit more of an impressionistic finish as we were unable to do much in the way of finished blending and detail.

Many people think that cement would make an ideal surface for street painting, but this isn't really the case. One obvious factor, the lightness of the cement, tends to make the painting look less dramatic in color and value. The same painting on an asphalt surface will be much more brilliant in color. Another factor with cement surfaces is that they are much harder than asphalt—more like a rock. Even though some cement has tooth, because of the hardness of the surface and lack of any binding qualities (no tar) the surface repels the pastel. As the pastel is applied, it appears to be making a nice enough mark, but as soon as you touch it to blend, you realize it won't sit still on the surface, moving everywhere, and soon enough shows the cement background, as the pastel is like a fine dust, just waiting for the first wind, or footprint, or blending finger to brush it away.

This applies to a normal, brushed sidewalk where it has been roughened for walking on, rather than smooth, sealed cement (see below). So, when you're working on a typical sidewalk, although the ability to take the pastel is fairly good in terms of the tooth, adjustments may need to be made to the value and the hardness or repellent nature of the cement. This can be done with a simple layer of tempera paint (see pages 80-1) which solves both of these issues.

SEALED CEMENT

This is similar to any smooth, hard surface in that it takes very little of the pastel and repels even the normal surface preparations you might use, such as tempera paint. Sealed cement is therefore best avoided; instead you should put an alternative surface on top of it on which to work.

Below left: A face emerging out of the cement in Salt Lake City, Utah—a copy of Michelangelo's God, from the Sistine Chapel ceiling. The one downside of preparing the surface with tempera paint ahead of time is that it can be more difficult to merge the edges with the surrounding surface.

Below right: A copy of Bouguereau's Art and Literature, completed in Corpus Christi, TX, by Melanie Stimmell Van Latum and myself. The work was done on cement, so we laid down a sienna-colored tempera paint base, which allowed us to work the pastel better, as well as giving us a background that complemented our painting.

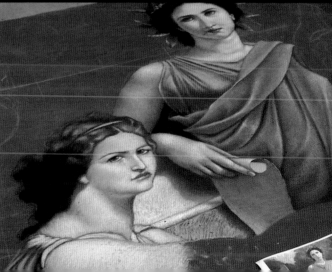

If you've read through the previous sections, you're probably familiar with which factors need to be assessed before you figure out how workable your surface is. When we look at brick, the first point is that not all brick is created equal! Sometimes bricks are made of a soft and toothy enough clay that you can paint right onto them, whereas at times they cross that fine line into being just a little too smooth to take the pastel well.

PREPARING THE SURFACE

As with cement, these issues can usually be addressed with a layer of tempera paint (see pages 80-1). The same applies to paving stones and cobble stones. Depending on how worn and smooth the stones are and what their original material is (such as man-made clay stones, sand stone, or granite) they might need adjustments—sometimes a lot of adjustment. You really need to take the time to assess the stone—try using some pastel on it, and also try to do a small test section where you build up a couple of layers. Sometimes you can build up layers on a difficult surface by using a small amount of a temporary fixative, such as cheap hair spray, or by doing a first layer using a watered-down pigment. I've also seen people dampen the surface first with a spray bottle of water, and then work on the damp surface with their pastels. I'm not terribly impressed with the results, but if you're desperate enough and stuck without other resources, use whatever you have access to! Just bear in mind that you can't make your painting really permanent and need to avoid any materials that might inadvertently do so, such as glues or stronger fixatives. As long as something can wash out with soap and water, it's probably okay to use.

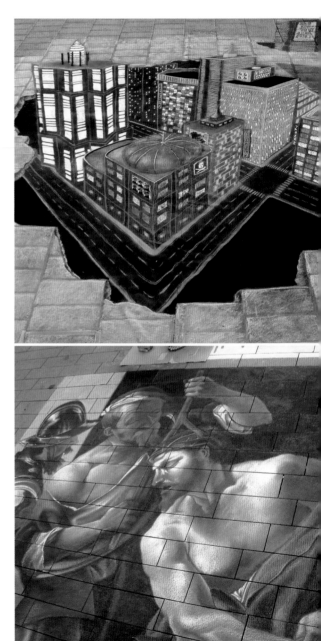

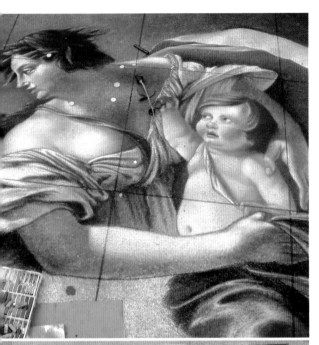

CREATIVE SOLUTIONS

Some surfaces are so smooth they won't even allow the tempera paint to stick well. This is rare on an outdoor surface and tends to be the issue only with polished granite or similar surfaces, but it does happen. If using a temporary surface such as canvas or boards (see pages 82–5 and 92–3) isn't an alternative, then it's time to get creative. Keep in mind that ultimately your surface preparation needs to wash off. Food-based binders, such as sugar and egg, might work where other things won't, and they can also be removed later with some scrubbing. I've tried techniques such as adding liquid egg whites to my tempera paint, or mixing sugar into warm water so it dissolves, then adding pigment or tempera paint to this. Both solutions ended up making the surface at least workable enough that I was able to finish the paintings. The solution to the problem can vary, especially when factoring in the heat or lack of it, as extreme heat can make surface preparations crack when laid on a really smooth ground surface.

Ultimately, problem solving is a big part of being a street painter, both in making your materials do what you want them to do as well as figuring out how to paint hundreds of square feet in a few days!

Opposite top left: A simple painting done in one day. It was completed on canvas, which was then cut to match the brick edges and finished off with additional painting to blend it in.

Opposite bottom left: A copy of Christ with the Crown of Thorns by Dirck van Baburen, painted on a type of granite brick in Utrecht, The Netherlands,

Top right: From a distance the painting, a copy of Allegory of Wealth by Simon Vouet, which was painted on granite in Istanbul, Turkey, appears mostly finished. As you get closer you can see how the granite has repelled the pastel and made it very difficult to cover completely, especially in darker value areas.

Bottom right: For this copy of Prometheus Being Chained by Dirck van Baburen I used a transparent sizing of wheat and sugar on this granite surface in order to help the pastel build up a little better on the slick surface.

GALLERY: SURFACES

No matter what surface a street painter might be working on, it's an interesting fact that the qualities of that surface rarely seem to detract from the work...in fact, they often add to it. Street painting is enhanced when you feel the grittiness of the surface, especially for some types of paintings which draw from this urban feel. The incorporation of fine art concepts from the permanent work some artists do is especially interesting to me. Even the old master copies take on the style of the individual who painted it, making these renditions a new twist on old favorites.

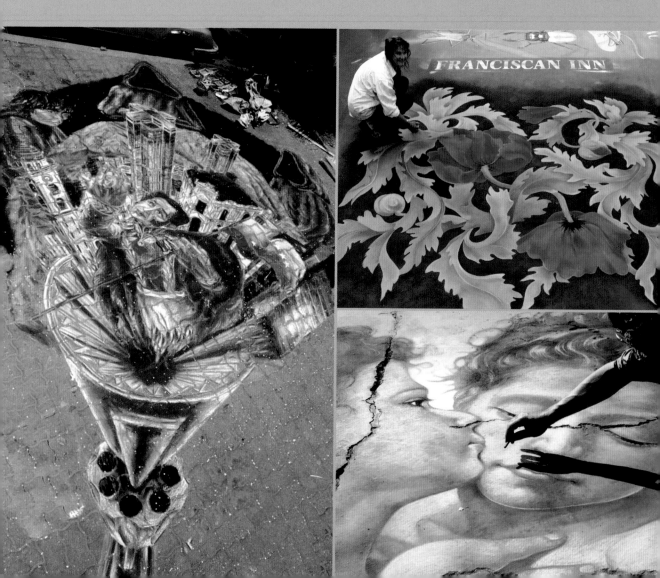

Opposite far left: This design by Michael Kirby was created in the center of Caracas, the capital of Venezuela. It is based on the South American independence leader, Simon Bolivar, who was from Caracas. Today the city is one of the most dangerous cities in the world due to the high crime rate. For that reason, in the painting Bolivar is covered in blood and falling into the barrel of a gun. The interlocking pavement below almost abstracts the painting, and yet also brings an immediate feeling of being in an older place, such as a city like Caracas.

Opposite top right: This painting, Memorial Day Poppies, was completed for the I Madonnari Festival in 2008 by Ann Hefferman. Ann's work— both permanent and temporary—often focuses

on botanical subjects. She is also interested in artists' books and print making. All of these subjects are somehow reflected in this design, and the beautiful, smooth surface she is working on helps the rendering to stand out even more.

Opposite bottom right: Tomoteru Saito works on an old master copy on broken asphalt, completing the impression of an Old World fresco!

Below top left: Work in progress of an old master copy, The Guardian Angel, by Ketty Grossi at Grazie, Italy. The painting uses subtle color temperature adjustments and a stylized edge to the form to create a sense of the street painter as well as the original artist. The colors of the painting against

the gray asphalt are almost like looking at a grisaille underpainting slowly coming to life.

Below bottom left: A street painting based on Juandres Vera's studio work—an extension of his fine art makes it onto the ground, and the slick rendered style of his work plays well against the marble floor. Psychodynamic Self-portrait, image from the FRINGEMK 3D and Anamorphic Street and Pavement Art Festival, CMK, UK 2010.

Below right: The rough ground at this location helps give an impressionistic flavor to this copy by Rod Tryon of the Libyan Sibyl from the Sistine Chapel. I Madonnari Street Painting Festival, San Luis Obispo, CA, 1997.

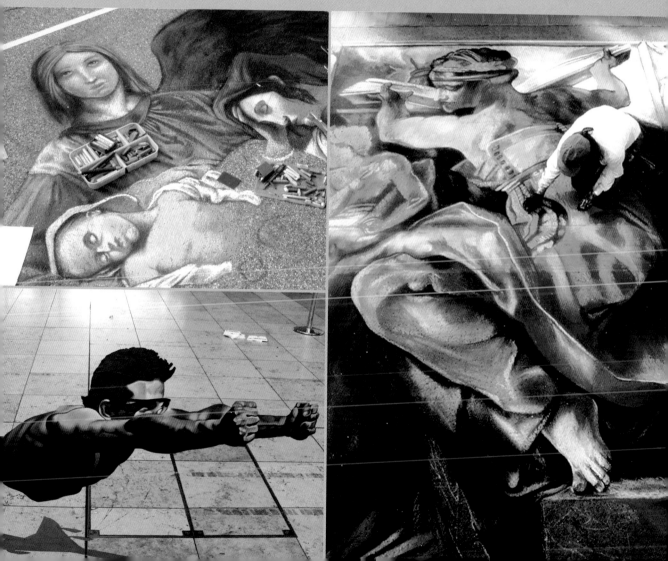

TEMPERA PAINT

Many types of surface can be made workable by using tempera paint—which is made by mixing pigments into a soluble oil emulsion such as gum, wax, or egg (see also page 59)—as a surface preparation. One of the advantages of ready-made tempera paint is the variety of colors it is available in, and this in turn addresses one of the issues of surface workability—value (see pages 130-3). Most of the time, tempera paint is laid in using black paint, and for almost any painting, this is a great choice. Bear in mind that parts of the underpainting may show through in your finished painting and can also influence the color of the final painting somewhat, so it helps to think about how you want your finished work to look.

QUALITY CONTROL

The quality of tempera paint is quite varied, but on the whole you'll find a tempera paint purchased at a good-quality art store much more useful than one purchased at a typical craft store. Occasionally I've picked up certain brands of tempera paint at a craft store when stuck for time and have found they were poor quality and not as much help as I would have liked—so I try to find the time in advance to go to an art store to pick up what I need.

Usually, I don't recommend using tempera paint straight out of the bottle, since it is too thick. Good-quality tempera paint will stretch further when mixed with water because it tends to have a higher pigment load in the first place. This means you get more square footage out of the bottle, and yet often it costs about the same as a poorer-quality paint. I don't use an exact proportion of water to paint—I judge it by feel and it varies according to the manufacturer of the tempera paint. If the paint is already fairly runny when I pour it into a bucket, I add only a little water before testing it. You should try to reach a consistency similar to heavy cream. When you put the paint down, you want it to cover the ground surface so you that can't see the color of the ground, but you can still see the surface texture. If the paint is so thick that it covers the "tooth" of the surface (see page 71), you've lost the ability to use that tooth to your advantage.

A DRY SURFACE

Another issue with tempera paint is that it doesn't always dry out. Instead, the surface of thick tempera paint stays soft and chalky, giving your pastel nothing to push against, which means it can leave a mark behind. However, if I water down tempera paint too far, to compensate for this I simply paint in a second layer of paint, which usually solves that problem. When covering large areas, I'll often use a paint roller and pan, but for small areas, or paintings where I'm using several different colors of tempera paint to block in a design, I'll use throw-away chip brushes (disposable paint brushes). These are easily purchased in the paint department of a local home improvement (DIY) store for a couple of dollars.

Opposite left: A painting completed in Las Vegas, NV, on a sidewalk prepared with black tempera paint. Copy of Luca Giordano's Archangel Michael Casting Out the Rebel Angels.

Opposite right: A painting completed in Denver, CO. The tempera paint base shows the simple blocking out of the design, as well as areas that have been painted with pastels and finished on top. The entire painting, tempera paint included, was washed away later that night in a heavy rain storm. I came back on Sunday morning and, using some of the faint shadowing from my original design and the help of my husband and friends, reblocked in the painting and completed all 400 square feet (122 square meters) of it in one 13-hour day, including the repainting of all of the washed-out areas.

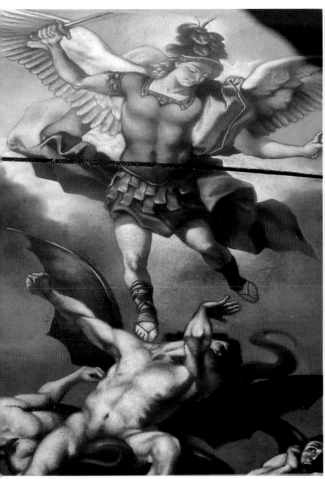

LAYING THE FOUNDATIONS

If you are doing a copy of an old master painting, it can make sense to lay in a ground color that complements the style or historic choice. For example, sienna or umber brown are typical underpainting colors for the traditional old masters. If you are doing a copy of a work by an Impressionist or Post Impressionist artist, you might choose colors such as deep purple, burgundy, or even red. Bear in mind that your ground color choice will affect how the viewer sees the colors on top. You might not always find the color you want in tempera paint, but you can usually mix a semblance of the color fairly easily.

Often I find that using black tempera paint mixed with a brighter color, such as red or purple, gives me a good dark background that is keyed nicely in color without conflicting with what I'm painting on top. Generally I try to keep my underpainting of tempera in a darker value—the lightest value I ever use is sienna brown. When laying in the underpainting, as well as preparing your surface to make it more workable, you can also use two or three underpainting colors to block out larger areas of your design, or to mass in the shadows and light sides of your forms. This is typically how I work when laying in a 3-D painting as it helps me envisage my composition more easily, while also giving me a colored base coat that stretches my pastels further—which is a big help for the large areas I usually paint for a 3-D image.

INDOOR AND ALTERNATIVE SURFACES

When I'm working indoors, I use an alternative surface most of the time, even if I happen to be on a surface that will take the pastel, simply as it's easier to clean up. Usually, though, indoor surfaces are unsuitable for painting on directly, so using an alternative surface is a necessity. Alternative surfaces are also handy for various outdoor issues. In jobs where weather has been a serious consideration, I've used canvases and worked indoors until the project was ready, then moved the canvases outdoors and finished off the edges to give them the appearance of having been painted in situ.

LONG-TERM PROJECTS

Some of my work has been done in amusement parks where I have worked on paintings that have taken several months to complete. Trying to solve the issues of short working hours (four-hour shifts), crowd control, and the need for the park's maintenance team to clean all walking surfaces nightly, as well as trying to find a way to work the design into an overall motif at the park, I came up with a way of using tiling boards (tile backer boards) cut into large mosaic designs. I painted the boards with black gesso (a primer paint, usually consisting of an acrylic base combined with ground marble to give it "tooth" or texture) and used them repeatedly. Whenever one of the paintings was completed, I would wash off the boards, recoat them with a thin layer of black gesso, and start again with a new painting. The boards could be picked up at the end of each work shift, moved into the back storage area of the park, and then brought out and set up the next time I needed to paint.

One nice design element that I incorporated into the painting was the use of several hundred one-foot (30-cm) square boards cut from tile boards, which children who came through the park were encouraged to paint. These were added as a mosaic border around the 20-ft (6-m) diameter mosaic I was painting, and so became a way for the public to be part of the creation of the art installation.

SURFACE SOLUTIONS

Whatever the reason for an alternative surface, there are several ways to create one. The surface I tend to opt for is canvas, which I prepare in a couple of ways depending on how I want the final painting to look. I've also used tiling boards, which are usually made from cement and glass fibers or ground sand. These can be purchased in the tile and flooring section at home improvement (DIY) stores. The tiling boards can either be cut into shapes, similar to thin plywood, or can be fitted together as entire pieces. The only real drawback of these boards is that they are heavy and can be difficult to move.

When working in Hong Kong, I've ended up working on pre-gessoed paper canvas purchased locally, which also worked well. Other solutions I've used have been canvas mounted on plywood (when we were working on an indoors carpeted area) as well as roofing paper (roofing tar paper) when I worked in Europe.

The basic requirement for an alternative surface is that it has some sort of tooth to it, or you need to be able to put some tooth on it. There are numerous ways to solve this problem, the only boundary being your own creativity and understanding of your materials.

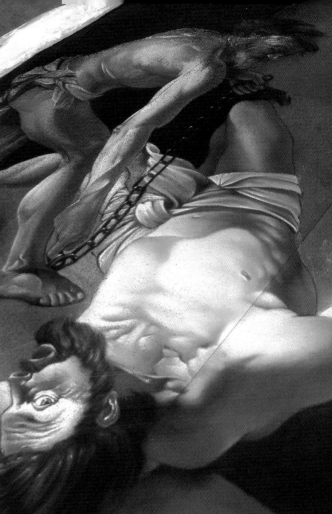

Above: Two of the individual tiling boards (tile backer boards) painted by children at Disney's California Adventure Park (see also bottom caption).

Top right: A detail of a painting completed in the Netherlands on roofing paper (roofing tar paper) due to the constant rainy weather. The painting was completed a few blocks away from the festival in an unused church and then moved piece by piece to the festival site and matched back up with the other pieces.

Right: Various street paintings done at Disney's California Adventure Park on tile boards that were cut to match a pattern and primed with black gesso. All of the small tiles in the background were done by children at the park and added into the mosaic of the final installation.

CANVAS

Using canvas is one of the most common ways to overcome the problem of painting street works indoors. There are several ways to prepare canvas according to how permanent you would like the final painting to be. Usually when I use canvas to make a street painting, the painting is for a single event, or I'm showing it just a couple of times—so it's not designed to be a permanent painting on display. This is actually preferable for me, as one of my favorite qualities of street painting is the ephemeral nature of the work—anything permanent feels more like a regular mural, whether or not it's done on the floor.

PREPARING CANVASES

Shrinking the canvas: To shrink a canvas, I buy regular raw cotton duck canvas with no gesso on it. It's best to pre-shrink the canvas so that the application of gesso later won't cause surface ripples. I do this by laying the canvas out on a flat, clean area of cement (my driveway!) on a sunny day. I clean the ground underneath the canvas and then wet it with a hose, afterward running the hose on top of the canvas so that it's thoroughly soaked. I then move around the canvas, pulling it flat and working out any wrinkles, and rewetting it if I notice areas aren't quite wet enough, or to rinse off any dirt. After it's flattened, I leave the canvas out in the sun to dry, checking it periodically to make sure the breeze hasn't flipped a corner over. Once dry, I either roll it and save gessoing for another day, or gesso it if I have enough sun left in the day to dry out the gesso before nightfall—gessoing too close to dark can result in insects getting caught in the paint.

Gessoing the canvas: I buy a high-quality black gesso (see page 82) from a mural supply store. This has an even texture and a fine tooth for grabbing the pastel and is half the price of the gesso from an art supplier—a consideration when buying gesso by the gallon (3.7 liters)! As with tempera paint, I use either a paint roller or chip brush (disposable paint brush), depending on how large the area is I need to paint. I roll the gesso on evenly, leaving no heavy, thick areas, but making sure that I don't leave any raw canvas showing. I let the canvas dry out completely in the sun. If there is a breeze, I anchor the corners and sides with stones to keep them from flipping over and damaging my surface. The canvas makes a wonderful surface, and the rich black background shows off pastel colors well.

Storing prepared canvases: After the canvas has been gessoed, it shouldn't be folded again. I roll it on old cardboard carpet rolls, or buy irrigation pipes from the gardening section of the home improvement (DIY) store. The ones I buy are 4 in (10 cm) in diameter and come in 10-ft (3-m) lengths that can be cut to size with a hacksaw. I use masking tape to secure one end of the canvas to the roll, then

roll it tightly, without wrinkles, until it is all on the roll. Afterward I use masking tape to secure it from falling open until I'm ready to use it. The roll can be reused; the only difference is that I put a thin plastic tarp (tarpaulin), or thin plastic drop cloth (dust sheet), on the top side of the painting before I roll it again to keep the pastel from rubbing off on the back side of the canvas. It should be rolled as tightly as possible, and kept from bumping or rubbing against other objects, since each tap knocks dust loose within the roll, possibly damaging parts of the painting. If I know a painting is going to be rolled and moved and re-rolled, I'll often use light coats of an inexpensive, high-hold hair spray to help "set" the pastel. These coats need to be light or they will "sink"–cause the pastel to disappear–into the black background. While hair spray is not a permanent solution, it helps to keep pastel dust from lifting so much, so minimizing any damage.

Opposite: Part of a large installation at Mills College, CA (see pages 98-9). Due to the short time allowed at the actual site, many of the paintings were completed ahead of time on canvas, rolled, and moved to the location where they were then installed and finished.

Right: The canvas for this painting completed in Oman, 2010, was cut to the shape of the shadows and smoke. Bricks that would have been inside the smoke were painted to match the real ones on the outside.

PERMANENT CANVAS STREET PAINTINGS

Part of the impact of street painting in the eyes of the viewing public is the temporary nature of the art. Turning it into permanent art—while taking away the horror the public feel when all that work gets washed away!—also takes away part of the beauty and romance. It has now become another mural done in a slightly different medium. However, there are times when a painting needs to be more permanent—maybe at the request of a client, or because a longer viewing term is required. Perhaps it is an interactive 3-D piece where the public might want to take photographs of themselves with the art.

THE DILEMMA OF PASTEL

People have often asked me how viable it is to put a clear coat of some sort onto an actual street painting. Although there are varnishes that can be painted over a street painting to save it, the caveat is that the saved painting bears little resemblance to the original. In spraying with clear sealers, the lighter pastels fade or disappear completely, and the subtle blending and various values and shades all but disappear. Also, once saved, the painting becomes very flat in color—for example, what was once a tree showing variations of blues and greens and yellows in hundreds of tints and shades becomes a tree in three or four hues with little variation. The harder the surface you are trying to save on—cement or asphalt—the less variation remains.

Above: A permanent 15- x 15-ft (5- x 5-m) street painting done on canvas and varnished for hanging in a local library in upstate New York.

PREPARING A PERMANENT SURFACE

One solution to permanently preserving street paintings is to address any problems through your choice of surface, your choice of a sealing medium (varnish), and your choice of the final media. When doing permanent paintings in the past, I've found some solutions that have worked well for me in terms of keeping the quality of a street painting while having the longevity of a painting that can be saved, hung for display, and cleaned as needed.

1. For my first consideration—choice of surface—I use raw canvas. I treat one side of the canvas with a sealing layer of paint. This can be gesso, or even a latex house paint (household emulsion paint). I prefer to use a colored acrylic or latex paint that has a color to complement my painting, as some of the paint will seep through to my top surface. The first step is to shrink my canvas (see page 85), then decide how the canvas will be hung. If it is going to be stretched flat on a wall or on stretcher bars, I don't have much to worry about. However, some paintings are free hung using wooden poles on the top end and hung on a chain, and then a second pole inserted along the bottom end to keep the canvas weighted down nicely, similar to the way a tapestry might be hung. If I need to hang the painting in this manner, then I will sew the loops on the ends of the canvas first, before coating it with paint.

2. Once these steps have been taken, I paint the back of my canvas with my chosen paint color. I usually do two coats to make sure that no raw canvas shows through. This is more important than you might think because once you flip over the canvas and start to use pastels, those unsealed pinpoints of canvas become the places where the canvas won't hold the color of the pastel painting later. After the paint has dried completely, I flip over the canvas and work on the raw side. This sealing layer of paint helps to color my canvas a little, but, more importantly, it seals the canvas so that as I work my

pastel on the raw side, it stays in the canvas. Without the sealing paint, it would work all the way through the canvas and right out to the back.

3. My canvas is now ready to start work on and I can begin pastel painting. One thing to be aware of when doing a painting in this manner is that you will go through four to five times the amount of pastel as you would with a typical street painting, and the painting will take you several times longer to complete. This is because you now have a layer of canvas to build up pastel in, and as the pastel fills that canvas first, it can take a while to get to the top layers, where you can actually blend and manipulate the color.

As the first layers of pastel are just filling in the weave, you might want to use mostly cheaper pastels, saving your better-quality ones for the top layers. Keep in mind as you paint that the top layers are the most affected by the varnish, so the more you can do to use pastels that will stick, the better. Some pastels, such as home-made street painting pastels (see pages 62–4 and 176–7), have a bit of wax and oil in them, which make them a better choice for the top layers as they are less affected by the varnishes. The less expensive pastels tend to be more dusty and have lower-quality binders, so their ability to withstand the wet varnishes is compromised.

It's good to be aware that excessive working and reworking of the pastel is going to show as such—once you apply varnish, old marks you thought you had covered up might show through—and lots of fine blending in the top layer might disappear with your varnish application. Keep your blending on the simpler side, and focus on the larger color and value choices you are making. Try to work cleanly and minimize your mistakes for the best final outcome.

4. Once the painting is finished, it is time to begin the process of varnishing. This is a several step process that involves two different types of varnish as well as

the reworking of your highlights (which most commonly disappear) with acrylic paint washes on top. I begin this process with a water-based spray varnish (see Resources, page 179), which is meant to be thinned down with water.

The purpose of this layer is to set the pastel as much as possible before I use a brush varnish. It is also necessary, especially due to the pliant nature of the canvas backing, to use a varnish that is pliable so that I don't have cracking in my final work. This precludes many varnishes that are brittle in nature. If you choose to use other products, bear in mind these requirements to ensure the best outcome. I water down the varnish to the higher amount shown on the label in a regular spray bottle. I then spray my painting, coating almost the entire painting with varnish.

Once this has dried completely, I use large brushes and a regular gloss acrylic varnish. The brand I prefer to use for my main gessoes and varnishes due to both the quality and the cost is listed in Resources (see page 179), but most standard acrylic varnishes will work too. I recommend a gloss finish, as I've found a matte finish tends to hide the true value and color of the pastel, especially clouding up the darker colors. Purchase enough varnish to cover the canvas twice—usually you'll need at least a gallon (3.7 liters) for an 8- x 12-ft (2- x 4-m) painting. With your first coat, try to make the brushwork follow the edges of forms or color breaks, as the brush and wet varnish will naturally pick up some of the looser dust lying on top and move it around; for this reason it is best not to drag across edges.

When doing extreme color transitions, such as a white to a black area, it's best to clean the brush in between, or have multiple brushes for different areas. You might have fine-lined areas that you don't fill in initially, and that is okay—it is better to work as cleanly as possible, minimizing color dragging and muddying of other areas. Softer brushes do less damage to the surface dust than harder, stiffer bristles, which tend to dig into the weave of the canvas and pull out more of the pigment.

5. Now that I've set the surface, it's time to address the last issue, that of bringing out some of the color and highlights lost in the varnish, as well as addressing any clean-up work on the edges. The varnish darkens the painting overall, and there is a general loss of highlights. So for this step, I bring out my acrylic paints and, thinning down with water and extender, add thin washes of color and light that match my underlying pastels. These washes lighten and clean up the existing painting.

As much as possible I try to maintain the sense of a pastel painting and to preserve what the original painting looked like. For this reason, I don't use acrylic to redo the painting or complete an unfinished section; only to bring back something lost in the varnish process. After I've completed this step of acrylic washes, I coat with one final layer of gloss acrylic varnish, which I apply again with a brush. This layer seals the entire painting together and gives the appearance of a sealed pastel painting. The painting now has a surface that will not be affected by mild cleaning, bumping, and so on. It has become much more permanent than the original painting ever could have been, while maintaining some of the beautiful qualities of the pastel work for the viewer.

Opposite: Images of a permanent street painting completed for the World Series win by the Anaheim Angels in 2004. At the time, the Angels were owned by Disney, so the painting was completed in the park during a victory parade, and then brought home later to finish varnishing. Notice the canvas seams sewn at the top and bottom for hanging. The painting hangs in the guest relations center at Angel Stadium.

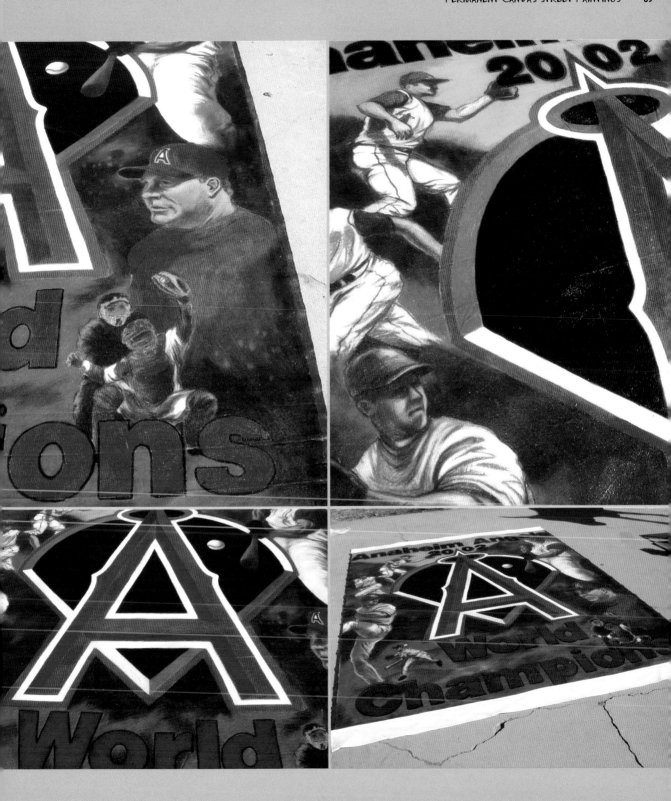

STORAGE, DISPLAY, AND CLEAN-UP

Storage and display apply only to paintings completed on movable surfaces, both impermanent and permanent. With permanent paintings, these issues are the same as with any canvas, and not really something to worry about here. However, with temporary paintings completed on movable surfaces, there are a few things to take note of that will help you to have more success.

Opposite: A light shower didn't wash away this small demo completely. Instead it aged it and made it seem even more real as a fresco copy of the Sistine Chapel.

TEMPORARY PAINTINGS

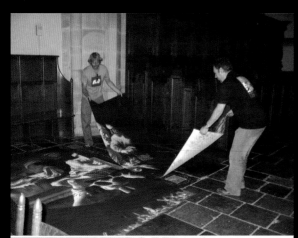

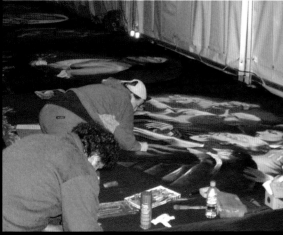

Above: Images of a large project in Utrecht, the Netherlands, involving 12 international street painters completing copies of paintings by various masters from Utrecht. Due to the inclement weather, the images were done on roofing paper (roofing tar paper) set up on wooden platforms to raise us up in case of rain seepage under the temporary tents we were working under. After the paintings were completed, they were moved to various locations throughout Utrecht for longer term viewing. This image is one of my painting being moved, with the help of a couple of the other painters, into the cathedral in Utrecht.

One thing to be aware of is the overall delicacy of a street painting. Anything that is abrasive will affect the surface, such as a brush, your fingers, raw canvas, a foot, and so on. Whereas most things that are non-abrasive, such as plastic sheeting, cardboard, and smooth wood, have little effect on the surface. So to protect your painting, you need to be constantly aware of the surface and think through what may have an impact.

This may sound like a rather simple explanation, but, as I've mentioned previously, street painting is synonymous with problem solving. Usually, you aren't in your studio with everything to hand, and might even be somewhere where items are available that you don't normally work with. For example, when I travel outside of the United States I am faced with products that I've never heard of before.

PROTECTING YOUR WORK

One of the best ways to protect your painting, whether while rolling it up on canvas to put it away, or protecting it from the sprinkles of oncoming rain, is with thin plastic tarps (tarpaulins), or thin plastic drop cloths (dust sheets), found in the paint section at the home improvement (DIY) store. You don't need heavy duty ones—in fact, the lighter the better, as they are often only good for one or two uses and then should be thrown away due to the pastel shadowing they eventually pick up on their surface.

To store a canvas properly, refer to the instructions listed in the section on preparing canvases (see page 85), where the directions for protecting and rolling a canvas are spelled out. For other types of paintings, such as tiling boards (tile backer boards), use common sense. You can stack boards on top of, or next to, each other, but I would probably use a plastic tarp in between the boards, as well as being careful not to flop the boards together, which will

cause a great deal of dust disturbance. However, stacking is very useful in protecting the surfaces from damage, for example from the sun, as some pastels have poor light-fast qualities and fade quickly.

DISCREET CANVASES

When displaying canvas paintings in public, I try to give the appearance of the canvases being street paintings and minimize the canvas surface. To do so, I use gaffer's tape to secure the edges of the canvas. I paint over the gaffer's tape with tempera paint and extend a painted border onto the street surface, both of which are then painted over with pastel. Gaffer's tape is a high-quality, matte surface cloth tape with good adhesion to the cement or asphalt. This has been my solution when I have a large-scale project that needs to be completed in either a short amount of time (requiring preparatory painting) or with questionable weather outcomes. Painting on canvas ahead of time allows flexibility both with the weather, the final display, and the access time to the final display location.

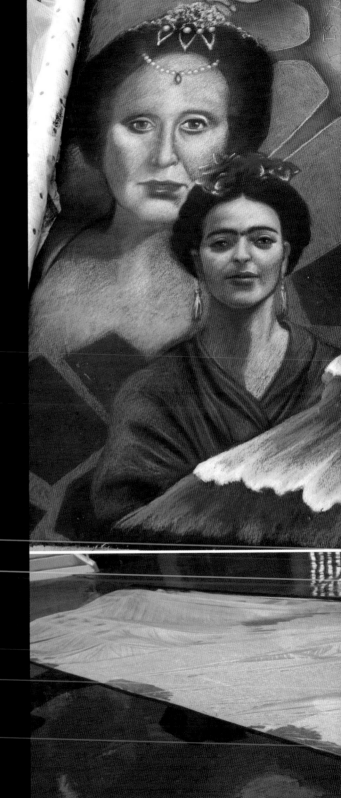

Top: Close-up of one of the Mills' paintings (see pages 98-9), still attached to its roll. The canvas has been prepared with black gesso. While it would be difficult to preserve this painting completely, this system works very well for retaining a sense of a beautiful street painting while meeting the need to move and store the painting for the client.

Right: I always seem to have fun dodging rain in Corpus Christi, TX. In 2010 I discovered the beauty of doing double and triple tarps to protect my work. Some small seepage is showing at the edge, but the rest of the painting was completely protected. A few boxes placed under the middle of the tarp ensured that rain would roll off the top, and not sit on the middle seams where it might

CLEANING UP...AND THE WEATHER!

The clean-up is relatively simple as often the weather does much of it for you! However, I am asked frequently by clients what is involved in cleaning up pastel, especially if the work has been done directly onto a recently made surface, such as a newer sidewalk.

CLEANING CONCRETE

When talking to artists who work with concrete, the consensus is that pastel and tempera paint do not have the ability to permanently stain concrete or asphalt. Let me preface this by saying that in 20 years of street painting I've only known this to happen once, on new cement, where the client ignored my advice and left the chalk paintings on to "wash away in the rain." Months later when they tried to pressure-wash the painting, there were still some shadowings of color that remained.

Usually, all that is needed to remove a painting is a high-power pressure washer; however, if for some reason this doesn't lift off all of the pastel, there are other milder alternatives. I talked with my fellow artists about concrete and they recommended a mild detergent and one of the rotating floor polishers with a bristle pad on it that can be rented at large equipment suppliers for re-doing floors. This solution successfully handled the problem of how to remove left-over pastel.

TEMPERA, PASTELS, AND STAINS

Tempera paint preparations wash out just as pastel does, and sometimes are even easier to remove than the hardier street painting pastels and similar as they have no oils or wax in them. If you accidentally use oil pastels or a waxy pastel, there are numerous environmentally safe citrus-based, or similar, cleaners specifically for breaking up this type of residue. These can even be found in the laundry section at the market (supermarket) or at home improvement (DIY) centers. These same cleaners also come in handy for cleaning surfaces where car oil has spilled or someone has dropped gum on the

ground, as both of these will wear through the pastel eventually, leaving oil marks that leach through into the final painting.

HOT, COLD, AND WINDY WEATHER

This brings us to the final topic of weather. For the most part, the issues of storage and display are not relevant to street paintings, but weather is usually a big factor in the final outcome. Sun, cold, wind, and rain—they all bring problems that must be dealt with.

Very hot or very cold weather is problematic in terms of your own discomfort. If you are able to erect a shade covering where you are working, this will help protect you from the sun, as will taking breaks in the middle, hottest part of the day, and making the most of the early morning and late afternoon hours. In extreme cases, I've waited to work until evening and brought out work lamps so I can see.

In some respects I dislike wind the most as it has such a devastating effect in blowing pastel dust, which in turn fades the painting. Many viewers don't even recognize how much damage it causes—they just assume that I produce faded paintings! There isn't much that you can do about it, apart from using less dusty pastels, trying to raise as little dust as possible on your own, moving slowly, and finishing your top layers well so they get blown off a little less. Also, save extreme color or value transitions for a time of day where there is less dust. In addition, the wind can be very uncomfortable to work in as you are at ground level where all of the dust is being blown about. If you have respiratory issues, you might choose not to work in windy conditions, or to at least wear a dust mask.

Opposite: Detail of a copy of the Sistine Chapel ceiling finished in 2003 in San Rafael, CA. This photograph shows the painting as it is being washed down in the middle of the night. Even in the process of being destroyed, there are moments of beauty.

RAIN

This is obviously the most damaging as it washes away
your painting. While a light mist can actually help set your
pastels and minimize dust, actual rain is destructive, and
your best defense is to try to protect what you are doing.
The quality of your pastels can make a big difference
here, but even then, you'll lose some of your painting.
Home-made pastels do stand up much better to weather
extremes than normal soft pastels.

When I'm trying to get work done over a long period
of time and the rain comes and goes, usually I use
either cardboard sheets (for drizzle) or a thin plastic
tarp (tarpaulin) that is taped down at one end, and then
weighted with whatever I can find—tables, chairs, boxes—on
top of my painting, only revealing the portion I'm working
on. Bear in mind that once the tarp gets wet underneath it,
the tarp is no longer of any use to you.

DEALING WITH WATER DAMAGE

If you end up with water damage, wait for it to dry before
trying to repaint. Most of the painting will probably still
be there and it's fairly quick to finish it off again. If you
lose your painting entirely, chalk it up to the wonderful
ephemeral qualities of street painting and just do what
you can given the time you have left—it's amazing how
quickly you can work the second time around with a
deadline at stake! For the most part, you'll only meet with
sympathy from the various onlookers who pass by. Lastly,
don't be disheartened—at some point we have all had a
painting (or two!) washed away. Consider it your initiation
into the wonderful world of street painting.

Top: It can feel a bit devastating when working hard on a design you are proud of
only to have a hail storm hit a few hours before completion. In a rare exception
to my desire not to repeat paintings, I did the same painting the next year at a
different festival so I could see it completed.

Bottom: A painting of an old master, Bouguereau's Art and Literature, that had
been protected inadequately by a tarp in Texas. The rain seeped under the tarp
and made puddles on portions of the painting. Using rags, Melanie Stimmell Van
Latum and I soaked up as much as we could of the extra water, let it dry out in
the sun, and repainted the image in time to still finish on Sunday afternoon.

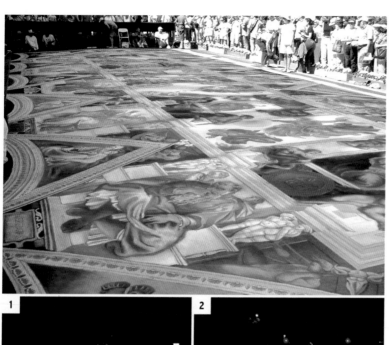

DOUBLE OR TRIPLE TARP

When trying to protect a painting overnight, I will double or triple tarp it. Multiple tarps (tarpaulins) are handled in this way: I do one smaller tarp on the bottom, which is then duct taped all the way around. I then do a second and/or third tarp on top, with an additional border all the way around that is a foot or two (30-60 cm) wider than the first tarp, and duct tape that too. Even weatherproof duct tape may lift in the rain and let water seep in underneath. This water gets trapped in between the tarp and ground, causing more damage sometimes than a light rain. However, double tarping the painting means that the water seeps under the top tarp, but rarely gets the underlying tarp wet enough to seep under that one also, so the painting is usually saved from water damage.

You can lay a few chairs or your pastel boxes in the middle of your painting before tarping, and these will help tent the tarp off of the actual paint surface. Another solution is to weight down the middle of the tarp on top with chairs, etc, besides taping it down with duct tape on the edges.

Top: A completed project in San Rafael, CA, showing half of the Sistine Chapel ceiling. The painting took 12 main artists, an architecture team of another 15–20 people, six days, and cases of pastels. It was completed at 4pm on Sunday afternoon, and washed away later that night at 2am.

1-2. The ominous lights of the water trucks just before they began spraying.

3-4. I always had images in my head that the pastel would swirl into multiple colors as the painting was washed away, but really it just turned brown!

5-6. Images of the hoses turned on the details of the painting. Notice how parts of the painting seem to disappear immediately while other portions are a bit more difficult to wash away. Those tougher areas are the better-quality pastels, with home-made pastels being the most resistant to the water.

MILLS WALK OF HONOR

The Walk of Honor, which I conceived and designed, was a project comprising 18 street paintings on canvas to commemorate the anniversary of the Mills College strike, an important event in women's education. The designs focused on the contributions of more than 70 women, as well as on the history of women's rights in the US. Thousands of people came through the installation over the course of a week. The artists were myself, Melanie Stimmell Van Latum, Genna Panzarella, and Lisa Jones. The mosaic pathway running through the paintings was filled in by students of Mills College, enacting the concept that all women have a chance to contribute.

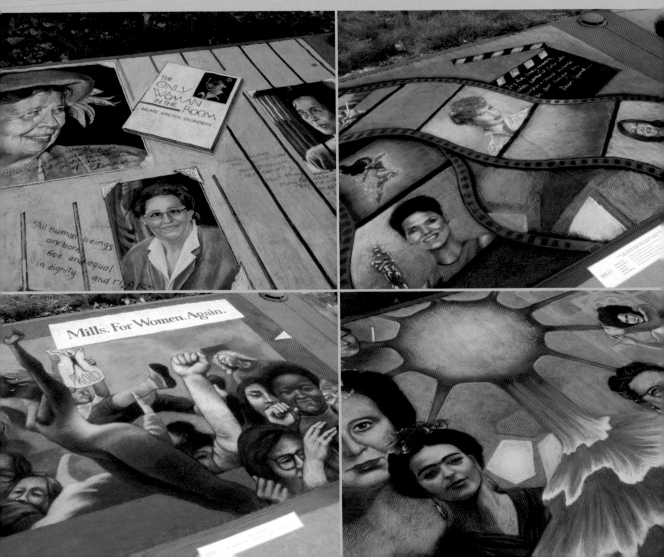

Opposite top left: The finished Human Rights square, painted by Genna Panzarella, featured Eleanor Roosevelt, Aung San Suu Kyi, Thoraya Ahmed Obaid, and Beate Sirota Gordon.

Opposite bottom left: My painting commemorating the Mills College Strike, which took place in 1990 and reaffirmed the school's dedication to remaining a women's college.

Opposite top right: The finished Women of Film square, painted by Melanie Stimmell Van Latum, featured Lucille Ball, Lynda Carter as Wonder Woman, Kathryn Bigelow, Halle Berry, and Michelle Yeoh.

Opposite bottom right: The finished Women of the Arts square, which I painted, featured Frida Kahlo, Pearl S. Buck, Julia Morgan, Trisha Brown, and Beverly Sills.

Below top left: The finished Women of Science square, painted by Genna Panzarella, featured Sally Ride, Marie Curie, Barbara McClintock, Margaret Mead, and Chien-Shiung Wu.

Below bottom left: Looking up through the Walk of Honor from the title square.

Below top right: The finished Women of the Environment square, which I painted, featured Rachel Carson, Stephanie Mills, and Jane Goodall.

Below bottom right: The finished Women in World Politics square, painted by Genna Panzarella, featured Corazon Aquino, Indira Gandhi, and Margaret Thatcher.

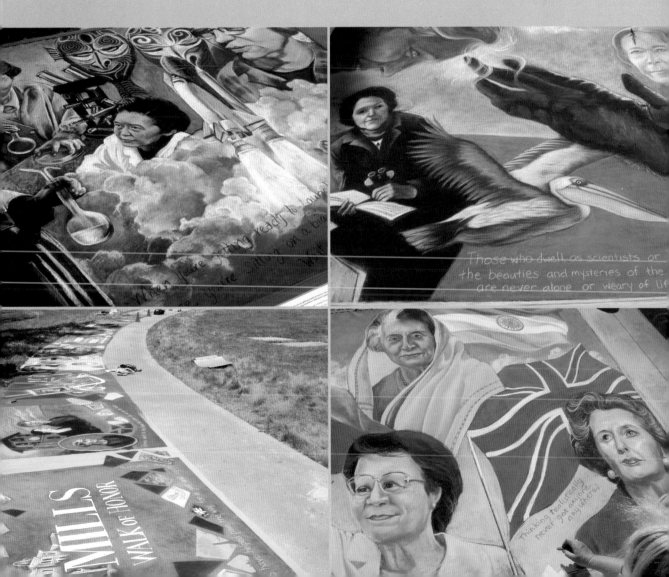

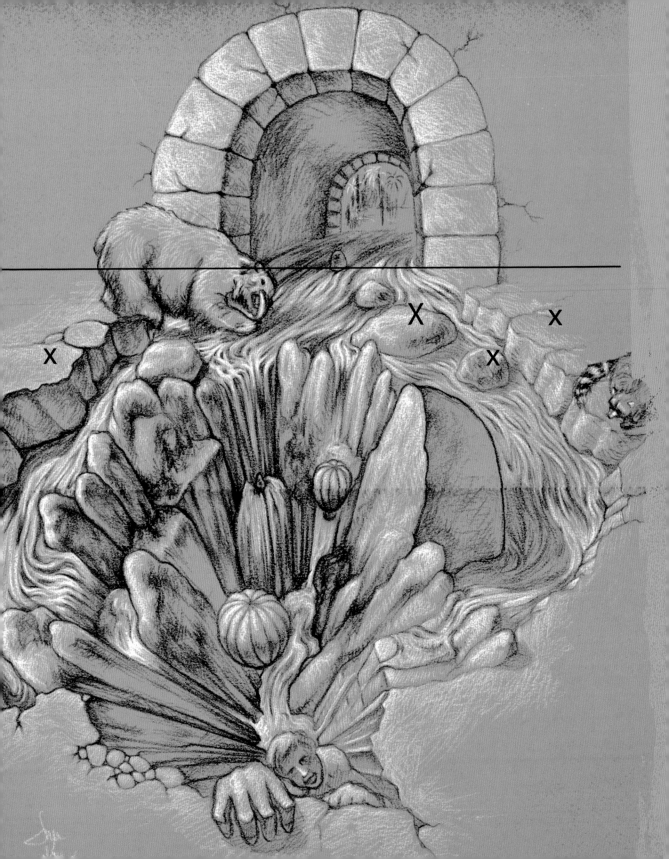

FROM DESIGN TO THE STREET

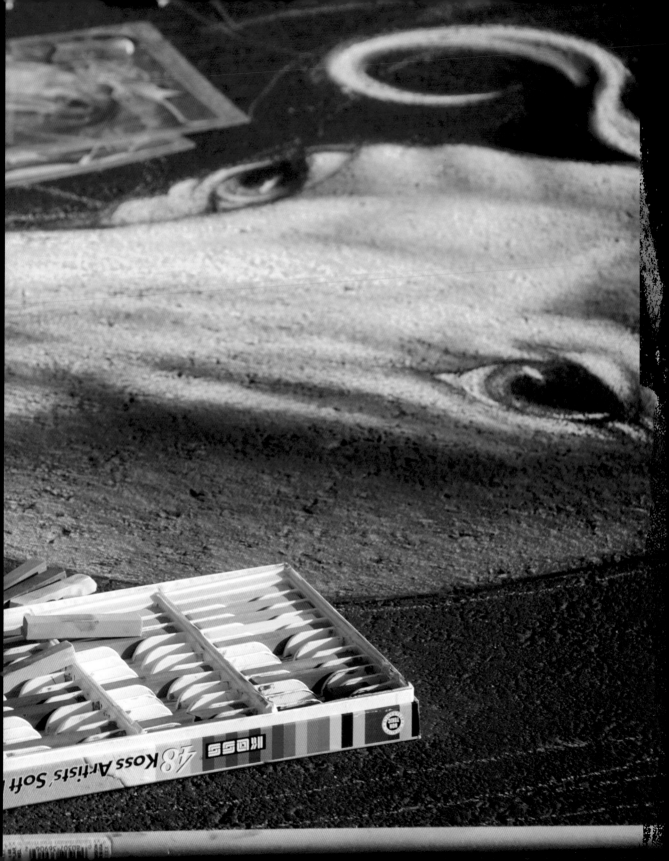

MAKING YOUR IDEA A REALITY

So, you've figured out an idea and you know what you think you'd like to paint. Maybe you've even done some rough sketches—or finished sketches—and think that you are ready to paint right now. Covering some of the basics and being better prepared for the actual experience of street painting can go a long way to making your ideas a more successful reality. There are specific steps that will make the experience a little bit easier to handle, and will help to keep you organized and sure of your direction—guessing can be a scary situation to find yourself in when you're in front of a crowd, especially when you're starting out!

Previous page: A finished value study for a 3-D painting that was intended to go on the floor as well as a background wall. The line across indicates the break from the floor to the wall and the "x"s were intended photo points, where someone could sit for a photo that would make full use of the perspective.

Opposite: A detail shot of the beginning of an original design.

ORIGINAL DESIGNS AND REFERENCE MATERIAL

When someone isn't used to working at the scale of street painting, it's easy to underestimate just how important the change in scale can be. A small drawing on paper might appear just fine–you may have figured out plenty of the detail (you thought!) as well as feeling fairly confident that your overall drawing is resolved enough to make the next leap into becoming a fully fledged painting. Often though, the details that were an inch or two on paper become a foot or two on the ground. All of a sudden, the detail that didn't matter in the small scale looks oversimplified in a large painting. The painting can appear too basic, or even unfinished, because there is too much unresolved form and it lacks the texture that gives it completeness. Often this type of mistake is inevitable when you're starting out, and is part of the learning experience of becoming a street painter; so don't let the possibility of making such a mistake keep you from even trying in the first place!

THINKING AHEAD

Looking at your design and trying to envisage the scale change to full-sized painting, as well as identifying the weaknesses in your composition or detail reference ahead of time, can help you address and minimize your chances of making this mistake. Street painting really is one of those things that, no matter how much you've prepared and how many art classes you've had, you just need to do in order to get better... and that is totally okay! Make your drawing as clear as possible, and, if it is a very small drawing, completing a finished value study of it at a larger size, such as 12 x 16 in (30.5 x 41 cm) or so, will give you a much better feeling for how the overall painting will turn out. It will also give you valuable insight into trouble spots, or how to refine aspects such as anatomy or drapery.

BEING PREPARED

Now, I will admit that I've done it both ways. I've gone to festivals with nothing but a ball-point pen rough sketch and some image reference for my details. But I've also gone to festivals with finished value-scale studies in dark and light media on toned paper, as well as additional image reference. In some paintings, I haven't even had image reference, but instead have used objects such as toy models to draw from. I've found that, even though I've had successful drawings in both situations–and mistakes in both respects–there is always a much greater feeling of comfort from the advantage of being well prepared. That preparation has also helped save me from costly mistakes when I've done a large, complicated design. So, my recommendation is to take the time to resolve your design–and resolve it to a fairly complete level.

Opposite top: My reference for this dragon, as well as dragons I painted previously in Denver–a small child's toy I bought in a gift shop!

Opposite bottom: A quick pencil sketch for the 3-D painting I completed at BankMuscat in Oman, 2010 (see also page 22).

Above: The original color composition (top) and the final painting (bottom) for a 12- x 15-ft (4- x 4.5-m) painting completed in New York City.

Opposite: Photographic reference of a sculpture in the Royal Museums of Fine Arts of Brussels, Belgium, (bottom) along with the final image (top) that evolved from the reference (see also page 34).

GAINING EXPERIENCE

Another recommendation I make is to choose your lessons wisely and in the order that you would like to learn. One of the ways that I look upon my street painting experience is as my extended education. In fact, often I tell my regular painting students that I feel I received half of my art education in school, where we learned partly from copying old masters, and the other half out street painting, applying what I learned from those old masters into my own original designs.

CONFIDENCE WITH COLOR

A good example of building knowledge is through learning to use color. I decided that I wanted to do a better job of applying color to my original compositions so that I had more freedom to make up my own figures and landscapes, and yet still incorporate a sense of realism, as well as the vibrancy and brilliance of pastel, into my work. I chose to do several paintings that would be built using monochromatic photographs of sculptures I'd taken for my reference, rather than photographs of real objects or other paintings. I did this as a teaching tool for myself to learn to enhance and build my knowledge of using original color. However, I didn't attempt this until I was about six or seven years into my street painting, by which time I'd developed a fairly knowledgeable understanding of the pastel medium. By this point, I'd done a number of old master copies to develop technical aspects of my painting, as well as observed other artists whose use of color and pastel I admired. When I painted sculptures, I had on hand not just my photographs of the sculptures from the vantage point I wanted them, but also a few images of related paintings by other artists who had used color in the way I hoped to work toward. I was so pleased with the results of a couple of those paintings that they remain in my portfolio today. Now, after 18 years of street painting, I feel extremely comfortable with my color palette and building up compositions from monochromatic tonal studies.

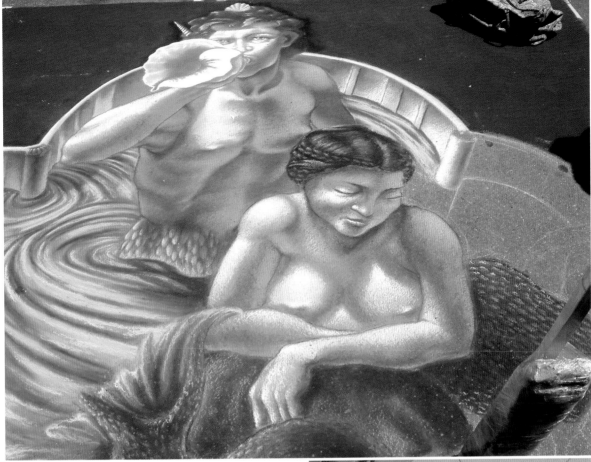

REFERENCE POINTS

The Internet has been a huge help in allowing me to be better prepared and educated as an artist. One of the most useful aspects for me is the ability to do image searches. From paintings to searches for photographic reference, I can find almost anything I want on the Internet. (There are websites that offer photographic images specifically for artists to use, and I recommend that you use these if you want to copy an image.) If I need photographic reference from a specific vantage point, I find further ways to be resourceful. For example, I visit local sculpture collections at museums, and when I travel I shoot hundreds of photos of sculptures from various vantage points (you should always ask permission first to photograph if the sculpture is in a museum or private collection). Also, when I run across random objects in my day-to-day activities, I shoot reference photographs with my phone if I don't have a camera on me.

CREATING A DESIGN

Typically, my steps when I'm developing my own design are as follows. With reference images sourced from the internet, I usually do a rough sketch of my design, working out my basic composition and what elements I'd like to include. I then search the Internet for the objects I'm looking for, such as a tiger, fairy, or a fish-websites that offer images specifically for artists are good place to start. I will then composite something such as a tiger from several shots. After I've gathered my reference materials, either from image searches or photographing my own, I sit down with paper and pen and start sketching, adjusting my composition to include the objects I referenced in their slightly different vantage points, or tweaking them from the original reference, but in a much more informed way.

Bringing it to completion: Once I have a more finished idea of the composition, I might look for other elements to flesh out any open spots that are too simple, or move objects around until I'm happy, using overlays of tracing paper to continue refining. Once I've arrived at a fairly finished idea, I refine the drawing and move it to tonal paper (paper in a middle value will do the job). Now I need to adjust my light source so that all of the objects are under the same light source, as well as deciding on how light and shadow are moving through my painting and unifying or dividing up the composition. I might do detailed studies of supporting elements, such as rock ledges or various figures within the composition, especially if they're items I'm making up with little or no reference. I should have a fairly complete idea now of the final painting in values. I also have a number of images that I can use to help support the design in the form of detailed studies or photographs. I gather all of this material together to use for completing my actual painting.

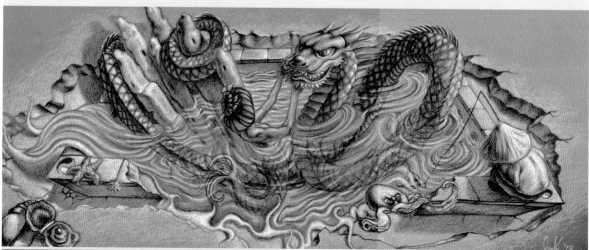

Above: The finished value-scale study for a painting in Hong Kong, 2008.

Left: The finished value-scale study for a design done in Corpus Christi, TX, 2009

Opposite: An image showing the reference laminates for a large copy of the Sistine Chapel ceiling completed by a group of artists in 2003. The panels shown are a section of my portion of the painting.

FINAL PREPARATIONS

When getting ready to do a copy of an old master, my preparation is fairly simple, but still important. Often I find a painting I'd like to copy and realize as I'm working on it that certain areas in the painting are not large enough to see clearly. So, once I've determined the work I'm doing, I do image searches online for both the painting's name as well as the artist's name, and try to find the highest resolution image possible. You will most likely find that various images of the same painting will be color keyed quite differently, depending on whether they are original photographs or taken from books or slide scans. Hopefully, the color key you like the most is one of the larger resolution images. If not, find a larger resolution image that you can use for your reference material to see the details, but definitely keep the image that has the correct color key in it for reference as you paint. If you're knowledgeable on the computer, you might be able to do the color adjustments to make your

high-resolution image match the key you like, but it's still workable to have the color image as a smaller image that you use as reference. I then look at my high-resolution image and identify any areas of detail I might need to focus on—from faces to still-life objects, or a complicated section of drapery. By choosing these areas and copying them into new documents to blow up much larger, you can develop a series of detailed images that help you understand how to paint the larger image better. Note: if you want to copy works by artists or photographers created in the last 150 years or so, check whether the work is still in copyright. If it is, you will need the permission of the copyright owner to copy it.

Once I've gathered all of my imagery, I take it to a copy shop and ask them to laminate my copies—usually putting copies back to back to save money. The laminated copies hold up much better than unprotected paper to the dirt and grime of street painting, and also become a plastic surface you can use to sit on or step into your drawing if needed.

GALLERY: TECHNIQUES

Styles and techniques of paintings can be quite different, and each artist tends to bring their own personality into the work they create—whether this is botanical designs, conceptual reinterpretations of old master themes, or historical reproductions. Some artists paint beautiful large old master copies, while others combine images from old masters with more modern compositional devices to make a new painting altogether. Truly, the street painting medium is a broad way of presenting artwork that appeals as much to viewers as to the artists.

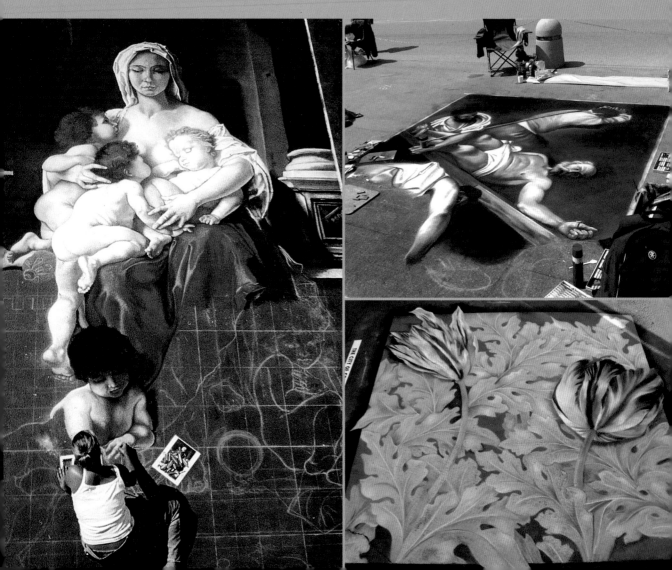

Opposite far left: A clear shot of the progress of a very large classical painting by Melanie Stimmell Van Latum. Bella Via Festival, CA, 2002.

Opposite top right: Gregor Wosik's beautiful copy of Caravaggio's The Death of St Peter has a depth and richness to the color that almost surpasses the original master.

Opposite bottom right: Ann Hefferman's skilled use of a limited palette with only small touches of color for accent and compositional attention.

Below top left: A magnificent painting showing an expanse of trompe l'oeil effects in a limited palette. Ann Hefferman, Santa Barbara, CA, 2007.

Below bottom left: Entitled Susanna and the Elders, this is a different take on the biblical story of the good wife falsely accused of promiscuity. The play of monochromatic versus color, as well as the emotional impact of all three figures, has conceptual implications beyond the traditional religious image. Valentina Sforzini, Grazie, 2010.

Below top right: Valentina Sforzini won first price for this original work entitled La Tomba della Falsità, on the theme of fear of revealing one's true self. Sarasota Chalk Festival, 2010.

Below bottom right: Genna Panzarella often integrates animals and details of masters, here Leighton's Flaming June, to create new images.

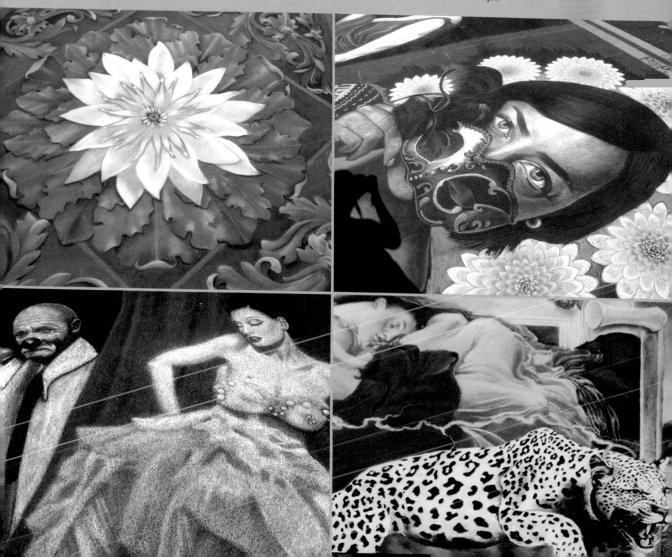

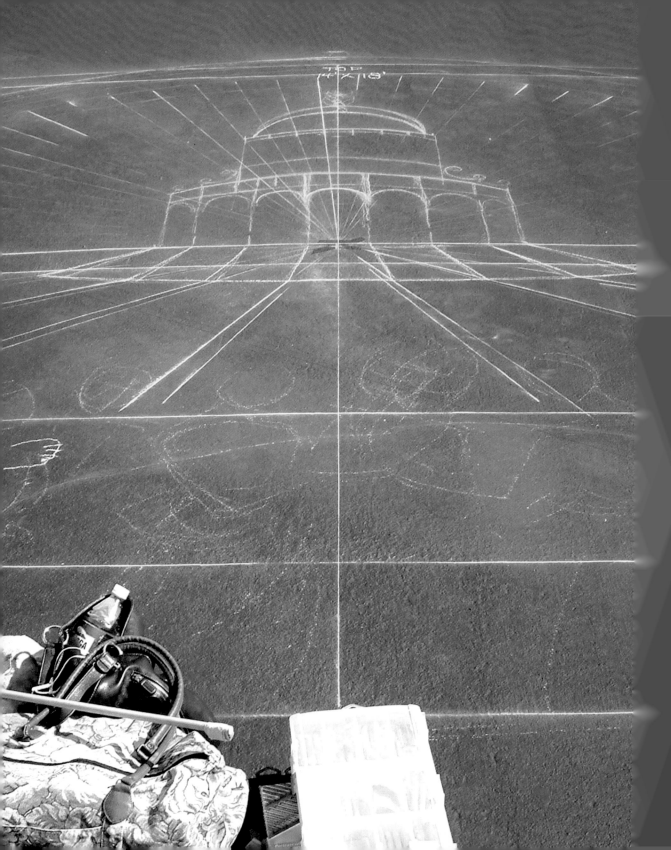

PUTTING YOUR DESIGN ON THE GROUND

Whichever route you choose to take—whether you opt for an original design or choose to do a copy—by now you probably have at least a few images to reference, both of the overall painting composition as well as specific details within the painting. Now it's time for you to make a decision as to how you will transfer the drawing onto the ground in the most accurate way possible. There are three usual methods of transferring—freehand drawing, gridding, and pounce patterns.

FREEHAND DRAWING

This is best saved either for experienced artists working to a large scale on the ground, or for fairly simple designs that are easy to block out. Freehand drawing entails using a painting tool such as a wooden dowel stick, about 3-4 ft (92-121 cm) in length and ½ in (1 cm) in diameter, which can be purchased either at home lumber (timber) yards or many craft stores. A stick of pastel can be taped to the end of the dowel stick so that it becomes an extension of your arm, allowing you to stand back from the drawing and simply block it out while moving around the square. This allows you to see the painting in the same way a viewer would, and makes it easier to correct your proportions.

Until you've refined the drawing and are sure everything is placed correctly, initially you'll want to use a very simple construction drawing, which captures the basic volumes and gestures of what you are doing. When I need to make adjustments on a drawing, I'll sometimes switch to a new pastel color to help me differentiate my first drawing from the correct one, making it less confusing for me to see. The stick method only works well for the outline drawings, so don't use this as a tool for painting. Once I've blocked my drawing out correctly, I can sit down and work, using my construction drawing as a guide for the more detailed drawing—then painting—I put down on top of it.

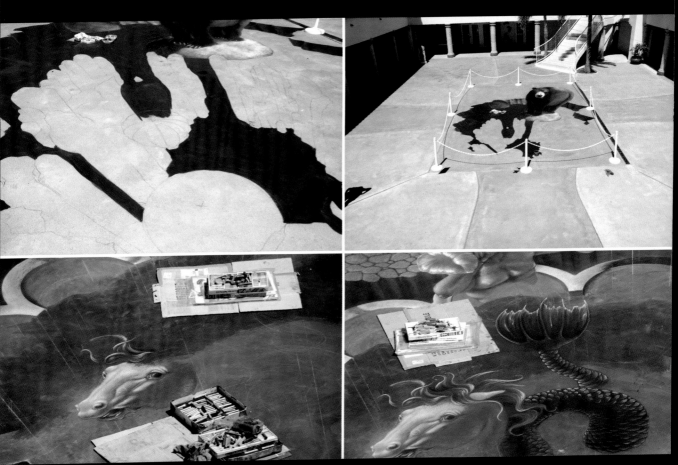

Right: The simple construction reference for the figures in this painting allow me to place them correctly in both perspective and proportion and make whatever changes are needed before I begin to lay in a more resolved outline.

Opposite top: Images from a painting in Texas in 2009 showing the development of the drawing on a tempera base surface. The tempera paint was used in different shades to be the background color behind the design. The freehand lines can be barely seen in blue, on top. The yellow lines were snapped with a chalk line.

Opposite bottom: Images showing the initial development of the drawing for this painting. The tempera paint helps me see the overall design better as I block in, as well as making the surface more workable. The underlying drawing is put in very simply.

GRIDDING

By applying square grids both on your original drawing, as well as on the ground, you can change the scale of the drawing while keeping the proportions accurate. To do this, I suggest making a color copy of your overall painting. (I prefer using a colored copy machine even for monochromatic images as the copy is a much higher-quality gray scale than a black-and-white copy can approximate.) Decide on the size of your final painting. For example, let's assume your final painting is a vertical one, 8 units wide by

10 units tall. It's most likely that your drawing won't fit the exact scale of your space, which is fine. I try to work out how to crop my original in the least destructive way, so the final result is as close as possible to how I want it to look. For example, I try to avoid cropping out a section I'd like to stay. Also, I avoid adding more space unless it is very minimal and easy to make up, or I can fill that space with something such as a frame of architecture around the painting.

MAPPING OUT YOUR GRID

Whatever I decide is the portion that will take the cropping—either the two vertical edges or the two horizontal edges—I choose the opposite edges for

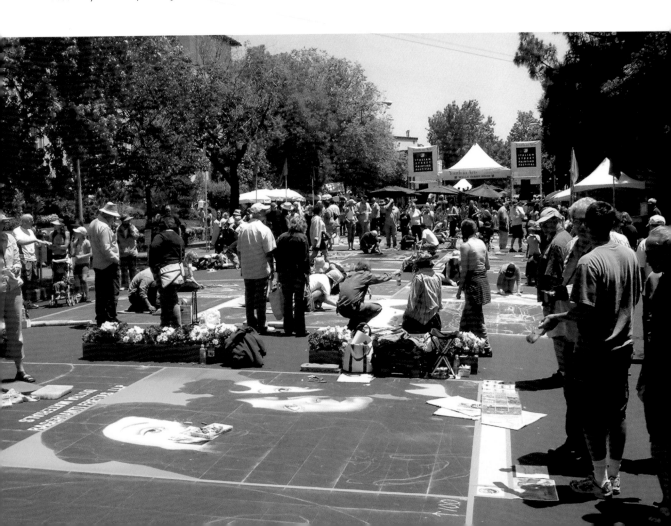

measurements. I then measure these out with a ruler and divide that amount by my number of units for the corresponding side in my painting space—in this case, either 8 units for my two vertical edges or 10 units for my two horizontal edges. The number I arrive at is my division for all four edges, and I mark this down each side of my laminate, being sure to start at the same edge on both sides—so the bottom edge for the two sides, or right side edge for the top and bottom edges. If I'm cropping, I might center those unit marks to crop equally off the top and bottom, or start at the edge I don't want cropped. Once I've marked these, I use my ruler to mark them on my color copy so that I make a corresponding grid.

I can now laminate my gridded copy and use it to help lay out my drawing on the ground. To draw the grid on the ground, I mark the same division of units (8 units by 10 units in this case) on the ground with a tape measure, and then connect the grid using a construction chalk line to mark it on the ground. By going square by square through the grid copy and matching the basic proportion of where different lines in the drawing cross square edges and so on, I can copy my drawing to the ground quite accurately. When I'm gridding I often use a dowel stick, similar to the freehand method, as it allows me to move more freely over the gridded space, as well as enabling me to see my overall proportions from square to square accurately.

Opposite: A shot of the Youth in Arts Italian Street Painting Festival in San Rafael, CA, 2006, showing a painting that has been gridded out partially finished.

Top left: This painting was so detailed, the grid became a necessity in order to place everything correctly in the space.

Bottom left: Artists snapping their grid with a construction chalk line.

CONSTRUCTION CHALK LINE

This small handheld device has a long line of string wound up inside. Chalk power is put inside the device and shaken up to cover the string. As the string is pulled out, it retains the powder. The string can then be held down at both ends snugly by the artist and an assistant, and then plucked, or "snapped," thereby leaving a chalk line on the ground exactly where the string was sitting (see image bottom left).

POUNCE PATTERNS

One other way to move your drawing to the ground is by using a pounce pattern. Pounce patterns, or cartoons, were a common way to transfer drawings onto surfaces for frescoes, and were used extensively by artists such as Michelangelo, where the drawing needed to be worked out ahead of time and put down quickly because the media used dried out quickly. The general idea is to get the life-size drawing onto a large piece of paper in a simple outline. A pounce wheel, also called a sign-maker's wheel, is a tool that has a small wheel on the end with sharp teeth that pierce through the paper. Running this wheel along the drawing lines stipples small holes along the outline. There are also computerized machines that will perform the same job for you, inputting the line drawing in and then precisely stippling lines in paper. Whether you use a manual tool or a computerized machine, the paper is then laid on top of the painting surface and taped down securely so that it won't shift in place. The artist then takes a pounce bag—it's easy to make one of these with an old athletic sock that is filled with loose chalk—and repeatedly knocks the pounce bag along the stippled lines, following this by rubbing excess chalk through the lines by hand. Once complete, the paper is lifted and the loose dust creates a new outline on the ground, which can be traced over with a pastel and then finished off from there. For simpler drawings, pounce patterns are extra work. This time-consuming method is probably best saved for more complex projects, for example ones with complicated Baroque border edges, where precise detail makes a big difference to the final outcome.

Above: A sign-maker's wheel, used for making pounce patterns. The teeth stipple small holes through the paper drawing, allowing you to push chalk through.

Left: Tape is being used to give clean border lines in this painting. The tape will be lifted later to show the fresh asphalt surface. Notice also the pounce pattern being used to lay in the drawing.

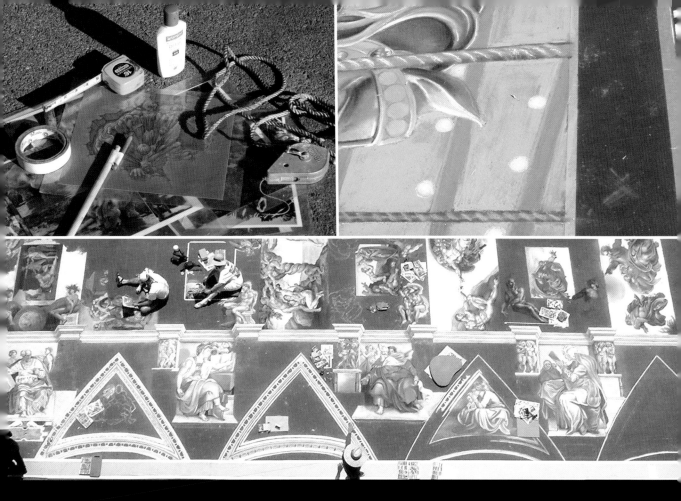

IDEAS TO HELP COMPLETE THE DRAWING

When using a grid or pounce pattern, most of the transferring of different elements of the drawing is already done. However, when freehand drawing, you might need to know how to make a correct circle or how to give yourself a long clean edge in a drawing, as well as making measurements for laying in type if needed. These are simple concepts, just moved to the larger scale of a street painting.

Materials: Some common tools (top left) that help to get the drawing down—from the bottom clockwise: A drawing stick; masking tape; measuring tape; sunscreen; a rope for perspective lines; a construction chalk line for snapping a grid or perspective lines; and laminated copies of my original value study as well as back-up reference.

Edges: Tape works very well for keeping a clean edge when lifted later (top right). If you have architecture or the like and would like a clean crisp edge, paint the portion that would go next to it first, keeping the edge fairly clean. Then lay regular masking tape on top of the part you've just painted, keeping it lined very carefully with where you

would like the edge to be. I run a finger along the edge of the tape where the line needs to be, and just lightly tap the rest down to keep it in place. Paint with pastel up to the edge, carefully working the pastel right up along the taped edge. Lift the tape. For short edges you can use the edge of your laminate, simply holding it in place until done.

Borders: The paper border (the cream border at the base of the photograph, bottom) on this large group project helped keep the edges clean for better photographs at the end. If you would like a painting border, you can use masking tape, or even better, roll out some of the craft paper that comes in one-foot (30-cm) widths at paint stores (used for covering where a drop cloth/dust sheet might not line up so well). Masking tape leaves a colored dust edge where dust has blown along the outside of the tape, but craft paper tends not to produce this effect. Once your painting is done, pull up the masking tape or craft paper. This method also works for preserving areas within a painting if you're doing extreme value/color changes (such as a white strip in the middle of a black background) and want to keep as much blown dust out of the area as possible.

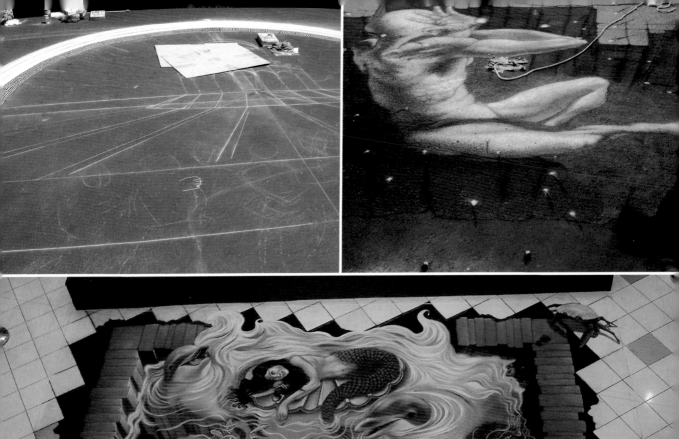

Perspective points: Traditional architectural details often have a perspective point you'll need to consider (top left), even if your overall painting isn't a perspective piece. Take the time to figure out where the vanishing point needs to be, tape a chalk line or string to your vanishing point, and use it consistently in order to achieve architectural uniformity. This painting uses a central vanishing point to establish both the perspective on the center building, as well as the pattern in the surrounding archway.

Edges: Using common tools such as a rope (top right) for long perspective lines or a measuring tape for a straight line is very helpful. It makes for less to pack and bring with you. For creating type, I like to run a line in a middle value pastel using my tape measure for a straight edge, along the top and bottom edges of the

letter. If needed, I also run a line to mark the mid point of the letters, such as the middle of an "E" or "A." I'll measure my lettering original and try to get an idea of the scale of the vertical to the horizontal, and figure out where the center of my word lies, marking that on the ground. Using pastel color I can lose easily in my background later, I block out lightly the verticals of the letters, watching my spacing.

Surfaces: Look at reference for details such as flagstone walkways, tile borders, or stonework to get an idea of how to keep the sense of the original stone in your drawing (bottom). If you are matching the edge of your painting to a paint surface, such as brick, don't just do the bricks in an even line around your painting: Use techniques such as breaking up the edge or interspersing drawn bricks out in the real bricks to avoid the feeling of a hard edge.

WORKING WITH YOUR ENVIRONMENT

If you have a choice as to where your painting is placed, consider the following factors before you start. In most of the situations below, however, your best bet is to find a better place if possible!

Slopes: If you're painting on a slope, and can place your painting so that the viewer is standing looking at it uphill, it will help a great deal. Due to the slope, your image is already facing the viewer more than it would if on a flat surface. Placing your painting so that the viewer is looking at it on a downhill slope means the painting turns away from them more than normal, making viewing more difficult.

Lane lines: Traffic lines and other road markings are very difficult to paint over. Covering them with tempera paint will help, but if lines go through the middle of the painting they are very distracting. It can help to run a border that is 2 ft (60 cm) wide around the painting with a framework of tempera paint. I've also mixed tempera paint in about the same value/color as my ground surface and covered the lane lines roughly so they are much less of a distraction.

Gum and grease: Yuck! These are both extremely difficult to cover, especially because they leach through your pastel over time; your best bet is to try to lift off as much of these as possible before you start. You can soak grease with a good grease remover—the ones that are for cleaning driveways usually work well. Try home improvement (DIY) stores for such products. Other products that break down gum in hair, wax, or grease work well for lifting gum off your surface. Spray with the product and let it sit for a while. Don't let the product dry out, just respray as necessary. Use an old rag and water bottle to clean up and reapply if necessary.

Spillages: If there is a spill of ice cream or soda on your space, clean it up before you start painting. Your pastel won't sit on top of food and drink spillages well and the dirt will keep leaching through to the surface. A little preparation means you can forget about it later.

Top: This painting, completed in Denver, CO, 2008, was done on a slope with the photographer standing downhill of the painting looking up. The artist is sitting on the mushroom.

Middle: In the background, behind the giant cougar, you can see the painted out lane lines. Still quite evident, but much better than brilliant white or yellow!

Bottom: In a couple of spots on this painting, the oil that was on the street surface is starting to show through the blue background.

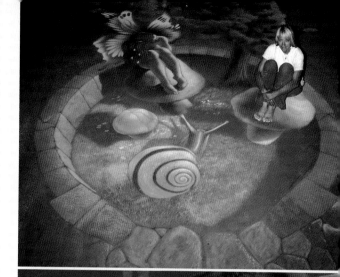

GENNA PANZARELLA

Genna Panzarella is a leading American street painter who is known for her original works that combine her love of animals and of the old masters into unique and dynamic compositions. A couple of Genna's favorite animals, her Lipizzan mares Rita and Ritza, have both found their way into the paintings included here. Genna was one of the very first Americans to be awarded the first prize in the Maestro category at the Grazie Festival, Italy. After decades of street painting, she continues to enthrall viewers in the US and internationally with her beautiful paintings.

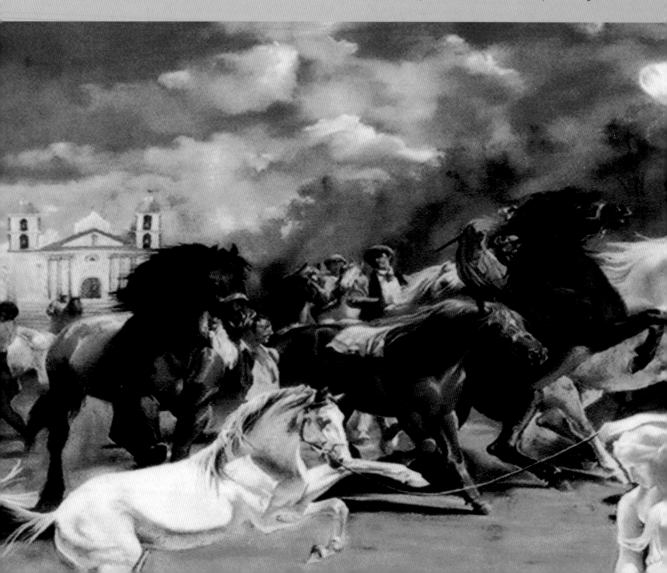

Right: Elements from Bougeureau and other classical artists help create a tender setting for the two horses which complete this painting called Gathering Apples for Venus.

Below: Rosa Bonheur's The Horse Fair becomes a fantastic backdrop for the elements Genna has added in, especially Ritza, her Lipizzan mare, to create a piece Genna calls Ritza's Horse Flair.

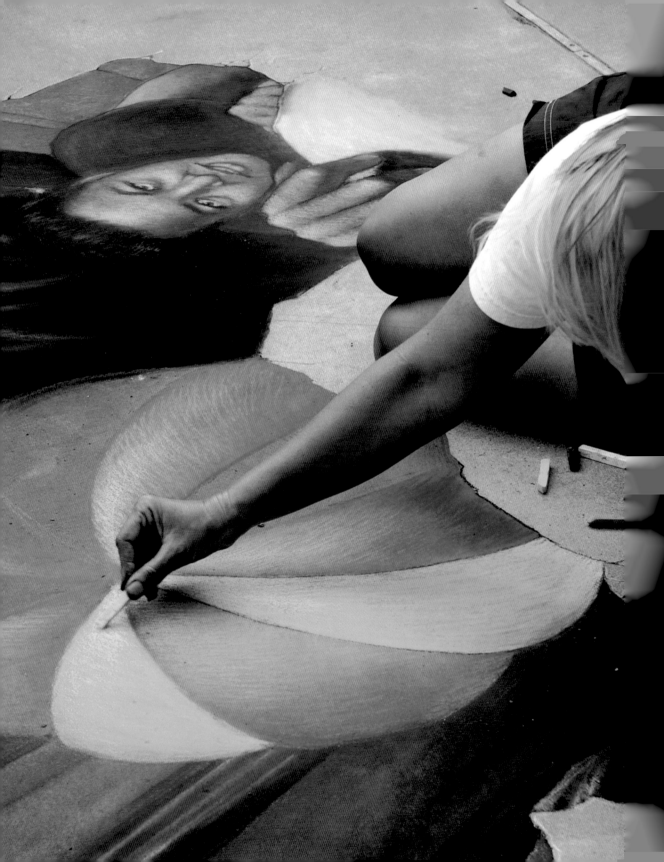

AINTING BASICS

Often people ask me where I learned to street paint. Part of that knowledge has come just from being on the street, doing the work, and watching other painters, but my knowledge also comes from what I learned about the basics of painting while at school. Understanding light, value, and color is essential to making a good painting, whether it be abstract or realistic. This statement also holds true for street painting. It is these basic foundation principles combined with the particulars of applying these principles to the media—pastel on asphalt—that help to make a successful street painting.

LIGHT LOGIC

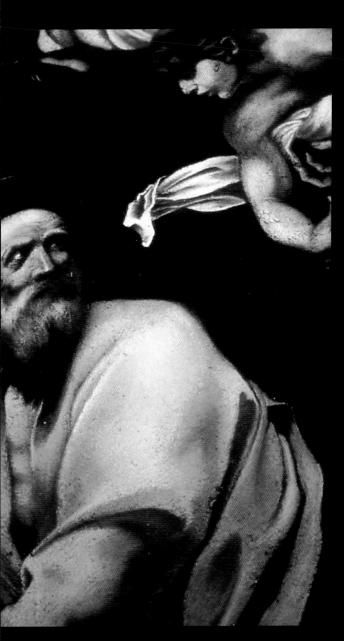

Much of what artists learn falls back on some fairly easy concepts to understand, such as the concept of light logic. Light logic is the application of certain rules to the way light hits an object that helps to express the volume. By looking for these characteristics of light, and then accurately representing them in your paintings, you can create a realistic sense of form in a two-dimensional work. The basics of light logic are simple—what can get complicated is compounding the light sources, the variety of objects, and the range of surfaces. Street artists typically use a single light source; this is helpful in keeping paintings unified, as multiple light sources in a large-scale painting could make it difficult to understand what is happening within the painting. Standard light logic is based on the following principles:

Light direction: Light rays are straight. They do not bend around a form, but are stopped from hitting the form directly at the widest point of the form.

Light values: Separation of values between the dark and light side of a painting is essential for building a solid sense of light as well as helping to make the composition clear to the viewer. The lightest side of the shadow side of an object cannot be the same value as the light side of the object: there is no way that reflective light—even strong reflective light—can carry the same intensity as the direct light source itself.

Above: This Caravaggio copy of The Inspiration of St Matthew painted in 1997 in San Rafael, CA, reflects the lessening of contrasts at the outside edges to allow the forms to roll back into the distance, thereby letting the light pull the volumes forward.

Proximity and angle: As light hits an object, the surfaces that are closest to the light source and most perpendicular are the brightest. Surfaces that are of equal angle to the light source, but further away, get slightly darker in value. This is called "rolling the lights."

SIX SECTIONS OF LIGHT LOGIC

There are six sections to watch for when applying light logic. The wider the turn of a form (a large ball versus a small ball), the more obvious some of these sections will be and the softer the edges. Sharp turns, such as a square edge on a cube, or a very narrow turn around the top of a cone, might be so sharp that you only see a couple of the sections—shadow and light, without the variations of each. These sections are:

1. (Light side) Highlight: The highlight is the brightest value on the value scale and is dependent on the surface quality of the object as well as the inherent color of the object. Smooth or shiny surfaces have brilliant highlights that are white. The more matte the surface, the more the highlight might fade, have softer edges, or even disappear completely.

2. (Light side) Light mass: The light mass is the main part of the object facing the light, before the edges begin to roll away from the light and into the shadow side. The light mass is toward the brighter end of the value scale and generally could contain several values of light before it rolls into the next section. Artists also use this term to refer to the entire side of the object that is being hit directly by the light source.

3. (Light side) Halftone: This is the part of the object where the form is rolling away from the light source. While this area is still being hit directly by light, the planes are at enough of an angle that light is beginning to skim the surface, rather than reflect back, so the value therefore begins to darken. This is generally the darkest value within the light side of the object.

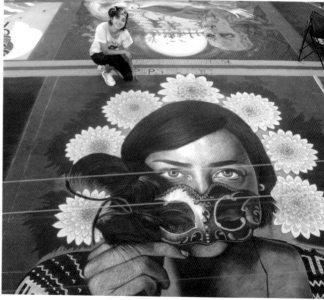

Above: Two beautiful portrait paintings by the Italian artist Valentina Sforzini, showing big differences in the way contrast is used. In the top portrait, there is a much higher contrast and the image has strong accents, which draw the viewer in. The bottom portrait uses a lot of middle values, with subtle transitions that are enhanced by the dramatic color accents.

**4. (Shadow side) Core shadow/form shadow/
terminator:** The name varies depending on who is
discussing it, but this is the shadow that is contained
within the form, and is at the point where the form is
at its widest, blocking itself from being hit by the light
source. This section is generally one of the darker values
within the object, which is the result of a couple of things.
One is that it is the furthest from reflected light, such as
a ground plane. The other factor is that it is closest to the
light side of the form, so appears darker because of the
contrast to the light close by. As viewers, we generally
read the core shadow as being the widest part of the
volume, so when you ignore putting in the core shadow, it
often makes the form look significantly flatter.

5. (Shadow side) Reflected light: This is a secondary
light within the form: Contained within the shadow side,
it is the area of shadow that is light in value due to light
being reflected onto it by other sources, such as the
ground plane, other objects, or even the form itself.
The reflected light is very dependent on the plane
that is reflecting the light, so will be lighter or darker
depending on how deep the value is on the reflective
surface. The reflected light is the lightest value on the
shadow side, but should not be higher than the value
of the half-tone area. When the reflected light doesn't
seem strong enough, and yet is painted within the value
area that should be correct for it, it's often a relationship
issue. Instead of lightening the area, try deepening the
surrounding values—the relationship of the reflected light
changes immediately and it will appear lighter.

6. (Shadow side) Cast shadow: This is where the form
is blocking light from hitting another surface, such as the
ground plane, an object, or another surface within itself
that would normally have been hit by the light. Rendering
cast shadows correctly builds a sense of depth and
direction to the lights, as well as giving a good sense of
the strength of the light source. Cast shadows generally
tend to be deeper in value immediately near the object,
and have crisper edges. As the shadow travels away from
the object, the value might lighten due to the influence of
more and more reflected light. With the greater distance,
edges become softer and less focused.

Immediately underneath the object, where it is sitting
on the ground plane, almost all reflected light would be
cut out, so there is often a much deeper shadow in this
small crevice. Adding in this dark edge will help delineate
the object as well as make it feel more closely tied to its
ground plane.

Using your knowledge of these basic rules of light logic
will not only help pull the painting together as a whole,
but will also help you to understand and apply your
medium—pastel—more effectively. Understanding light
logic also comes in handy when trying various trompe
l'oeil effects (see pages 136-9).

Opposite top: A sphere in pastel showing the
various bands of light/shadow: 1. Highlight
2. Light mass 3. Halftone 4. Core shadow
5. Reflected light 6. Cast shadow

Opposite bottom left: A 10-step gray scale
showing the range of gray pastels used to paint
the sphere on the left.

Opposite bottom right: The various faces in
this detail of a painting from the Mill's College
installation (see pages 98-9), completed in 2010,
have a wide range of value to show different skin
tones, as well as applied light to build volume.

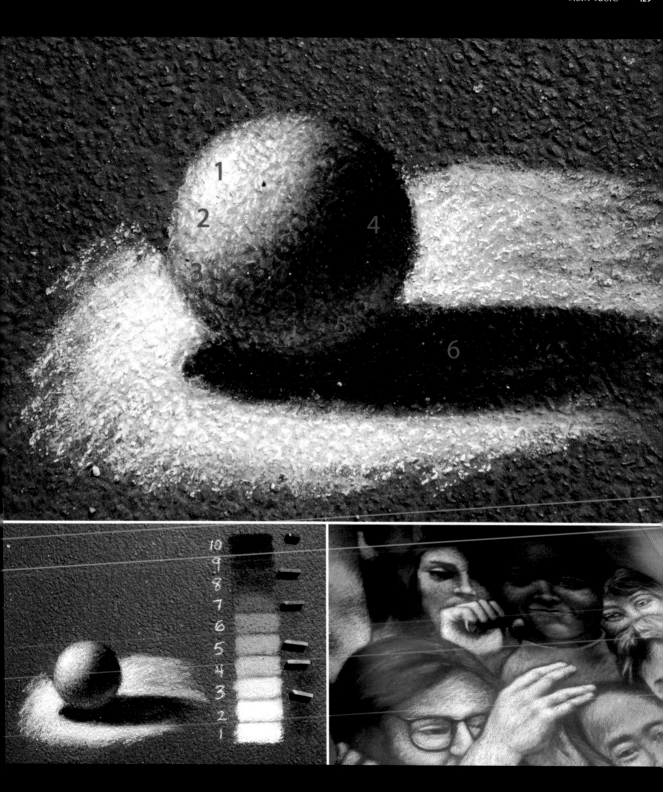

USING VALUE EFFECTIVELY WITH PASTEL

Understanding the application of light to the form is essential to bring realism into any painting or drawing, but within street painting it is even more important to enable the media to work effectively. Pastel has qualities that it shares with paints in the way color is applied and blending can be handled, but some of the qualities and strengths unique to pastel can become problematic very quickly if not handled correctly. One of pastel's strengths is that it remains unchanged if untouched, but can be manipulated constantly, even months later. This makes it a wonderful medium for street painting, since a finished painting can be attained and its effect seen immediately—not hours or days later after the media has dried. There is also no concern about portions "drying out" and being hard to manipulate, and yet it is still easy to clean and wash away later. Layers can be added on top of other layers, with previous colors showing through, or can be blended back and mixed in with everything underneath.

It is these qualities that mean it is even more important for the artist to be clear on both their color choices and the separation of light and dark values, because every layer affects the subsequent layers, either by being blended into them or by showing through the later mark-making of the top layers.

LIGHT AND SHADOW

If you go back to the discussion of light logic (see pages 126-9), I covered some basics of value when I discussed the different areas of light within the form. I mentioned that the reflected light area should not compete with

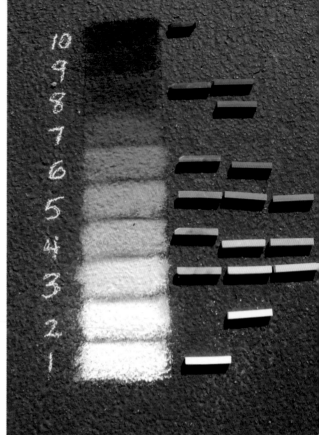

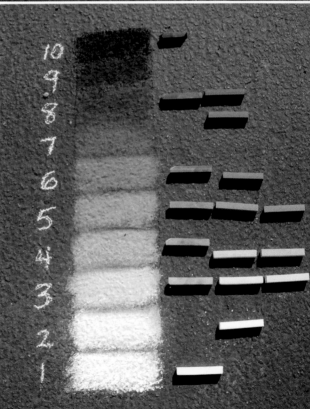

Opposite: Two photographs showing the same pastels. The top one shows the colors next to their assumed values; the bottom black-and-white photograph shows the reality of the value comparison when all color information is removed.

Top right: The shadows and lights on these canyon rocks use simple light logic principles applied repeatedly in a limited palette.

Bottom right: The oranges are just little spheres; the oranges and reds contrast well with the greens.

the light side of the form. So the values within the reflected light area should not be as bright as the light side, since this is impossible within the normal settings we usually paint. This reflected light is essentially a second- or third-generation light and so cannot be as strong in value as the initial light source on the object. Logic follows that if you are looking at an object under light and comparing it to a value scale, you should be able to separate the values of the shadow side from the light side.

REMEMBER VALUES

One of the mistakes many beginners make, in painting as well as street painting, is that the second they move to color they forget about value. They think in terms of "Which color red do I need to buy to paint that apple?" and forget about all of the lessons they've learned previously regarding light and shadow. The reality is that if they were to paint the apple the wrong shade of red, but managed to render the correct values, it would appear more correct than if the apple had no value modeling but was painted the right red. The apple could be painted purple, but if the light appeared correct, we would assume it was a strange type of new apple!

Without light and shadow you flatten your form, so one of the key elements when aiming for a realistic image is to apply the idea of value correctly to the painting. By analyzing forms and trying to get an idea of what the light side and dark side of each form is, you can separate the values needed for rendering the forms realistically in the painting. This is especially important

in pastel painting because the ability of pastels to remain malleable, even days later, means that laying in colors in the wrong values makes them difficult to correct, especially when laying in too light, or with a pure color with no regard for shadows and lights.

Each color has a basic value and every object has a defined value range for its lights and darks, dependent in part on its base color. A black object might fall entirely in the top end of the value scale, while a red object might sit more in the middle to dark values, and a white object might spread fairly evenly through most of the values.

The first step when painting an object is to establish what that value range is, and to mass shadows into a certain value range, keeping that value range keyed into the darker values where it needs to be. For your lights, you need to get an idea of a base value too. The range of values for your shadows should be different than for your lights; usually, the only place the two meet is in sharing similar values for the brightest portion of the reflected light in the shadow side and the darker parts of the halftone area in the light side. By separating these values as you work, you will bring clarity to the form of your objects.

DARK TO LIGHT

One old adage in painting—dark to light—is very important in pastel work. Keep in mind that the lighter pastels are filled with white pigment and will wash out your colors quickly—and remember too that your pastels will not be dark enough in value most of the time! Therefore if you lay in your base values slightly darker—and more saturated in color—than you think you should, it gives you room to build your lights in a way that makes sense physically as well as visually.

UNDERSTANDING LAYERS

The easiest way to think of this is like viewing a round form. Where you see the light appear the brightest on that round form tells you that this is the apex of the curve. Where the light darkens and turns, the form is receding. So, if you think of your value as a way of building physical depth, it makes sense that your first layers might be darker in value, getting progressively lighter as you do smaller and smaller sections on top, building that roundness. With bits of the darker values showing at the edges and then gently receding into the top of your "hill," you are creating that visual impression of the physical roundness of the form. Keep this concept in mind as you indicate a form turning in space—the edges of the form should recede in space as they turn away. The way to achieve this using value is to make your value a lower value than the higher values in the light side. Generally, you move the outside edge values into a

Above: Despite the high-value reflected lights in this copy of Guercino's Return of the Prodigal Son, the value of the shadow side is still much darker than the light side of the form. Part of the reason the reflected light feels so strong is the fact that it is surrounded by deep shadows. Building those shadows from a lighter color first would have been impossible!

middle value range, which lowers the value from the core lights, as well as often lowering the contrast of those outside edges in comparison to the background.

DEALING WITH SHADOWS

When laying in darks, think shadows first and color second. For example, don't lay in a "flesh" color and then think you'll darken it where the shadow appears. The flesh color will muddy and gray your darks quickly. It is important to lay in your shadows in pastels that are no lighter than what your value needs to be. So if you have determined that your shadow side is about a value eight, do not choose a color that is a value five to lay it in. This may sound like common sense, but it is one of the most prevalent mistakes seen at festivals. It is much easier to lighten the pastel afterward, and far more difficult to bring saturation and value depth to something that has too much light in it. Therefore make a choice about where the form is in shadow and where it is in light and paint your values accordingly. You can then build up in value where you need to, using middle values to soften the turning form in the halftone areas where the turns are wider. Brush on top of the lighter side of the form with progressively lighter pastels: don't add strong creams or whites until the very end! Try to avoid over blending, and allow the colors of the pastels to work by sitting side by side, instead of constantly mixing them and softening the effects of both the light and color.

Top: An example of the separation of light and dark, as well as the build up of light, bringing the volume forward as the middle values recede.

Bottom: The blue reflected light on the arm stands out strongly due to the deep shadows, but is far darker than the values within the light side.

GALLERY: LIGHT LOGIC

The way that an artist renders light becomes highly personal, just as most aspects of painting are. Some artists choose to use a soft, subtle light in a higher key with almost a glowing effect to it. Others are strong and forceful, building dramatic form and volume as they make their statement—the key is to apply light logic and values. The dramatic size of a street painting can exaggerate the effects of light and shadow and, when standing in front of such a painting, can create an unforgettable impression.

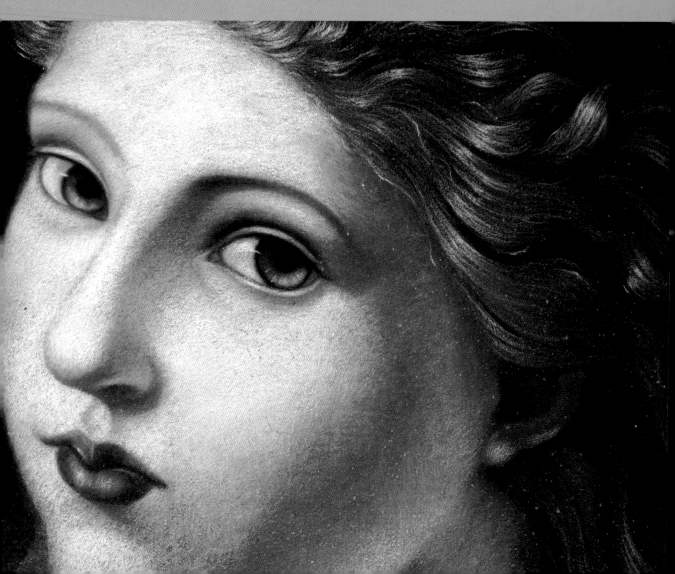

Opposite: Melanie Stimmell Van Latum's use of light in this painting creates a glowing effect, both within the hair as well as in the face itself.

Below left: This original design was painted in Corpus Christi, TX, with the help of Melanie Stimmell Van Latum as well as two assistants. It is key in original designs to keep in mind a constant source of light that is used throughout the painting to create a sense of reality.

Below top right: The attention to light and shadow—especially in the drapery—helps to build form in this copy of a Guido Reni completed by Melanie Stimmell Van Latum in Valencia, CA.

Below bottom right: This painting by Tomoteru Saito is a combination of a figure from an old master painting within a pool built in perspective. Notice the effects of light throughout the painting, and details such as the shadow being cast by the figure to help create depth.

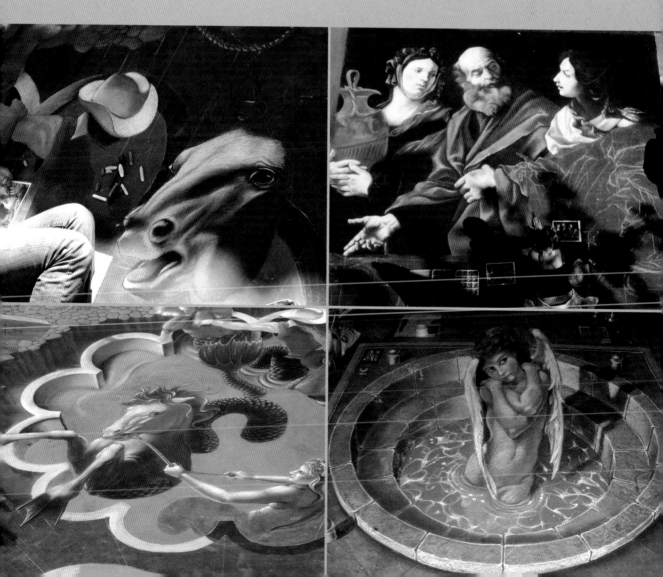

TROMPE L'OEIL

The addition of trompe l'oeil—objects and borders that are painted to have the illusion of reality—can have quite an impact on the viewer's reaction to your painting. All it takes is a small border for someone to react really positively, and yet these items are often the simplest things to paint if you understand and correctly apply your knowledge of light logic. Often they are just repetitive strips of light, core shadow, and reflected light that appear to the viewer as areas of architecture or framework. If you would like to make the frame or other work more decorative, look through images of Baroque and Rococo architecture and painting. Murals from these periods often have fancy frames built around them as well as trompe l'oeil signage, which can be great reference to add to your own work. If the detail is very elaborate, you might consider using a pounce pattern (see pages 118-19) to put the drawing down on the ground so that you maintain the precision of the original design.

BUILDING YOUR OWN FRAME

Besides looking at trompe l'oeil frames and examples in architecture, feel free to create your own frame.

Symmetry is necessary for the base frame if you want it to feel realistic. Find a mid point for the edge you are working along, then sketch or measure out one side of the frame. After figuring out how it will look, find critical points you can measure out and match on the opposing side of the same edge, and rebuild the design using these points as reference.

If you are adding a common motif, such as an octagon or diamond shape, into the frame and the part of the frame it is on is flat to the viewer, you can create a template for the shape. This will make putting the drawing down much quicker and also maintain the continuity of the repeating shape. If, however, you choose to add a motif that is on a vertical plane in your drawing, where the plane is being used to create a sense of depth, you will need to use your perspective point in order to depict the motif correctly. Find the top edge of the motif and run the perspective point to the motif to find its center line as well as the outside edges that are going into the distance. If the motif is circular, it helps to mark in a box that would encompass the circle so that you can draw the circle correctly in perspective.

As mentioned before, if the border is complicated, consider marking it out ahead of time on a pounce pattern and transferring it.

Left: The trompe l'oeil frame of a painting done at the Grazie Festival in 2003 was added as a finishing touch so the top end of the painting wouldn't feel so empty. The frame was developed by drawing out the left side from the mid point of the painting, and then copying the mirror image of it over to the right side. Simple light logic was applied, keeping in mind where the light source was coming from.

LIGHT AND SHADE ON SURFACES

How you work your light and shadow, as well as your color palette, will also depend on what you want your final surfaces to represent–smooth stone and architecture will not have sharp highlights, but metal will. Your color palette should also reflect what you are trying to indicate. For example, metal often has warm reflected lights, and I generally like to paint my reflected lights using a mid-value warm tone, such as a brick red or a rust brown. With warm metals, I try to keep the color palette of my light side on the yellow-toned end, so that my shadow side can have the redder tones in the reflected light and feel connected and yet separate. I find that fluorescent orange pastels can be a nice replacement for the bright light found on metal surfaces.

Top left: Blocking in of values and base colors. Here, black is used to heighten the core shadow.

Middle left: This shows a blending of the bottom layer and heightening both the light side and the reflected lights.

Bottom left: A sharp highlight is put in with tints of ochre, softened, and then hit slightly with white. Fluorescent orange also achieves this effect.

Above: A simple weather vane painted in black and dark brown, with heightening in fluorescent orange. With such a limited palette, understanding how to handle the light is imperative.

CAST SHADOWS

When adding trompe l'oeil effects to your painting, it is also necessary to figure out your cast shadows. There is a specific perspective to cast shadows that makes them feel correct, which can be found in most books dealing with perspective; however, even just laying in approximate shadow shapes can be a help. If you choose to put in a perspective point for your shadows, I would recommend not using your chalk line to mark it, as this will also leave chalk lines on areas you might want to keep clean. A thin rope attached to the perspective point helps you to indicate what those lines would be by stretching out the rope and marking along the length with a pastel. Keep in mind your overall light source for the painting as this helps determine the direction of your cast shadows. How far up you would like the object to feel in relation to the ground plane will determine how angled the shadow is, as well as how dark it is and how faded the edges might be. When building perspective into the painting, you'll need to pay attention to this light source to decide what parts of the vertical walls are being hidden in shadow or hit by light. Using your understanding of light logic and applying your color palette intelligently can make for beautiful effects within the painting.

Top: A trompe l'oeil sign used at a festival was based on Baroque sign panels often put on murals, but with a slightly more modern feel. The strong lights and darks use almost the same palette as the trompe l'oeil examples, just a bit more blended and rendered.

Bottom: A trompe l'oeil frame and lettering are a nice way of taking this Tiepolo detail from The Education of the Virgin and making it feel like a finished 12- x 12- ft (3.5- x 3.5-m) painting. Bakersfield, CA, 2005.

CRACKS AND LETTERING

Often, the sought-after trompe l'oeil effect involves cracks in the stone, or engraved lettering. After seeing too many paintings where someone has created stone cracks without looking at how they really form, I strongly recommend finding some images to help you paint these realistically. I have an entire folder on my computer that contains only reference images found searching for asphalt, crumbling asphalt, cracked pavement, basalt columns, and so on. By studying these images and mimicking the lines, you'll see the organic nature in the way a crack forms—a variety of straight and curved edges, as well as the unevenness of the crack itself in width and character. I normally draw in cracks using darker pastel—dark brown or black—then come back along the edge that is opposite the light source with a lighter pastel to give the line a sense of depth. I might come back through with a very light or white pastel to create a highlight and the contrast to really pull this crack out from the "depth" of the dark line, which indicates the inside of the crack.

Lettering is handled very similarly. Paying attention to whether I would think of it as carved in or raised up, I figure out where the light would be hitting it and run a lighter pastel along that edge. The shadow along the opposite edge makes the letter feel like it has depth in the "stone" that I've set it into.

BRICK AND TILE EFFECTS

Painting bricks or tiles is often one of the simpler things to accomplish. The natural texture of the asphalt mimics the final effect of stone—watch the way light skims the surface of a flat plane, and use tighter values and colors to copy this effect. Once the basic color has been applied, using a lighter pastel to barely brush the top surface—where it hits only the higher textured portions of the asphalt—will mimic the effect of the light skimming the rocky texture very accurately. Add an organic character to the tile and make it look realistic by looking for areas in the edges of tiles where they pit or crack naturally.

Top: This close-up of cracks shows the value modeling used to develop a sense of realism. Varied lines, highlights, and fading off the cracks all do their part to heighten the realism.

Bottom: Close-ups of cliffs from a painting done in Denver, CO, in 2010; the natural cracks in the asphalt work into the drawing.

GALLERY: TROMPE L'OEIL

The idea of trompe l'oeil—to fool the eye—means that a work might contain a single element incorporating this illusion, or could use the concept to apply to the painting as a whole. Much of this work uses some sort of perspective, as well as applying the rules of light to the forms painted so that they create an illusion of reality. The rest is up to the viewer, inviting them to relax and enjoy a little, and allow their belief in reality to be suspended for a short bit.

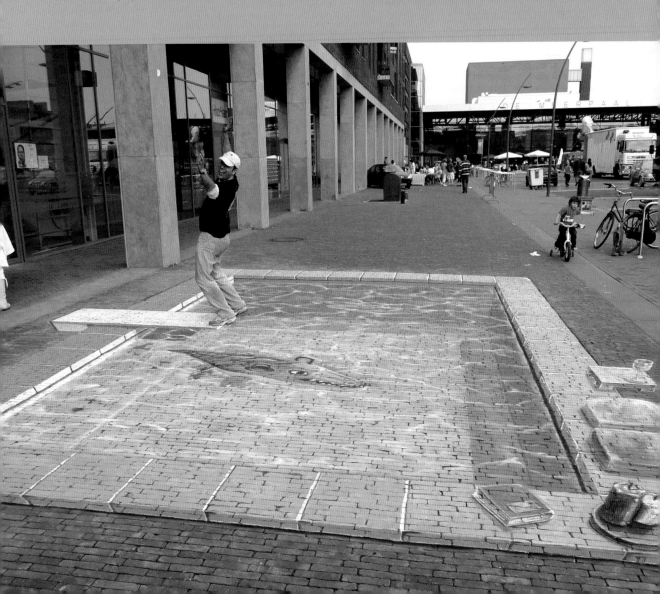

Opposite: Even with the bricks peeking through the painting, there is still a strong sense of illusion in this pool painted by Planet Streetpainting. Probably best not to swim with crocodiles!

Below top left: The use of perspective in this painting by Tomoteru Saito creates a comical image–try to imagine that fork fitting into anyone's mouth.

Below bottom left: This detail of a painting by Melanie Stimmell Van Latum uses trompe l'oeil mostly in the signage in the top right corner to beautiful effect. Houston, TX.

Below top right: A 3-D anamorphic image of a car breaking through the pavement, completed by Planet Streetpainting. Simply painted, yet very effective in creating depth and reality.

Below bottom right: The trompe l'oeil scroll at the bottom of this painting by Melanie Stimmell Van Latum is a simple way to include the lettering needed for this painting in a way that adds to the painting and makes it feel more complete. Houston, TX.

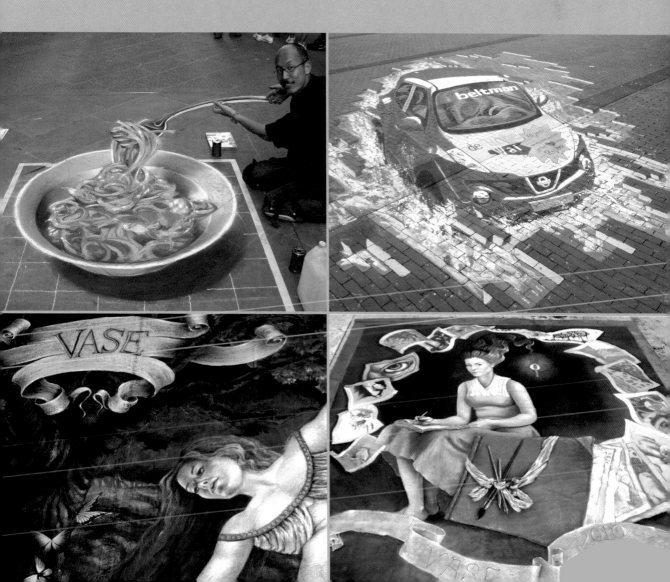

COLOR BASICS

Color: Such a short word for such a complex subject! This section looks at the basic ideas of color theory, and then helps you to understand how you can apply these ideas to your street painting to create more intensity and add richness to your work—even to areas of color that you might think of as being subtle.

Interest in color theory is recorded as far back as da Vinci, but the scientific study of color was taken up in the early 18th century by Sir Isaac Newton and others. Color theory is an involved area—even when the observation of it moves between different media, such as print, paint, or photography—that becomes fairly complex when discussing whether you are looking at "additive" or "subtractive" color. Additive color is color that is produced using light and mixing colored light together. Subtractive color is produced using opaque media such as paints and dyes. For example, mixing the three primary colors together in subtractive color produces a warm to cool dark gray. The understanding of color mixing as regards to paint can be defined in rather simple terms at an initial glance, but how knowledge of color usage is then used practically to enhance a painting is where the real complexity begins.

THE INTERACTION OF COLORS

The basics of color theory covers the relationships between the colors on a traditional color wheel. Colors that are adjacent to each other on the color wheel are called "analogous," and colors that are opposite each other on the color wheel are called "complementary." If we understand the way our eyes perceive light rays, we know that analogous colors have similar light waves, which explains why they mix together well and meld into each other so easily. On the other hand, complementary colors have light waves that are mathematically opposite each other. When placed side by side, complementary colors show each other off to advantage because of this extreme change in light rays, but when mixed together, the opposing light rays cancel out each other. In effect, mixing complementary colors cancels out the color, resulting in a gray or brown.

THEORY AND PRACTICE

The theoretical study of color doesn't always work so cleanly when applied to practical matters, such as painting. Mixing colors on the color wheel lowers the intensity of the resulting color so that it cannot be the same intensity as the original colors. Even when mixing colors that are analogous to each other, there is still a lowering of intensity, though this might be small.

As well as mixing pure colors, when you mix neutral ones—white, black, and gray—with pure colors, the effects are not as straightforward as you might expect. Theoretically, when adding white or black to a color you would assume that the color would remain the same as far as "temperature" (see page 145) is concerned, just becoming lighter or darker. Instead, when you add white to a color (making a tint), or black to a color (making a shade), you cause it to shift a little into the green or blue spectrum, making it a cooler color, especially when mixing reds and oranges. When you mix gray into a color, you create a tone, which doesn't have this effect.

So when addressing painting using color theory, it helps to think less about mixing—saving this for making adjustments to pigment colors—and rather to concentrate on working out how to arrive at a new, pure color. To do this, it helps to understand the placement of different pigments in relationship to each other, in terms of both color and temperature, as well as in "saturation" (see page 144).

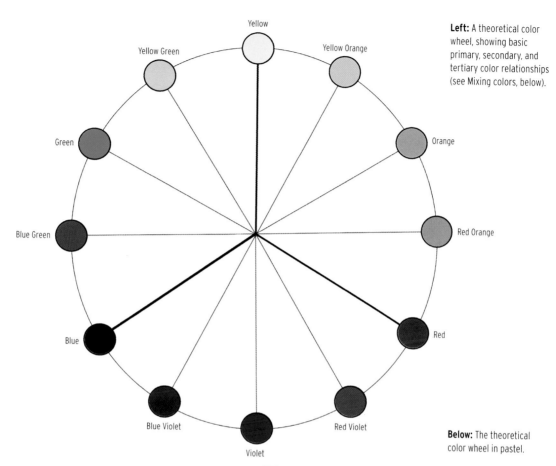

Yellow

Yellow Green

Yellow Orange

Green

Orange

Blue Green

Red Orange

Blue

Red

Blue Violet

Red Violet

Violet

Left: A theoretical color wheel, showing basic primary, secondary, and tertiary color relationships (see Mixing colors, below).

Below: The theoretical color wheel in pastel.

MIXING COLORS

In simple color theory, much like what is taught in the earliest years of school, there are three primary colors—red, blue, and yellow—from which all of the other colors can be mixed. The secondary colors—violet, green, and orange—are created by mixing these three colors together. By mixing these secondary colors back with a primary color, you get the tertiary set of colors, such as red-orange, blue-green, and so on. Anyone with much paint-mixing experience knows it is not quite as simple as this. When mixing the primary colors together, you rarely get colors that are the same level of saturation—or color intensity—as the original colors. Instead you get secondary and tertiary colors that are quite toned down from the original. To get secondary and tertiary colors that are as intense as original spectrum colors, you need to use pigments of those colors, not mix them from other colors.

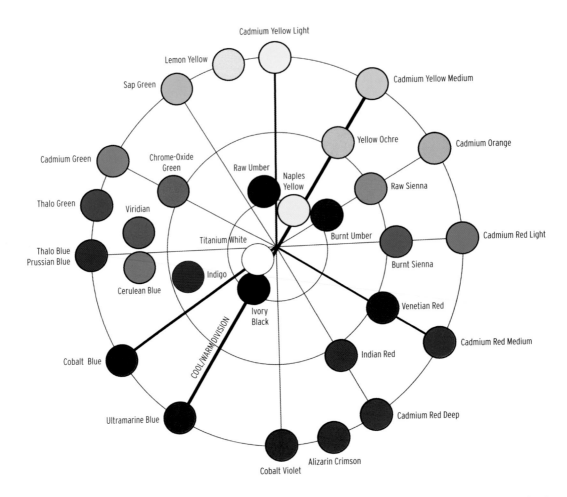

COLOR INTENSITY

Saturation is the intensity of a color and is talked about in two ways. The first refers to the color itself when it is mixed with a neutral color—white, black, or gray—taking it away from its original pure color. The second describes the relationship of one color to another and explains how close or far a color is to the color spectrum—ie the six colors that make up the pure color of light. (When light passes through a prism, for example, it separates out into six colors: Red, orange, yellow, green, blue, and violet; the same effect is produced when light passes through the prism of water or mist to create a rainbow.) So a color such as cadmium red light could be considered a saturated color compared to burnt sienna. On the other hand, you might desaturate it by adding a neutral color such as Mars black...and could possibly add enough Mars black to make it even more desaturated than burnt sienna.

The color wheel shown above attempts to address the idea of saturation. By analyzing the hue base of each pigment, it can be placed appropriately around the circle, but the less intensity the original color has, the further inward on the circle it is placed. By adding the inward desaturated color to a pure spectrum color, you can desaturate, lighten, or darken the spectrum color without shifting it out of its hue family. The color wheel also shows the relationship of white and black pigments and helps you to understand better where these pigments might shift to when mixed with a certain color, such as in the

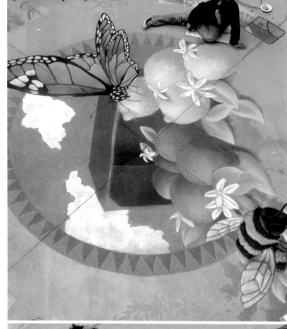

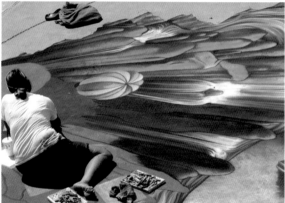

Top: This painting relies on lots of warm, saturated color to jump off the pavement.

Bottom: The rich complementary color scheme in this painting, completed in Corpus Christi, TX, in 2010, means that the warmer orange-based canyon comes forward to the viewer, while the blue water recedes and also creates a nice backdrop to show off the canyon.

Opposite: This color wheel is based on one developed by Don Lagerberg, an artist and professor at CSU Fullerton. While it doesn't show value relationships (which would require a 3-D color wheel) it does show the relationship of pigments by color temperature and saturation. As with so many other factors in art, everything is relative, and this is the case when making color comparisons. An example might be a color such as alizarin crimson, which appears warm compared to ultramarine blue and yet cool compared to cadmium red. Saturation also affects the analysis of color. For example, even though burnt umber is the desaturated version of an orange, thereby placing it inward from cadmium orange, the intensity of cadmium orange would make it appear much warmer in comparison.

case of ivory black, a blue-based black, and yellow ochre, a desaturated yellow. If you mix blue and yellow together, you know you'll get green. When you mix these two desaturated versions in those hue families together, you do indeed get green—an olive green, desaturated in color.

WARM AND COOL COLORS

Besides saturation, you also need to pay attention to color temperature. It is the combination of color temperature and saturation that determines where a pigment lies on the painter's color wheel—value (see pages 126-31) is not taken into account on this wheel. Pigments within each color family (blue, red, violet, and so on) have a temperature relationship that tells you

their placement on the color wheel compared to other pigments. Generally, colors in the red-yellow range are considered warmer ones, and colors that lie in the green to violet range are cooler.

In the color wheel opposite left, see how ultramarine blue is near the violet end of the color spectrum, and phthalo, or thalo, blue is toward the green end. Various theorists consider the division of warm and cool to be in differing places on the wheel, but this color wheel has put the break at the blue-violet line for cool and the yellow-orange line for warm. This means that ultramarine blue is a cooler blue than phthalo blue. Bear in mind that all of this placement is subjective, since opinions can differ, but the concept of these relationships is important.

GALLERY: COLOR

The creation of a street painting uses many of the same techniques and color palettes as other art mediums to create diverse statements by the artists who make them. From the gorgeous color of an old master copy to historical religious images to paintings that make comments on contemporary issues, the works are as diverse as the personalities who meet to create them. One of the beauties of a street painting festival is the capacity for a place for everyone to create, no matter what their experience level or conceptual leanings.

Opposite: Butterflies lift off of the pavement in Ann Hefferman's design for the 2007 I Madonnari Street Painting Festival.

Below top left: This design—called Katrina—was created in 2005 while working with the Red Cross to help raise funds for victims of Hurricane Katrina. Michael Kirby and a selected group of volunteers from the Red Cross traveled throughout the US, creating this original image repeatedly to raise tens of thousands of dollars which went to the Red Cross.

Below bottom left: Bold color marks this copy of a Baroque painting completed by Ketty Grossi, at the Incontro Nazionale dei Madonnari di Grazie di Curtatone, Grazie, Italy, 1999.

Below right: This detail of a woman's face painted by Melanie Stimmell Van Latum is replete with saturated colors and pastel tints.

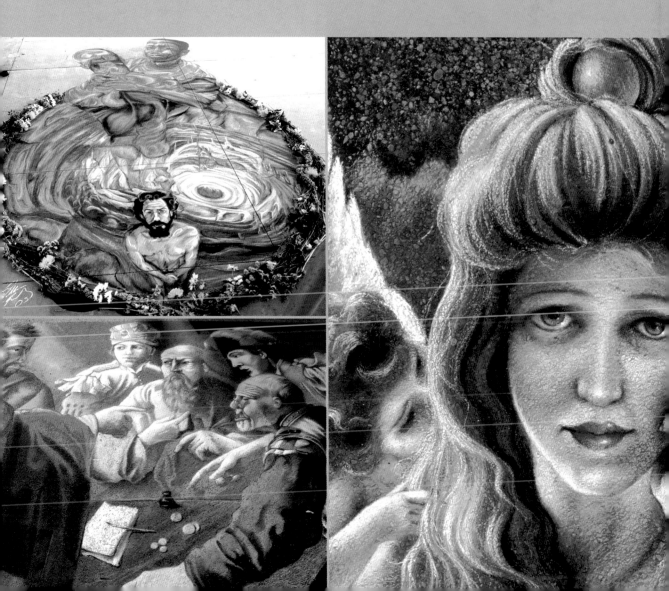

COLOR FOR THE STREET

In all forms of paint media color is always a factor, but there are some aspects of pastel painting that make an informed understanding of color even more important. Not only do you have a media where you can constantly mix and blend all the way down to your bottom layers, but also you can just as easily lay your colors side by side, or in cross-hatched layers on top of each other.

Pastels are completely matte and opaque, and yet have a depth and resonance to them that is brought out best through using colors wisely. You cannot get the same effect in subtle areas such as skin tones or white drapery if you do not understand how to juxtapose your colors, and one of the best ways of doing that is by layering much more intense colors on the bottom, with less intense, light-building colors on top.

Bear in mind that by tinting a color, you are also desaturating it, which can make it appear cooler. To combat this and keep warmth, make sure you use warmer tints, such as ochre tints, rather than straight white. The old adage of painting—right alongside the one about dark to light—is that warm colors come forward and cool colors recede. So, if you want light to bring volume to your form to bring it forward, then avoid letting it get too cool too fast—using warmer tints to build light, and keeping pure white for the final highlights.

WARM AND COOL COLORS

Recalling the earlier lessons in value, you know also that to make a form recede in space—or roll back if it is a round form—you should lower the contrast on the portions that recede. This might be the edge of a sphere, or an entire form in the background. With monochromatic color, you do this by using middle values that are not as contrasting as your lightest values, but when you move to color, you have a couple of other options. You can choose to use desaturated colors for those edges, or you can desaturate your original color by making it a tone, or by mixing a little bit of its complement into the color—again desaturating it. This play of saturation versus desaturation helps to bring out the form where you want it to be drawn out.

Complementary color, therefore, becomes a very important part of manipulating space in your painting as well as creating depth in your media. Complements can have a gorgeous effect because of the way they play against each other when viewed from a distance—desaturating much like the French pointillists in the 19th century did and yet also keeping the pure color intact—but they can become problematic when over-mixed. You need to remain constantly aware of how you are working your complementary colors, as it is easy to let them run away from you and, for example, muddy skin tones. And yet, by layering them without blending them, you can build the depth that comes with bits of the complement showing through to your top layers.

Opposite top left: Pay close attention to how the shadows and lights are formed on this balloon. Purples cool down reds, helping them to turn into shadow, while brighter orange is used to lighten the red without washing it out. Within the yellow strips, dark brick red is used for the shadow mass, then overlaid with lighter oranges and yellows.

Opposite top right: A colorful crocodile makes his way into this original design. Lots of home-made Prussian blue is my base, with turquoise and ochre yellows to lighten. Even though the reflected light in the jaw is strong, it is in the warmer–and lower value–light ochres. The top of the head, which is in the light, is developed with the cooler and more brilliant whites.

Opposite bottom left: The tiger and man in this painting from 2008 have lots of bright orange and purple. Fluorescent orange was one of the key colors for adding the highlights along the tiger's shoulders and back leg.

Opposite bottom right: This cherub's bottom from a Tiepolo copy in 2004 has much more color than you would have expected. The shadows are primarily gray and red, and the light side has a lot of rich pinks, purples, and greens.

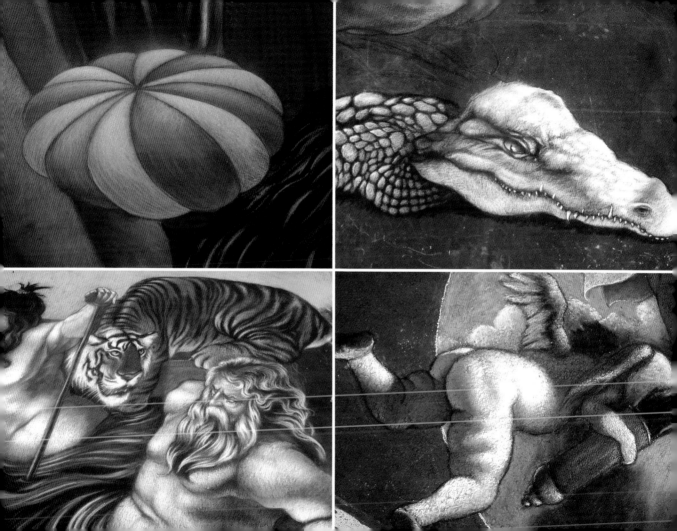

LEARNING TO APPLY COLOR

There is a general pattern I like to follow when building color within my paintings. This pattern is not set in stone, and you might discover your own ideas about color along the way (please do!), but, at the same time, the logic of the pattern might help you to figure out your use of color.

1. Usually my first step lies in establishing the dark/light pattern of the form because I tend to gravitate toward these areas first. Mostly, I start out with the obvious deepest darks of the core shadows, establishing the depths of my shadows with dark values, but rarely using black, especially in skin tones.

2. From there, normally I'll move toward my reflected lights and the lighter areas of shadow in general, working value for value—meaning that I come in at about the value it needs to stay, or go darker. I don't wash through an entire shadow side with one value/color, as you might do in an oil painting. With value, I tend to err on the side of making it darker, rather than lighter, because the darker shadow is easier to lighten, as well as more unifying for the shadow mass. I'm already paying attention to color saturation at this point, and applying much stronger colors than I'll end up with—it's easy to tone down on top and yet keep something of the underlying color showing through.

3. At around this stage I'm also paying attention to the halftone turns of my forms, which is often where the most saturated pigments appear. I lay these areas in with similar values to my reflected lights, sometimes using the same colors, sometimes working with even more saturated versions of those same colors. My most saturated colors in my base layers are usually these halftone areas. This is accurate to reality where the halftone is the portion of the object still in light, but the least washed out by that light, and so contains its most saturated version of whatever is the base color.

4. As I build into my light side, I key the values down several steps from where they'll end up. For example, if the value were to end up as a 2 (on a scale of 1–10, with 1 being white), I will most likely work it with a bit more of a 4 or 5 initially. The color will have to be more saturated because the lighter it gets, the less saturated it is, so even when using the same base color I will later finish with, it will end up being more saturated in a lower value. However, I might also vary my color slightly to break up my palette and balance how the color ends up. For example, I might not want a pure ochre tint as my final skin tone color and would balance it out with a Venetian red tint, so it doesn't appear too yellow or too pink.

About now, I would probably do some blending (shown in picture 4). My technique has changed over the years and, where I used to do a lot of blending and smoothing to my pastel work, now I blend it just enough to fill in, but usually do not smooth it out completely. I like to have the asphalt covered, but also retain more of the color I've just laid down—blending will lose my color variation as it all blends into one color.

5. Now that I've filled in much of the form, I can start working it on top. I often go back over what I've blended with similar colors to my base. I also start varying my color, sometimes choosing complements to begin the process of desaturating and naturalizing my color, or tints, in a slightly lighter value, which will desaturate anyhow, but also start to roll the form up for me, giving it dimension. Depending on what I'm painting, I might choose to shift the color slightly (for example, in some metals I'll put rust and olive green on top of a dark rust base to give it that greenish cast of tarnish). Other than my bottom layer, I do very little blending, so all of the color I put down now is playing against another color, unless I decide I've made a mistake and need to knock it back, which I then do by blending. The final addition to my painting is to re-establish the outside contour line and apply any bright highlights with white.

6. I look continuously to refine and build form, and in the process find that the building of the light side happens a little at a time. Just as in music, the light builds up to a crescendo of sorts, finally establishing itself against a background of color notes that give the light a glowing depth unique to pastel.

Above: A photograph of my husband, used for reference in a painting in 2010.

Top: The finished painting: Climbing up out of the canyon.

NOTE ON IDENTIFYING COLOR

I've found over the years that my love of oil painting has had a key influence on my street painting and vice versa. Sometimes I'll try things in pastel only to realize how well they work, and then use a similar technique in an oil painting. There are differences, of course, but much of the same palette is used in both media.

One of the things I've learned from both media is to work out which colors aren't there when I look at the form I'm painting. Over time you begin to see how what appears to a beginner to be certain colors—ochre, white, pink, rust—is actually a key color with lots of side notes. Part of the beauty of painting the figure is painting skin tones, and one of the reasons that is such fun is because of the myriad of color shifts in human skin. To a certain extent, seeing this comes with experience, which takes time, but the more you seek out color, the more you begin to use it intuitively, and the more intuitively you use it, the more you bring your own sense of style to the painting.

Above: This original painting by Emily Bonham was completed in 2008 at the I Madonnari Festival in Santa Barbara, CA. The shadows and lights in the landscape were created by blending darker blues or yellows into the green—not black and white.

A FEW HELPFUL COLOR TIPS REGARDING SPECIFIC PIGMENTS

Black: Because black will muddy lighter colors, I rarely use it for areas such as Caucasian skin tones, apart from to heighten the deepest part of a shadow in which I've already laid in with a deep color. However, black does work well with some colors to depict deep-colored drapery and metalwork, especially in paintings that have intense, dramatic backgrounds, such as copies of Baroque paintings.

White: Don't lay in with straight white—even in something that will end up white, such as white drapery. White is at the top of your value scale and has no color attributed to it, so by laying in with white, you have no way to build more light, and you are completely devoid of color reference, which flattens the pastel. Lay in with lavenders, mint greens, turquoises, and/or ochres, and establish your shadows with deeper colors of purple or blue or dark ochre, balanced with darker grays or browns. Refine and build an overall light side by controlling your hand pressure as you unify the light side with white on top, letting bits of your color peak through in the halftone areas. This gives you a color base underneath, and allows you still to give a strong sense of the white form.

This concept isn't just about controlling pastels, it is about the rules of light logic. A sense of volume is built by creating light on the portion of the volume that is emerging toward the viewer. By laying in with mid-tones, you physically build the feeling of light on the apex of the curve outward.

Using white in skin tones: A lot of my highest lightening in the light side is done with light tints of yellow ochre, or very light tints of cadmium yellow. I rarely use white when building skin tones, and if I do, it is only to apply finally the very last highlight within the light side, or to blend back into the cream colored tints I've already put in. I dislike the coldness of using pure white in skin tones, except in cases where it is specifically called for, such as in dead skin tones.

There is a lot of warmth in skin-tone reflected lights—watch for reds, oranges, or warm olive greens.

Shadows: When laying in shadows, I tend to gravitate to certain pigments: Dark browns (raw umbers and madder browns); dark blues (Prussian blue and indigo); and deep violets (finder's violet and also a mixture I make of ultramarine blue and caput mortem deep).

VARIATIONS IN COLOR PALETTES

Part of the fun of street painting is experimenting with color—you'll soon find that when you do copies, different paintings will have different solutions for color use. You'll also find that as you gain more experience and confidence in your street painting, you'll enjoy applying some of these new palettes into your original designs. In these photographs are a number of color palettes all trying to solve the same problem: How to render a face.

1. Lots of rich color and shadows help create a sense of drama in this copy of Merry-Joseph Blondel's Hecuba and Polyxena.
2. Detail of a Tiepolo in a more classical palette.
3. Detail of the fairy king in a Tiepolo—purples and ochres are the key colors.
4. This portrait was done in gray scale, then brushed in the light side with flesh-toned pastels to achieve a look of hand-colored photographs.
5. Here, the underlying warm red layers were then overlaid with ochres and creams to reproduce this detail from a Ruben's painting.
6. The saturated color in the under layer will give the final rendering a subtle touch of bright color.
7. An underlying base of olive green helps complete the "dead skin" look of this copy of Holofernes' head by Christofano Allori.
8. Lots of subtle color was used to create beautiful flesh tones in this copy of a Navez.
9. There is fairly limited color in the skin tones of this copy of Tiepolo's Neptune Offering Gifts to Venice, but a nice layering of lights to build the hair.
10. This centaur was enhanced by the experimental color palette used to paint him.
11. Working from reference images of a sculpture gave me some leeway to play with the color palette.
12. The rich color in this Ellen Degeneres portrait helps keep a sense of contemporary palettes in the painting.

1

2

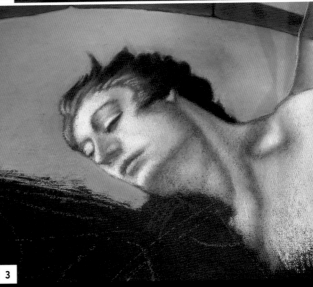
3

BUILDING SKIN TONES

As a figurative painter, I'm always interested in learning how to paint skin tones that have color and luminosity. Painting human skin is much more complicated than most people think. We tend to look at someone and see their skin as a certain color, but the reality is that the turning form, the varying distance to the surface of the underlying muscles or veins, the different color keys due to the light source (candle, sunlight, and so on), and the variety of skin pigmentation—even in one person—can all vary the surface color dramatically.

The most helpful way I've found to refine my sensibilities in this matter has been by embarking on copies of old masters whose figures appeal to me. I've found myself seeking out paintings in museums that can teach me something, and have spent long hours studying these paintings for the lessons contained within them, as well as trying to complete my own versions.

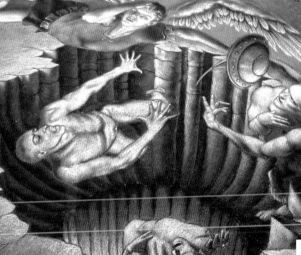

4

5

6

1. Notice how the entire shadow side of the figure is painted using reds and pinks in this copy of a Sebastiano Ricci's The Punishment of Eros. The only place darker browns show up is minimally, within the core shadow.

2. A nice warm-toned palette was used for Samson's back in this Rubens copy, painted in Santa Barbara, CA, in 2007, and furthered with reds for the reflected lights. Notice the "rolling of the lights" as the back gets further away from the light source.

3. The feet from a Pieta painting. Again, notice the cool-toned dead skin, and the purples, greens, and blues used to build that effect, as well as the re-established outside contour edge.

4. This painting, a copy of Cristo Mostrato al Popolo by Paolo Farinati, was done in San Rafael, CA, at the Youth in Arts Festival–one of the largest in the country. I chose to do it specifically to work on torso anatomy as well as the coloration of the skin. The rich variety of lavender, light greens, and soft yellows enhances the complicated rendition of the torso without overdeveloping it, as deeper shadows might have done.

5. I wanted to give the devils in this painting for the Grazie Festival in Italy a more sickly look, so painted the bases in olive greens and purples, lifting the lights out with ochre. Notice how different they are compared to Archangel Michael shown opposite top.

6. This figure, taken from Hecuba and Polyxena by Merry-Joseph Blondel, has a very different color palette to the one I normally use, but the original called for it. The lower contrast shadows are in purples and grays and the glowing reflected light is achieved with pinks. As bright as the reflected light is, pay attention to how it is still a deeper value than the light side of the form. Another section of interest is the drapery, which is almost undeveloped, other than a few key lights to establish the form. The rest is left to our imagination and a plentiful use of purples and greens.

BASICS OF TECHNIQUE

Many of the basics have been covered in the sections within this book, but it's always a good idea to sum up. Here are a few tips:

Starting point: Start at the top portion of your drawing and work your way down. Early on, find an area to finish off that will draw interest, such as a face in the upper quadrant to get started and encourage viewer interaction.

Layers: Your first layer establishes lights and darks, as well as filling in your ground surface for subsequent layers. One mistake many beginners make is to grind in lots of pastel. This builds up dust—dust you now have to figure out what to do with, and possibly annoy some neighbors in the process. Control your hand pressure, fill in enough to give yourself something to blend, then smooth. Get a feel for how much pastel needs to go down to fill in the layer.

Protecting your fingertips: When blending, try short latex fingertip covers, or full latex gloves. These work better than looser, non-latex ones, which bunch up under your fingers as you work. Sheets of polystyrene foam work well for blending large areas; most inexpensive pastels come with these sheets, and this is what I use it for, tearing it into small squares as needed. Sports tape protects fingertips while you blend. Some artists use paintbrushes to smooth out details. Generally, I use my fingers unless I'm filling in a large area.

Large background areas: Chalkboard erasers—the old black felt kind—will do the job of spreading your pigments quickly. After I use the eraser to smooth and fill in everything, I like to run the flat of my hand over the surface one more time to smooth out the marks.

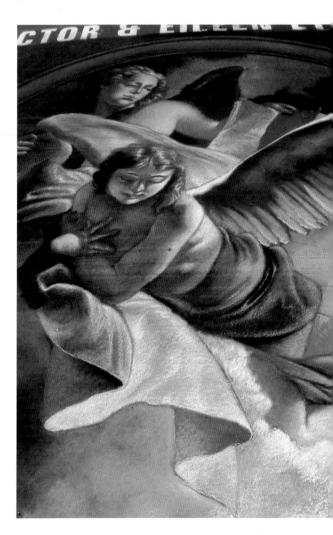

Above: This is a nice detail shot of a Tiepolo copy done in California in 2005. Notice both the hatch-marked lights used to build the drapery as well as the rich pink reflected light within the figure.

Above: I used many reference sources for this image, then created my own lion with its distinctive, strong color palette and overall style to make it a striking street painting.

Above: Water being laid in and then refined with blending, with some last touches of pastel on top to bring out the contrast.

Cross-hatching: Once you've laid in your bottom layer, work on top with light marks. Cross-hatching works nicely and allows you to use your mark to help build volume. If you use a light hand pressure, you'll make little dust and you can control how much your mark blends off into other colors/layers.

Tamping: Rather than blending top layers, use your fingers to lightly "tamp" down the rough edges of the marks, or even just touch the marks without smoothing at all. This allows you to soften the edges of your marks without blending the color out of them.

Outlining: After your figure or object is completed, re-establish the outside edge. It's nice to use a color that offsets what you have done. Use a contour line that varies in weight and run your fingertip over it to smooth it out and blend it just a tad. This type of outlining was often used in murals, such as in the Sistine Chapel ceiling, that needed to be seen from a distance as it helps clarify the edges from further away. Avoid outlining so heavily that it flattens the form; instead, outline just enough to refine the edge.

Cleaning up mistakes: A damp rag is handy—you can drop a little more water on the rag, and wipe out a mistake or old grid lines. A wet rag is also handy for cleaning dirty fingertips as you switch colors. Put the rag on a plastic laminate sheet so that it stays damp longer and doesn't damage your drawing.

Minimizing damage: When sitting down to work, sheets of cardboard are useful—I often salvage something from a local restaurant or business bin. You can sit on anything that won't damage the painting, so cardboard, sheets of plywood, and plastic sheeting are all suitable. When moving into the painting, if you wear shoes that have smooth soles, not athletic shoes with tread patterns, you can walk on the painting with minimal damage. You can also lay out more sheets of cardboard or laminate sheets to step on.

Top: The giant bear in this painting was a bit of a challenge—he was almost 15 ft (5 m) tall! He was painted using a base of darks and lights, then the hair modeling was done on top. His muzzle was done in the same way, and the gentle brushing of the pastel adds to the softness of the muzzle.

Bottom: A close-up shot of the pastel technique in a copy of a Rubens done in Santa Barbara, CA, in 2007. Notice both the development of the drapery lights as well as the cross-hatching within the arm and hand that develops across the contours, building form.

THE DEVELOPMENT OF WHITE DRAPERY

Above: The coloration of the arm as well as the cross-hatching on top to build form are nicely handled. The hair locks are blocked in with black, then the only thing developed is the highlights to define the form in this copy of Merry-Joseph Blondel's Hecuba and Polyxena.

1. Blocking in the lights and darks is achieved with the use of lots of colors in this case. The brighter lights are actually a cream color.

2. As I blend the colors together, it softens their effect as well as the intensity of the original color, while also filling in the underlying surface.

3. I now work back on top with whites and almost white to finish the drapery off. Notice how much of the "white" drapery is not white in this case. The slightly deeper values of the blocked-in tints allows more light to be built into the drapery, something that would not have been possible if the starting color was white.

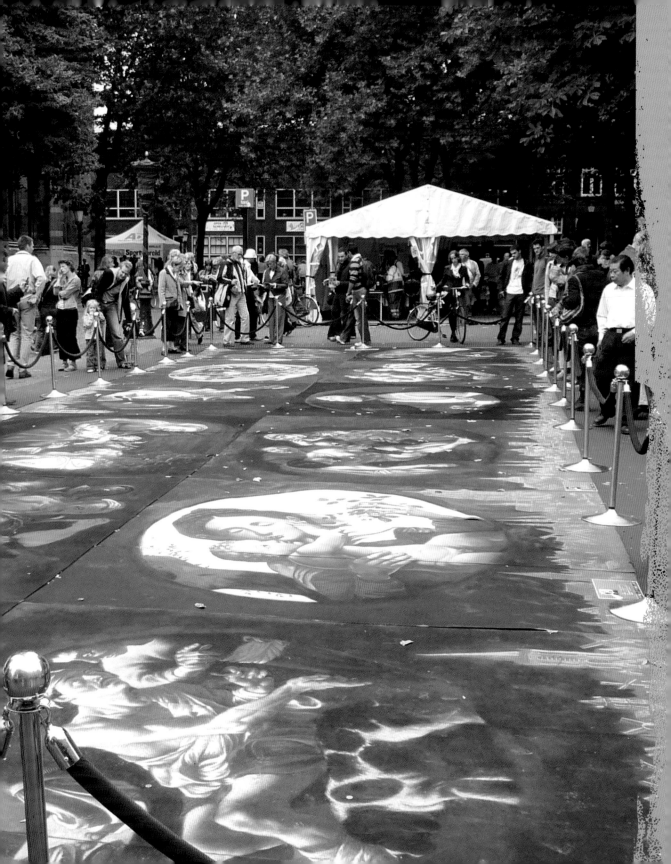

FESTIVALS

THE FESTIVAL EXPERIENCE

The Grazie Festival, started in 1972, is the oldest street painting festival in the world. It is held every year over the popular Italian religious holiday, the Feast of the Ascension on 15 August, in front of the church in Grazie di Curtatone, Italy. Pre-competition festivities include a blessing of the chalk, where chalks are placed in baskets and blessed by local church officials. The artists then line up to collect a piece of chalk to use in their work. At 6pm on the evening of the 14th, a bell heralds the start of the competition. Artists work throughout the night and must finish by 6pm the following day. Over the next couple of hours, town officials meet, decide on the winners, and hold an awards ceremony with podiums and medals for the winners.

FESTIVAL AWARDS

For a Madonnaro or Madonnara—the name given to a male or female Italian street painter—winning an award at the Grazie Festival is not only the moment of a lifetime, it also confers rankings, as the competition is divided into three levels: Semplici, Qualificati, and Maestri. Each person begins at the bottom level and must win first place even to be considered a qualified Madonnaro/a. This means that they must beat around 100 to 150 other artists from around the world. Once they attain this rank, they compete in the next level the following year, hoping to win the next rank so that eventually they are considered a Maestri. Winners are given monetary prizes as well as medals. In 2003, I attended the festival for the first time and won the Semplici level. Since then, I've returned to compete, and enjoy the friendships I've made with people from around the world, who love street painting as much as I do.

Previous page: Street painting installation celebrating Utrecht's Caravaggisti, the Netherlands.

Opposite: Top two rows: Grazie artists; church officials and the judging panel. Bottom row: The perpetual trophy given to the artist who wins the Qualificati level and officially becomes a Maestri; images of the festival and church in the daytime and at night, while the artists are working.

Right: My copy of Judith and Holofernes by Cristofano Allori, Grazie, 2003.

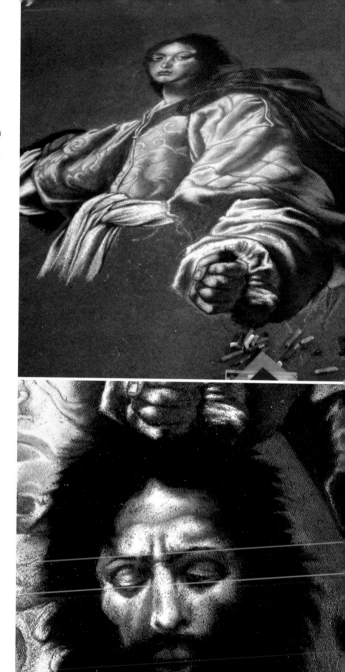

WHAT TO EXPECT AND HOW TO PREPARE

Some festivals try to ease the worries of first-time artists by offering an artist's workshop in advance. These are a great chance to see work being done by someone with experience, and hear their insights on the art form, and to learn some street-painting techniques. You might have a chance to ask questions, and possibly even an opportunity to work with pastels and see how to manipulate them to improve a painting.

EUROPEAN FESTIVALS

Depending on where your festival is being held—in the US or in Europe—what to expect on the day of the festival can differ. European festivals typically expect the artist to be there in advance for registration—sometimes the day before the festival. They give little in the way of food or water, but often have stipends for the artists at the end of the event. Often, European competitions award prizes and titles, sometimes with additional rewards. At these festivals, you'll most likely be painting with other street painters (as opposed to a mix of artists and groups such as school children), some of whom earn part of their living from this type of work. You may even find that some artists, if they feel you present competition, do things to throw you off your game. It's all part of the fun of the competition, so try to take it in your stride.

FESTIVALS IN NORTH AMERICA

In North America it's a bit different in that most festivals aren't competitions—or at least, not obvious ones with prizes, although some artists might feel competitive! Festivals are often organized to raise money for a charity. This means that you'll probably be painting side by side with other artists, school groups, and any assortment of families and friends. The festivals often give some odds and ends to the artists, such as a gift bag with sunscreen, a festival T-shirt or poster, and small items or coupons from local businesses. Expect to be provided with some pastels—even just a box is a help! You might also be treated to an artist's lunch, or even an artist's reception on one of the nights. Occasionally, these festivals arrange shows for artists where they can display their permanent work. There are usually no stipends available, though some festivals will cover hotel and/or travel for an out-of-town artist if that artist is known for doing excellent street paintings. The lack of competition and the fact that people are there to support a charity means that these festivals tend to be good bonding experiences for artists, as well as a chance for artists who are relatively new to the form to view the work of more experienced artists.

This collaborative project of 12 copies of historical master works by 12 artists was coordinated by Peter Westerlink with Planet Streetpainting.

FESTIVAL CHECKLIST

WHAT TO BRING WITH YOU

1. Sunscreen! This cannot be emphasized enough. Bear in mind that you may be spending two or three days out in the sun for eight or nine hours solidly. I recommend a high SPF of the spray-on kind because your hands will be dirty—nothing is yuckier than spreading sunscreen with pastel-covered hands!

2. A terry cloth rag you can wet for wiping up mistakes.

3. Thick baby wipes for cleaning fingers (the rag also works for this).

4. Tape measure.

5. Chalkboard eraser for spreading large areas of pigment.

6. Wooden dowel stick for drawing.

7. Construction chalk line.

8. Masking tape.

9. Painter's craft paper for the border if desired.

10. Check with the festival and find out if they are supplying boxes of pastels, and, if so, how many. Many US festivals offer a free box or two of pastels. Bring additional pastels as needed, especially darker values.

11. Laminates of your painting reference.

12. Things to protect your fingers, such as finger cots, sports tape, and latex gloves.

13. Business cards and a portfolio if you are seeking work.

14. Camera.

15. Some festivals allow you to bring something to provide shade, such as a small pop-up tent or an umbrella. Check first as certain festivals don't allow these due to the wind.

16. Something to sit on—a sheet of cardboard is most typical.

17. The right clothes—if it's hot, dress appropriately, which does not mean stripping down to nothing. To avoid sunburn, keep yourself covered, but in lighter-colored clothes. Jeans and a white T-shirt are good as they'll protect you from burning as well as the hot pavement. Bring a sweatshirt for later in the day—it's amazing how cold it can feel after spending all day in the heat.

18. At some festivals you might be able to work at night. If you can bring a light source, such as a propane lantern which gives off a pure white light, it will help you to see your colors more correctly. (Many light sources have light that has a certain color cast to it, such as yellow or blue, which will affect the way you interpret your painting.) However, propane lanterns might not be allowed. Electric camp lanterns should be allowed no matter what, but their light is cooler-keyed and will affect how you see the color that you're painting.

PREPARE FOR THE WEATHER

If it's even somewhat sunny, it can get quite hot on the pavement. Besides dressing to avoid overexposure to the sun, you need to take additional care. Heat stroke is not a fun thing to experience. On hot days, plan on working early in the day through until 1 or 2pm, when the heat gets unbearable, and then take a break. Come back around 4 or 5pm when it starts to cool down and work as late as you need to. Drink plenty of water, and avoid alcohol and soda. Stay in the shade whenever you can!

If the weather is threatening rain, you could bring some cheap thin plastic tarps (tarpaulins), or thin plastic drop cloths (dust sheets), to cover your painting. Keep one end taped at the top of your painting when the threat of rain is imminent, so that you can pull it down and quickly cover your painting. If tarping overnight, be aware that the tarp alone will not protect your painting and in fact might cause more damage. Use the tarp only for very light showers. If it is going to rain heavily, you'll want to either double or triple tarp (see page 97) or not cover it at all and just do repairs the next day.

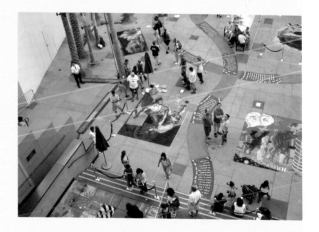

Bird's eye view of a charitable festival held in Hollywood, CA. The surface is mainly granite, so difficult to paint on and needed preparation.

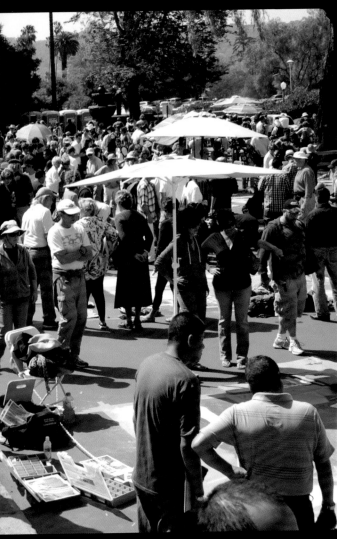

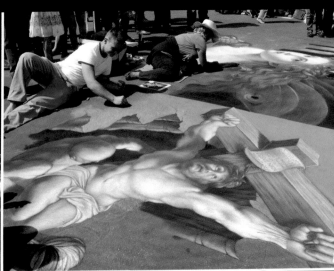

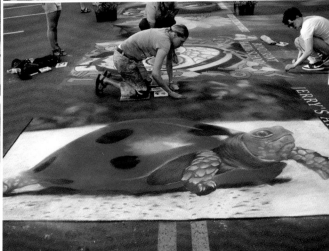

Above left: The crowds of onlookers that attend a street painting festival are fascinated with both the process of creating a street painting as well as the finished product.

Above right: Instead of doing straight copies, sometimes I take old master paintings and recompose them into new designs which use perspective to create depth. This image was built from characters in Ruben's The Raising of The Cross and specifically chosen for both the perspective and the anatomy.

Below right: Aimee Bonham created this ladybug turtle painting at a new festival in Gilbert, Arizona in 2010. Aimee often does large paintings of animals, which really appeal to the younger audiences at the festivals.

WRAPPING UP THE PAINTING: PHOTOGRAPHS!

Once the painting is done, it's time to remove the tape, write a title, and sign your name, then take lots of photographs! As well as taking shots throughout to capture specifics, such as a detail that you are proud of, you will definitely want to photograph the finished work, making sure that you record it from different angles and heights.

Although street painting feels very different in a photograph from the reality, pictures are nice keepsakes and can also help you when applying to other festivals. You might want to do some close-up shots, as well as make a record of work by other artists. If you have a friend, ask them to take a few frames of you working on the painting, as this helps to give a sense of the scale of your work.

THE BEST PHOTOGRAPHIC RESULTS

Photographing street paintings in sunlight tends to be the best way to capture the most vibrant colors, as long as the sun is not low in the sky and backlighting the pigment. Photographs taken in shade can also be effective, though not quite as dramatic in coloration. The one thing to avoid is taking a shot of a painting when it's part in shade and part in sun or has cast shadows of people standing near by. One part or the other will have exposure issues, so if you have an umbrella or something else for shade, try to remove the umbrella first or photograph later when the sun and shade are no longer an issue.

One last word of advice—enjoy yourself and learn something new. The art form of street painting has a long history, but it can also be your history if you want to be part of it. Worry less about failing and more about how to solve problems and what you can do to improve. Take the time to make new friends, engage with the crowd, and enjoy the art form for what it is—a brief moment that you share with others at the event. These art memories will make your efforts worth it and help you improve as an artist. Besides, what could be more fun than spending an entire weekend painting? Best of luck!

ETIQUETTE

A few simple actions on your part will make you a much better painting neighbor to others. Basically, just think about how your actions impact on others and be a considerate neighbor to those around you. It's a tight squeeze and a long weekend, and it always works out much better if you get along:

1. Dust—don't create it, or blow it. Draw lightly, build up layers, and avoid scrubbing hard, where you create a lot of dust. If you must blow, blow away from other paintings. You can also blow gently to create a small pile of dust and then wipe that up with your wet rag.

2. Keep your painting materials and tools cleaned up and in a small space—don't spread out everywhere.

3. Don't use your neighbor's space to cut through, or sit on without permission first. I always laugh at myself and others because, once we're assigned our spot for the festival, we become very territorial—for that weekend that 12- x 12-ft (4- x 4-m) piece of empty pavement belongs to us.

4. No boom boxes, loud conversations, and so on. Remember that others are trying to work too. Use headphones if you want to listen to music.

5. Offer to help other artists with tasks such as gridding their squares.

6. Put away your personal things—I've never had anything disappear while street painting, but by keeping items out of sight you lessen the temptation.

7. It is customary for artists to approach others for more sticks of pastels in colors they need. Etiquette is that the person asking should offer to trade sticks back.

8. Any drinks should have lids on them—the last thing you want is for a drink to spill and run into someone else's painting!

9. Many festivals have limitations on what media you can use—for example, only pastel and chalk and no wet media (including tempera paint!), and may also stipulate that fixatives of any type are not allowed.

SPOTLIGHT ON:
I MADONNARI ITALIAN STREET PAINTING FESTIVAL

The I Madonnari Italian Street Painting Festival is the first festival of its kind in North America. As executive director of the Children's Creative Project, Kathy Koury had been searching nearly a decade for a fund-raising event idea that would stand out from all the others. Since 1987, the I Madonnari Festival has benefitted the Children's Creative Project, an innovative nonprofit arts education organization of the Santa Barbara County Education Office, devoted to bringing visual and performing arts workshops and performances to tens of thousands of school children annually.

THE BEGINNINGS

Koury first learned about the international street painting competition in Grazie di Curtatone in Italy when talking with her friend, photographer Jesse Alexander. She decided to travel to Italy where she witnessed the festival first-hand, and became friends with some of the street painters, including artists Kurt Wenner and Manfred Stader, who later became the Santa Barbara festival's featured artists for the first two years.

After returning to Santa Barbara, Koury wanted to combine the idea of an Italian street painting festival with her need for an innovative fund-raising event. Coincidentally, the Santa Barbara Mission was planning its bicentennial celebration and Father Virgil Cordano and the Mission's planning committee invited Koury and the Children's Creative Project to hold the first festival at the Old Mission in May 1987. This first festival year was the most challenging because at this time street painting was

Opposite: The paintings are as varied as the artists' personalities, reflecting classical and contemporary tastes. The park in the background becomes a three-day venue for an assortment of musicians and performers, as well as providing space for a wonderful collection of food stalls. All proceeds go to the Children's Creative Project, an organization devoted to bringing the arts to children in local schools. The painting in the foreground was designed by me; the one above was completed by artist Lisa Jones; and the furthest painting was completed by Ann Hefferman.

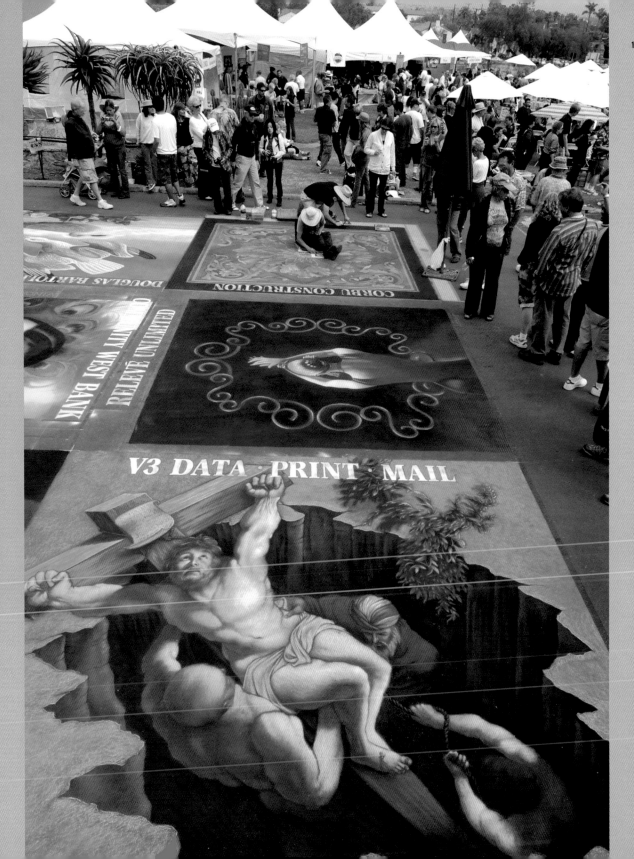

not a well-known art form. Koury created the fund-raising concept of sponsored street painting squares and local artists and children were recruited to become madonnari and cover these pavement canvases with their own unique ideas. Now each year a featured street painter completes a larger drawing at the base of the Mission steps to represent the festival's major sponsors. The Children's Creative Project Board of Directors and staff have worked from the beginning to develop an outdoor market of fine Italian cuisine with live music.

Koury felt the street-painting medium would be a perfect complement to the mission of the Children's Creative Project. The gradual progression of each street painting from start to finish demonstrates the creative process for onlookers. Also, the impermanent nature of street painting shifts the focus from the finished product to the joy of creating. Unlike the festival in Italy, she felt the Santa Barbara festival should not be a competition nor have an overall religious or particular theme.

AN ENDURING FESTIVAL

Held annually each May at the Santa Barbara Mission, the I Madonnari Italian Street Painting Festival celebrates its 25th anniversary in 2011. The festival has played a prominent role in introducing street painting to the US. When one looks at the development of street painting over the last couple of decades, it is evident that most of the US festivals can trace their roots and some of their operations back to the I Madonnari Festival.

Kathy Koury is to be credited with a great deal of this as she has spent much time over the years both inventing and refining the festival's structure and fund raising. Koury and the Children's Creative Project Board of Directors and staff continue to update the look and feel of the event, what it offers, and the logistics for it to run well on all levels. The I Madonnari Festival attracts some of the best street painters in the world, many of whom are located in California, and many can claim their first festival experience as the Santa Barbara event.

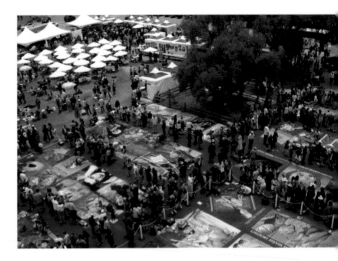

Above: An overview of the I Madonnari Italian Street Painting Festival in Santa Barbara, CA. This was taken from the bell towers of the Santa Barbara mission, and does a nice job of showing both the high crowd count at such a popular festival as well as the variety of images.

Opposite: Looking up a row of paintings toward the beautiful Santa Barbara Mission. The Mission has become a wonderful backdrop for the oldest street painting festival in the US, which flourishes both due to the support of the Mission as well as the Children's Creative Project, the street artists who come from around the world to paint, and the community itself. The painting in the direct foreground was painted by artist Ann Hefferman.

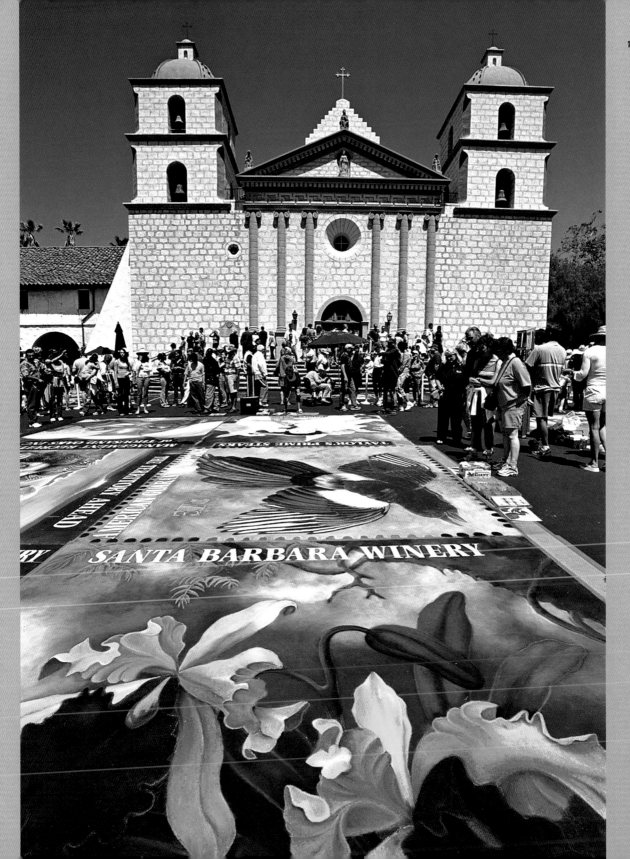

APPENDICES

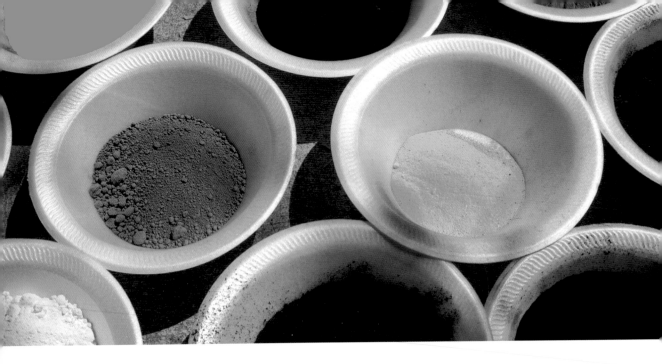

RECIPES

The two-part recipe given here is one that has circulated among artists who street paint. I'm not entirely sure of its origins, or who first came up with it, but it has been specifically adjusted to work with the street-painting medium in several ways. The binder is fairly inexpensive to make, being made of commonly found materials, such as boiled linseed oil, Ivory bar soap (or any simple soap mainly composed of tallow and glycerine), and beeswax. These are less costly than materials such as gum tragacanth and therefore an attractive choice for street artists because of the large quantities of pastels they use as compared to a regular pastel painter. Due to the small amounts of wax, soap, and oil, the pastels adhere well to the asphalt or cement and raise less dust than most of the commercially available soft pastels—yet they are still able to blend easily, unlike normal oil pastels.

The recipe is comprised of a glue mixture that is made up of wheat in the manner of old-fashioned wallpaper paste and an emulsion mixture, which is the wax, oil, and soap. These are added to the pigments to make pastels (see pages 62-4 for method). Substituting modern pre-made wallpaper glues for wheat paste is not recommended. However, wheat paste is essentially just a mixture of wheat flour and water, in the proportions I've included here. The boiled linseed oil is found in home painting sections, as it is commonly used with household oil-based paints. The beeswax can be found online from various candle suppliers, and can also be bought at some craft and art supply stores. It comes in solid block form or in pellets, which are easier to melt evenly—either one works fine. Ivory bar soap can be harder to find, but is a simple soap free of most additives and fragrances—though I do notice the soap smell when I use my pastels out in the sun!

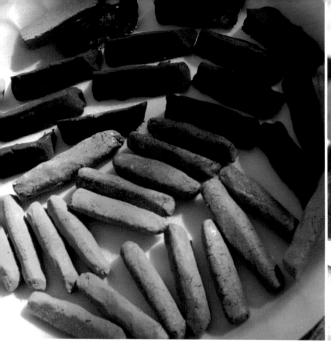

WHEAT PASTE GLUE

2½ cups (312 g/11 oz) wheat flour
½ cup (100 g/3½ oz) sugar
2 quarts (1.9 liters/3 pints 6½ fl oz) water

1. Put the flour in a pot and add just enough of the water to stir it into a thick paste, working out any lumps with a whisk. At the same time, heat up the remaining water in a separate pot that will be large enough to hold all of the flour and sugar.

2. Once the water is heated, add the flour mixture slowly, being sure to work out the lumps with the whisk. Continue heating, stirring constantly, until the mixture reaches a full boil.

3. Add the sugar and stir thoroughly, then remove from the heat and allow it to cool completely to room temperature.

STREET-PAINTING PASTEL BASE

For the emulsion:
½ cup (liquid measure/118 ml/4 fl oz) beeswax
½ cup (118 ml/4 fl oz) of boiled linseed oil
5 oz (142 g) Ivory bar soap or similar (see opposite)
2½ cups (591 ml/21 fl oz) water
Wheat paste left (see above, prepare ahead of time)
Electric skillet (frying pan) and microwave

1. Melt the beeswax in a microwave oven, if available, otherwise melt in an electric skillet until liquid. Measure ½ cup (118 ml/ 4 fl oz) of the beeswax and combine with the linseed oil. Remove

any excess beeswax from the skillet. Return the oil/beeswax mixture to the skillet and heat to 350°F (176°C).

2. While the oil/beeswax mixture is heating up, prepare an ice water bath. Use a container that is large enough to hold the pan used in Step 5. Fill the container a quarter full with cold water and add lots of ice cubes to keep the water as cold as possible. Place in the refrigerator until ready to use.

3. Grate the soap and place in a pan with 2 cups (473 ml/16½ fl oz) of water. Over a medium heat, bring to a rapid boil and stir with a whisk until dissolved.

4. Pour the boiling soap solution extremely slowly into the 350°F (176°C) oil/beeswax solution, beating rapidly with a whisk until well combined. Add ½ cup (118 ml/4 fl oz) of boiling water to the emulsion, whipping it constantly until well combined. You can add more, or less, boiling water to adjust the consistency, which should be like a heavy cream.

5. Pour the resulting emulsion into a metal pan and place the pan into the ice water bath, still stirring constantly. Stir until the solution reaches room temperature.

6. Mix in the wheat paste glue. For a normal pastel, combine one part emulsion to two parts wheat paste glue. For a waxier pastel, combine an equal part wheat paste solution to an equal part emulsion. Stir with a whisk until well combined.

7. You can add your pigments straight away (see pages 62-4), or store in a covered container in a cool, dry place and make up your pastels when you're ready over the next few days.

PROFESSIONAL CONCERNS

If you've gained expertise in street painting and are being approached for jobs, there are various things to bear in mind. A professional manner is important—you have expectations, and the client has expectations of you.

TERMS OF SERVICE

It helps to draw up a "terms of service" contract for a client. This outlines what you expect from them, what the consequences are if they do not follow through on their obligations, and what your responsibilities are as well. A terms of service contract is similar to a standard contract, but can be given in addition to the contract the client gives you. Check your legal rights for your state or country. Many states have an arts council of some sort. These councils charge a nominal fee to join, and often offer free legal advice to members. It's a good idea to look into a service like this so that you are well aware of what your rights are. A council might even be able to advise you on specific legalities within a contract that you or a client draws up.

Some of the requirements I ask for in terms of service:

1. Payment due—I typically expect payment rendered on the day I complete the painting. I normally ask for a deposit in advance to hold a date, and will only hold this date for a short time if I have not received a deposit. In some companies, this can be difficult to push through, but it is the best safeguard you have from last-minute cancellations. In my contracts I include a cancellation policy that lays out how long they have to refund their deposit, and when they are responsible for payment, even if the painting no longer happens, as well as what my responsibilities are if I cancel (I do repay the deposit). I make sure to include that payments not completed by the due date are subject to a late charge. Some clients are in a billable situation where there is no way for them to have the cheque there when you complete work, but submit the invoice as soon as possible, put the due date on the invoice as being the day the work was completed, and include notice of a late charge after 30 days of a certain percentage (mine is usually 15 percent). It's amazing how much

an invoice like this can speed up a sluggish payer. I've found big corporations and government jobs to be the most difficult to get payment from, but this has seemed to make the process go much quicker—months quicker, in some cases!

2. Design requirements and fees—I don't always add a separate design fee, but I do put in a payment schedule on large jobs that outlines when a deposit (and additional payment on larger jobs) are due and when they cannot be refunded if the client cancels the job. I will sometimes include a separate fee for if the job itself does not go through when I've done all of the design work.

3. Weather issues—list a possible rain date reschedule, if you can do, as well as a note that weather conditions can hinder the completion of a project. Request that the client provides shade if it's an outdoor location.

4. List your responsibilities as regards to providing design materials to the client, as well as their responsibilities to provide logos, type, design theme, and so on.

5. List specifics for the material and surface, including whether you need them to provide something in the way of flooring for a canvas, or for cleaning cement and so on.

6. List the clean-up responsibilities for the painting.

7. List travel arrangements and per diem requirements. I typically require all travel and per diem covered for myself and an assistant if needed, and I require the client to pay them upfront—I do not pay them out of pocket and wait for reimbursement.

8. List other responsibilities on your part or the clients, for example, photography, protection of the painting (such as stanchions, security at night), workshops if they are needed, and materials for painting and/or workshops.

RESOURCES

PASTELS AND CANVAS SUPPLIERS

In general, you can find most of your commercial pastels and materials through various online art sources. I've listed a few here, but most art suppliers sell at least a few of these things. Canvas can be ordered in wide widths through the same art suppliers listed in the pastel section, and can also be purchased in person at most of the better art stores.
www.pearlpaint.com
www.dickblick.com
www.danielsmith.com Daniel Smith is located in Washington State and does have store locations. They also have a pretty good selection of reasonably priced pigments by the pound.

Koss chalk pastels: these lower-quality pastels are actually great value for street painting at a very affordable price. You need to order in increments of 1 dozen, they come in boxes of 12, 24, and 48 pastels.

Koss International
3250 Wilshire Blvd. Suite 2150
Los Angeles CA 90010
Tel: 213.383.2474

In the UK visit www.greatart.co.uk and look for inexpensive pastel starter sets from Faber-Castell, Rembrandt, Schmincke, Sennelier, and Unison.

PIGMENT AND PIGMENT HOUSES

www.sinopia.com (also locations in San Francisco, CA, and New York City)
www.guerrapaint.com
www.kremerpigments.com - US
www.kremer-pigmente.de/en - International
www.williamsburgoils.com
www.naturalpigments.com
www.earthpigments.com
www.wgball.com
www.artmail.co.uk
www.greatart.co.uk
www.kamapigment.com
www.rendona.co.uk
www.rghartistoilpaints.com

BINDER AND VARNISH SUPPLIES

Beeswax: From craft stores (for making candles, etc)
Boiled Linseed Oil: Can be found at most places that sell house paint, as well as home improvement (DIY) stores
Gesso: www.novacolorpaint.com—I prefer to use Nova Color's black gesso as it is a high-quality gesso with great tooth to it, and very reasonably priced since Nova Color deals primarily with muralists.
Matte acrylic varnish: www.goldenpaints.com—I prefer to use Golden's water-based UV matte acrylic varnish which is designed to be thinned down with water.
Gloss acrylic varnish: Nova Gloss Acrylic Varnish

FREE REFERENCE MATERIAL FOR ARTISTS

Here is a selection of websites that offer free reference material for artists:
www.morguefile.com
www.artmorgue.com
www.photos4artists.co.uk
painting.about.com/od/artistreferencephotos/Reference_Photographs_for_Artists.htm

WEBSITES ON CYLINDRICAL MIRROR IMAGES

www.anamorphosis.com/UsersGuide.pdf
anamorphicart.wordpress.com/2010/04/21/cylindrical-mirror-anamorphoses/
britton.disted.camosun.bc.ca/anamorphic/cylmirror.html

FESTIVAL LISTINGS

**UNITED STATES STREET
PAINTING FESTIVALS**

Bella Strada
Gilbert, AZ–April
www.bellastrada.com

Chalk It Up Prescott
Prescott, AZ–mid April
www.prescottchalkart.com

Via Arte Italian Street Painting Festival
Bakersfield, CA–October
www.bmoa.org

Carlsbad Art Splash
Carlsbad, CA–late September
www.carlsbadartsplash.com

South Western College Street Painting Festival
Chula Vista, CA–first week of March
www.swccd.edu/3rdLevel/index.asp?L2=441

Calle Color–La Jolla Festival of the Arts
La Jolla, CA–early June
www.lajollaartfestival.org

Lake Tahoe Street Painting Festival
Lake Tahoe, CA–mid July
www.laketahoeartsfestival.com/home

Italian Street Painting Festival
Martinez, CA–late September
www.mainstreetmartinez.org/php/
ItalianStreetPaintingFest.html

Fun with Chalk
Mission Viejo, CA–June
www.funwithchalk.org

La Strada dell'Arte
Napa Valley, CA–May
www.newtechhigh.org/la-strada-dell-arte.html

Santa Clarita Street Art Festival
Old Town Newhall, CA–late September
www.streetartfest.com

Palo Alto Festival of the Arts
Palo Alto, CA–mid-late August
Contact: claudette@designingleads.com

Pasadena Chalk Festival
Pasadena, CA–mid June
www.pasadenachalkfestival.com

Chalk It Up
Sacramento, CA–Labor Day Weekend
www.chalkitup.org

Chalk La Strada
San Diego, CA–October
www.chalklastrada.com

I Madonnari Italian Street Painting Festival
San Luis Obispo, CA–September
www.imadonnarifestival.com

Italian Street Painting Festival
San Rafael, CA–Early June
www.youthinarts.org

I Madonnari Italian Street Painting Festival
Santa Barbara, CA–Memorial Day weekend
www.imadonnarifestival.com

Tehachapi Festival–Chalk the Walk
Tehachapi, CA–early August
www.mainstreettehachapi.org/Events/

Temecula Street Painting Festival
Temecula, CA–mid June
Tel: 909.678.1456

Denver Chalk Art Festival
Denver, CO–June
www.larimerarts.org

Emerald Bay Street Painting Festival
Emerald Coast, FL–mid November
www.vac.org.cn/madonnaro/Madonnaro.html

**A.E. Backus Art Festival &
Chalk-Walk Street Painting Competition**
Fort Pierce, FL
Backus Gallery: 772.465.063

Lake Worth Street Painting Festival
Lake Worth, FL–late February
www.streetpaintingfestivalinc.org

Chalk It Up
Orlando, FL–February/March
chalk-it-up.com

**Port Orange Family Days Street
Painting Festival**
Port Orange, FL–first weekend of October
Tel: 386.767.0076

Royal Palm Art & Music Festival
Royal Palm Beach, FL–late March
maureen@palmswest.com

Bloom N Garden N Chalk Festival
Safety Harbor, FL–late March
www.bloomnchalkfest.com

Sarasota Chalk Festival
Sarasota, FL–early May
www.chalkfestival.com/

Madonnari Off Main
Glen Ellyn, IL–mid/late August
www.madonnarioffmain.org

Chalk Walk at Historic Northeast
Kansas City, MO–late April
chalkwalk.org/Chalk_Walk/Home.html

Kansas City Chalk & Walk Festival
Kansas City, MO–mid June
www.kcchalkandwalk.org

Visual Art Exchange Street Painting Festival
Raleigh, NC–mid June
www.visualartexchange.org/

Raleigh Street Painting Festival
Raleigh, NC–third weekend in September
Executive Director: 919.828.7834

Elmira Street Painting Festival
Elmira, NY–early July
www.elmirastreetpaintingfestival.org

Springville Street Painting Festival
Springville, NY–August
www.springvillestreetpaintingfestival.com

Balloons Over Bend Street Painting Festival
Bend, OR–early June
www.balloonsoverbend.com/details/street-painting/

Sidewalk Chalk Art Festival
Forest Grove, OR–mid September
www.valleyart.org/events/chalkart/index.php

Central PA Festival of the Arts
State College, PA–mid July
www.arts-festival.com

Providence Rotary Street Painting Festival
Providence, RI–late September
www.providencestreetpainting.com

Mayfest's Oak Ridge Rotary Street Painting Festival
Oakridge, TN–mid May
www.rotaryor.org/streetpaintingfestival

Via Colori® Street Painting Festival
Houston, TX–late November
www.houstonviacolori.com

Via Colori® Street Painting Festival
Various cities throughout the US
www.viacolori.com/index.asp

CANADIAN STREET PAINTING FESTIVALS
Expressions in Chalk Street Painting Festival
London Ontario, Canada–early August
Contact: imadon2006@yahoo.ca

Massey Street Painting Festival
Massey, Ontario, Canada–October.
contact: info@masseystreetpaintingfestival.com

Chalk and Chocolate Festival
Windsor, Ontario, Canada–July
Contact: fringe@actorstheatreofwindsor.com

MEXICAN STREET PAINTING FESTIVALS
Bella Via Street Painting Festival
Monterey, Mexico–early October
Contact: info@bellavia.mx

EUROPEAN STREET PAINTING FESTIVALS
Geldern Street Painting Festival
Geldern, Germany–Dates fluctate annually from late summer to fall (autumn)
Contact: Rainer.niersmann@geldern.de

Les Craies d'Azur
Nice, France–mid June
Contact: John Di Rico, info@craiesdazur.org

I Madonnari International Street Painting Festival
Alatri, Italy–Mid June
Pastelizacija, Croatia–Early June
Contact: info@zagrebpastel.com

Grazie di Curtatone
Mantova, Italy–August 14–15
www.curtatone.it

Internazionale dei Madonnari
Nocera Superiore, Napoli, Italy–May
Contact: info@concorsomadonnari.it

Italian Street Painting Festival
Utrecht, The Netherlands–summer
Contact: info@streetpainting.nl
P.O. BOX 43 3500 AA Utrecht, The Netherlands

Colours of Valkenburg
Valkenburg aan de Geul, The Netherlands–Late August
Contact: coloursofvalkenburg@gmail.com

AUSTRALIAN STREET PAINTING FESTIVALS
Chalk Urban Art Festival
Sydney, Australia–late October, early November
Contact: chalkenquiry@zestevents.com.au

STREET PAINTING ON THE INTERNET
Street painting information sites are new and cropping up all of the time. A few of the more common and less commercially oriented sites are:
www.streetpaintingsociety.com
www.streetpainting.net
www.madonnari.mn.it/
www.chalkcircle.com.au

SCHOOL WORKSHOPS AND WORKING WITH CHILDREN

Street painting is a natural fit with children of all ages, from preschool to high school—anywhere from one-day school festivals to long-term residencies will work. When running a one-day festival, it is probably best to stick to a short presentation, showing images of what the art form is, and explaining some of the background and history. Tying the work into other types of art, such as murals and Renaissance art, is a nice way of placing it historically to a time period that children will recognize. In longer term workshops, you might develop lesson plans that tie back into street painting by teaching various aspects of art, such as perspective, composition, light and value, color, and so on. You can then show them how to use that knowledge to build more effective street paintings, culminating in a street-painting event.

AGE-RELATED CONSIDERATIONS

When working with children, bear in mind their attention spans. With younger children these are quite short, so keep presentations short, active, and find images that will appeal to your audience. Try not to get caught up in specific facts, but instead focus on the broader ideas and concepts. I generally try to focus my teaching with younger children around concepts such as basic colors, looking at Fauve (Expressionist) painters, and how to use color creatively, and encourage children to reach beyond the norm and have some fun with the medium. I try to de-emphasize drawing skills and focus more on composition and color skills. Drawing skills are harder for young children to master as they do not have the level of maturity to see drawing the way we need to teach it, so leave these for basic lessons elsewhere and residencies where you might have more time to focus on them. For composition, try to focus your teaching on how to use the space dynamically and fill it with larger objects, as the tendency will often be to paint small objects.

Older children have their own difficulties. Speaking with a teacher in advance about how the classroom is as a whole and what types of things appeal more to them can really help you build rapport more quickly. Sometimes the difficulty is getting them interested. Reiterate the history of the medium as well as the tie-in to other time periods and art techniques they are already familiar with. For short-term day projects, you might choose to focus on drawing out a large mural they can assist each other in filling in. Working together can avoid older children and teenagers focusing too much on the imperfection of their drawing, instead of the fun activity street painting

can be. By drawing out the image first, you also avoid some of that. When you have a longer time with a class, do take time to teach some basic drawing skills, such as the simple construction of forms, simple approaches to a good composition, and so on. With longer residencies, depending on the age group and its relative maturity, you might be able to cover some quite in-depth material.

MATERIALS, SURFACES, AND WEATHER

It really helps to see a surface in advance and have a good discussion with the school regarding where to hold the actual street painting. Emphasize the need to avoid sidewalks, if possible, and find a more suitable surface where the students will get a better product. For a small class, you might even consider using a paint roller and laying out tempera paint for a surface. Not all black top (tarmac) is created equal—look for the best quality you can find, since sometimes it is rather gray and chewed up, which makes the experience miserable for children.

Take into account the weather too—make sure that the school avoids scheduling sessions in the hottest times of the day, and has reminded children to dress appropriately, including bringing sweatshirts if the weather is chilly. If there is a threat of rain, you might set up a rain date in advance in case the threat becomes real.

Make sure the school is not purchasing sidewalk chalk for the event! Give the school contact details and material information a long way in advance, as school systems can be bureaucratic. They need to order soft pastels—I recommend the lower-quality pastels mentioned in Resources (see page 179). Generally I use 24 count boxes, one for every 4–6 students, depending on how they are working (if simultaneously you might need a box for every two students). Let the school know that the children will need to clean up afterward—if the school has a rest room nearby, this shouldn't be a problem; if the rest room is far away, ordering some boxes of thick baby wipes can help to make the experience more pleasant.

SPECIFICS ON DESIGNS

Keep the compositions child-focused. Take into account the size and final format of the painting on the ground, and encourage students to avoid lots of tiny detail, and go for bolder shapes if possible. Choose themes that are broad and visually based, rather than conceptually based—at least for younger children. Themes such as habitats, animals, gardens, the ocean, families, professions, historical time periods and events are all good places to start. I usually ask teachers for advice on the units they've been covering and try to find a way to tie into what they are doing. If they are older children, the math and science aspects of how we draw perspective, or how we understand and see color, can be great lessons to help tie in with what is being taught in the classroom.

SPECIFICS ON TIME AND SPACE

A one- to two-hour period for the actual street painting part is about all you can do before children get restless. For younger children, a one-hour, or possibly shorter, session is enough. Anything you can do to make the experience pleasant will help to keep their interest longer. I divide children up into groups so the space is less overwhelming. So if they are doing individual paintings, I allocate two to four children to each painting. For large murals you draw out, this isn't a concern—you can assign various groups to different parts of the mural. I like to encourage the team-building aspects of street painting, and talk a bit with them about that before we begin.

For one-hour paintings, I usually mark out a 3- x 5-ft (0.9- x 1.5-m) space for each painting. If you have larger groups of four to five students, then 5 x 7 ft (1.5 x 2 m) might be more reasonable. As for marking out squares, I never worry about strict measurements, especially since I'm usually marking it alone. I'll span the space using my own feet, end to end, as my measuring tool, marking with a pastel on the end of a dowel stick as I go, then using the same dowel stick to draw the long lines for the edges of a row of paintings.

ABOUT THE ARTISTS

C.C.A.M. (Italy)

Founded in 2000 in Curtatone–Mantova, Italy, and certified by C.I.M. (Centro Italiano Madonnari), C.C.A.M. (Centro Culturale Artisti Madonnari) counts 30 members who are expert Madonnari from many cities in Italy. The president is Selica Trippini. During the first 10 years of activity, C.C.A.M. participated in an incredible amount of Madonnari Festivals in Italy, and it is especially involved in the organization of the Grazie Festival in Curtatone (MN). C.C.A.M. also participates in many festivals outside of Italy, especially in California, Mexico, Holland, France, Spain, Switzerland, and Croatia.

www.madonnari.mn.it

Vera Bugatti (Italy)

An Italian artist and street painter, Vera Bugatti was born in 1979. She gained a Liberal-Arts degree in college, and in everyday life she is a librarian. She finds time for art and pastels around her work schedule. She enjoys painting people and human emotions particularly and at festivals she often composes montages of different images. In 2009 she won the Maestro title at the Grazie Festival, Italy. She has painted in France, Holland, Croatia, as well as in the US. In her fine art she does painting and drawing, as well as working with wire and nails to create characters that seem to change their appearance as the light moves.

www.verabugatti.it

Bruno Fabriani (Italy)

Born in Serrone, Italy, in 1956, pavement artist and painter Fabriani Bruno resides in Villafranca di Verona, Italy. He is part of C.C.A.M. of Buscoldo-Mantova-Italy (see above). He has participated in the following US festivals: I Madonnari Festival in Santa Barbara, CA; Youth in Arts Italian Street Painting Festival in San Rafael, CA; and the one-day painting organized by artist Mark Wagner for the Guinness Book of Records in Alameda, CA. For over a decade he has also been participating in the festival in Grazie Curtatone in Mantova, Italy.

www.artmajeur.com/madonnaro

Ketty Grossi (Italy)

Born in Mantua, Italy, in 1975, Ketty Grossi is a freelance artist and first began street painting in 1994. Since that time she has worked extensively throughout Europe, and has won medals in festivals in Nocera, Grazie, Ferrara, and Rome. She is now considered a Maestra Madonnara at the Grazie Festival, Italy. In addition she is one of the founding members of C.C.A.M (see left).

Ann Hefferman (US)

A resident of Santa Barbara, CA, Ann Hefferman was born in San Francisco and raised in the bay area. She has been street painting since 1993, when she completed her first painting at the I Madonnari Italian Street Painting Festival in Santa Barbara, CA. As an art student at UC Santa Barbara, Ann focused primarily on printmaking and artists' books. What draws her to street painting is the very thing that appealed to her about creating book pieces. Each has an inherent accessibility, bringing the art form out of the gallery, or off the wall, allowing a closer, more personal connection between artist and audience.

Street painting has given Ann opportunities to travel throughout the US, as well as to Europe, Japan, and Mexico, where she has participated in festivals and exhibitions. In recent years Ann has been involved with outreach through the Santa Barbara Children's Creative Project and Santa Barbara's Sister Cities Program to introduce street painting to Toba, Japan, and Puerto Vallarta, Mexico.

Ann's work can be seen on Facebook under the name of Ann Hefferman

Michael William Kirby (US)

A leading public artist and street painter from Baltimore, MD, Michael Kirby has over 20 years of experience creating permanent and temporary public art pieces around the world. In the early 1990s Michael Kirby began to work in Europe as a street painter and was the first artist to create original work based on contemporary issues and not on classical ideas and designs. His work has been featured at the Smithsonian Institution in Washington DC, National Geographic, North Carolina Museum of Art, RAI Television, and others. Today his studio, Murals of Baltimore, is hired to create public art around the world. Since the early 1990s, he been commissioned and contracted for his unique and original view of anamorphic or forced perspective street paintings.

Michael Kirby is considered a master in the art form and was the first American artist to have won the title of Master Street Painter in all the major European street painting festivals. Since the early 1990s he has spread the art form to numerous locations that include Germany, Colombia, Mexico, Italy, Canada, Guatemala, England, Ireland, France, various locations in the US and many others. He has worked for such clients as Honda, Johns Hopkins University, University of Maryland, McDonalds, Carnival Cruise Ships and been featured on the David Letterman Show, Ace of Cakes, BBC, Good Morning America, Il Tempo, Venezia Gazatte, Informador, and others. He also teaches workshops and lectures on technique and the history of street painting.
www.muralsofbaltimore.com

Genna Panzarella (US)

An artist and teacher, Genna Panzarella has explored many diverse media. Besides painting and drawing, she has worked in stained glass, wearable art, lamp-worked beads, bronze sculpture, scrimshaw, jewelry design, photography, commercial art, and children's book writing and illustration. She loves teaching and has taught all age levels. For the last 15 years she has enjoyed passionately her sidewalk art. When her local town of San Rafael, CA, began a chalk festival in 1994, she was selected to be their featured artist the next year, and again in 2001 and 2008. She continued drawing there and in Santa Barbara every year, as well as at other festivals across the country. Genna has conducted workshops at the De Young Museum of San Francisco, and at the Museum of Modern Art in Kansas City, as well as running classes and workshops in schools and universities. Her extensive travels to do chalk drawing have included trips to Mexico, Canada, China, the Netherlands, and often to Italy. She has drawn different sections of the Sistine Chapel ceiling in three different countries.

In 1999, Genna won a prize in the first level of Semplice at the Grazie Festival, Italy. She returned the next year to win first prize in the next, Qualificato level, thus becoming a Maestro in just two years! Then, in 2002, she was awarded first prize for the Maestro level—the top prize in the festival. She continues to compete on the Maestro level and has occasionally won additional awards there.
www.gennasart.com

Planet Streetpainting (The Netherlands)

A European street painting events company, Planet Streetpainting is based in Utrecht, The Netherlands. They are one of only three such companies worldwide. They develop, offer, and produce catchy street-painting services for a wide range of international customers. They created the world's largest 3-D street painting ever in September 2009, measuring a staggering 750-square meters (2460-square feet). Planet Streetpainting offers XXL spectaculars, festival start-ups, live demos, and of course 3D/Anamorphs. Last, but not least, they host a group of outstanding international street painters from the Netherlands, Italy, Germany, the UK, the US, and Mexico.

Planet Streetpainting was founded by Peter Westerink in 2003. During an unexpected visit to the Youth in Arts festival in San Rafael, CA, in 2001, he immediately fell in love with this unique art form. He decided to take it to the streets of his homeland, the Netherlands. Having a business MBA but no artistic background, he started

organizing small events, paid out of pocket, and traveled to street painting events in Europe. He connected with experienced street painters there and on the web, and started to work with them. It seemed inevitable when Peter also started to street paint. Since then he has put his passion and organizing talents, as well as his artistic and networking skills to good use, promoting the fine art of street painting to as many people as possible.

www.planetstreetpainting.com
www.mega3d.nl

Marion Ruthardt (Germany)

Born in Rheinhausen near Düsseldorf, Marion Ruthardt happened to be living near the city of Geldern, where the largest international street painting festival in Germany takes place. In the beginning she took part just for fun, but over time it developed into a goal in her life. Her father, a talented caricaturist, gave her the inspiration to paint from a young age, and a local artist, Volkram Anthon Scharf, was an important teacher in her early years. Her first steps into the world of street painting were strongly supported by street artist Edgar Müller, and it is thanks to Edgar's activities that street painting has flourished in Germany.

Nowadays Marion Ruthardt is very happy that she can make her living from an activity that she is passionate about. She works most of the time with Gregor Wosik, and they get many street painting commissions for advertisements, city festivals, and art projects all over the world. They also paint murals and in oils, but both artists prefer working on large-sized paintings.

Tomoteru Saito (Japan)

Born in Osaka, Japan, Tomoteru Saito mainly works on the streets of Europe. Formerly, an architect in Tokyo, he has been awarded top prizes at the Grazie Festival, Italy, including first place among Maestri Madonnari in 2000 and 2001. Tomoteru participates in street painting festivals throughout Europe, the US, Mexico, and Hong Kong.

tomoteru.web.fc2.com

Valentina Sforzini (Italy)

It was at the young age of eight that Valentina Sforzini first participated in the Grazie Festival, Italy. At only 15 years of age, she won first place in the Madonnari Semplici category. At this point she made the decision to be a street painter in a more serious way, and she joined the C.C.A.M. (see page 184) at its foundation. Her street-painting career has been rich with good experiences, prizes, and participation in festivals all around the world, including Mexico, Italy, Florida, Holland, and France. She occasionally teaches workshops on street painting, as well as being part of the jury group at street painting competitions. She considers the art of being a Madonnara her passion, and enjoys the opportunity to meet great artists, interesting people, and visit interesting places.

Melanie Stimmell Van Latum (US)

A Signature Member of the Pastel Society of America, Melanie Stimmell is the Founder of two organizations in the chalk-painting world, the Street Painting Society and the Street Painting Academy. She began street painting in 1998 and has painted in festivals throughout the US and internationally. The only woman to have won the title of Maestro and several Gold Medals in both Italy and Germany, Melanie is an internationally recognized street painter, working with clients in Turkey, Holland, France, England, Canada, and throughout the US. Commissioned by corporations and advertising agencies for special events, performance art, and interactive media, which includes television, film, and print, Melanie's street paintings convey the spirit of creativity, art, and culture.

Born and raised in Los Angeles, Melanie earned her BFA in illustration from the prestigious Art Center College of Design, and a Masters in Drawing and Painting from Cal State Fullerton. She began her career as a freelance illustrator for children's magazines and educational toys and landed a job as a Lead Technical Director for the feature film South Park...Bigger, Longer, and Uncut. She was then asked to join the crew of the very popular South

Park series where she worked for seven years. Leaving the entertainment industry to follow her passion and paint full time, Melanie has found her voice in street painting and figurative art. She has exhibited at prominent Southern California galleries such as La Luz De Jesus, The Brewery, The 57 Underground, Spring Arts Collective, Deborah Martin Gallery, and Rebecca Molayam Gallery.
www.melaniestimmell.com

Ulla Taylor (Australia)

At three years old, her mother Hildegard despaired at the continual appearance of smiley faces drawn on the white walls at home—but as an artist herself she encouraged Ulla Taylor in her painting. At 17, Ulla went to art school, and at 18 she landed her first pavement art commission with Melbourne City. By 23 she was on her first international tour as a part of Chalk Circle. Now working solo, she loves her work, touring, and making art at a "grass-roots" level.

With pastels and knee pads in tow, Ulla creates public, (con)temporary street art and takes part in corporate art events in Australia, Canada, Europe, and Asia. She also conducts art workshops at public events and within schools. Ulla holds a degree in Fine Art (painting and sculpture), and a Diploma of Education. She specializes in creating artworks relative to the local community they are produced in, often on an environmental or conservational theme. Ulla has won prizes in competition pavement art in Australia and Germany, and her paintings are represented in government, corporate, and private collections in Australia and overseas.
www.ullart.com

Rod Tryon (US)

After visiting the inaugural I Madonnari Italian Street Painting Festival in Santa Barbara, CA, in 1987 (the first street painting festival in the US), Rod Tryon knew it was something he had to continue to do. Since then, he has been street painting for the past 23 years. He has participated in the Santa Barbara Italian Street Painting Festival 17 times, including appearing as the featured artist in 1993 and 2010.

Rod has also been featured at street painting festivals and corporate events across the US and worldwide. He has created pieces in Hong Kong, Mexico, France, the Caribbean, and Dubai. In 2003, Rod was invited to join 11 other featured artists to create the entire Sistine Chapel ceiling in half size at the Youth in Arts Italian Street Painting Festival in San Rafael, CA. Rod has also created street paintings for special events. He has done images for Lynx Toyota Atlantic Racing Team, Kinko's Kawasaki motorcycle racing team, a documentary film Life Beyond Earth for PBS television, and a music video. Rod lives on the east end of Long Island, in Cutchogue, NY.

Juandres Vera (Mexico)

Born in Moneterrey, Mexico, in 1980, from an early age Juandres Vera showed an outstanding ability for drawing. At 17 he began his studies at the School of Visual Arts at the Autonomous University of Nuevo Leon. A year later, participating in a mural-painting competition, Vera stood out for his photorealistic technique, and used this ability to take the first place prize on two consecutive occasions. Since that time, Vera has been dedicated to painting as a career. Subsequently, in 2004 after completing his degree, he began his production of studio work, using a unique technique of acrylic on vinyl.

In 2007 he participated for the first time in the Bella Via Street Painting Festival in Monterrey, Mexico. He won first prize, which initiated a new stage of his work in this urban art form. To date, Juandres has participated in a number of street painting festivals in Mexico, the US, the UK, and Italy. He became the first Mexican to win two silver medals at the Grazie Festival, Italy—one in the Semplici level and one in the Qualificati level. Vera was also featured in the first Pavement Art Prize by FRINGE MK at Milton Keynes, UK in 2010, commissioned to create four original anamorphic paintings.
www.juandresvera.com

Kurt Wenner (US)

After attending Rhode Island School of Design and Art Center College of Design, Kurt Wenner worked for NASA as an advanced scientific space illustrator. Wenner eventually left NASA for Italy in order to pursue his love of classical art.

In the spring of 1982, Wenner moved to Rome. He studied the works of the great masters and drew constantly from classical sculpture. He became particularly interested in the Mannerist period, finding in the monumental scale and sophisticated decoration a direction for his own artistic expression. For several years Wenner traveled extensively to experience first-hand most of the major masterpieces and monuments throughout Europe. To finance his travels and studies, he became a Madonnaro and created chalk paintings on the streets of Rome. He won numerous gold medals at European competitions and become officially recognized as a master of this art form. In 1984, Wenner invented an art form all of his own that has come to be known as anamorphic or illusionistic street painting (see pages 52-3). In 1985, his work was the subject of an award-winning National Geographic documentary titled Masterpieces in Chalk.

Eventually, Wenner's knowledge of Renaissance classicism provided a foundation for his own art, as well as material for numerous lectures and workshops given throughout the US. Wenner taught more than a 100,000 children over a 10-year period, and received the Kennedy Center Medallion in recognition of his outstanding contribution to arts education. He has lectured at corporate events and conducted seminars and workshops for organizations ranging from the National Gallery of Art and the Smithsonian Institution to Disney Studios, Warner Bros. Studios, Toyota, and General Motors.

When Pope John Paul II arrived in Mantua, Italy, Wenner was commissioned to create an original composition for a 15- x 75-ft (4.5- x 23-m) street painting based on the Last Judgment. Under Wenner's direction, 30 of Europe's best street painters worked 10 days to create the work. The Pope signed the mural, officially recognizing street painting as an official form of Sacred Art.

During his first years abroad, Wenner executed several large permanent works. They can be found in corporate high-rises, government buildings, hotel lobbies, as well as in churches and museums. Wenner's mural work brought him in touch with architects and clients who were building large homes in traditional styles. Soon he was asked to create architectural details, along with vaults and coffers in sculptural relief, as well as figurative sculptures for exclusive residences. After working many years finishing and decorating homes, it was inevitable that Wenner would be asked to design them and he has spent the last several years designing large residences.

Currently, Wenner spends his time working in all the various disciplines he has come to love. His illusionistic paintings are increasingly popular with corporate clients and advertising agencies. His images have been used in print ads, television spots, and point-of-sale displays. **www.kurtwenner.com**

Gregor Wosik (Germany)

Born in Swietochlowice in Upper Silesia, Poland, Gregor Wosik started his career as a professional footballer, but eventually left the then strongly socialist Poland to build a new life in Germany with his wife. Since childhood, Wosik had been interested in art and painting, and he was given the opportunity to build and develop his talent at the Möenchengladbach Art Academy in Germany under the tutelage of Samsodin Achmadof and Daniel Deberac. His special strengths lie in street painting, murals, as well as oil painting, especially copies of old masters.

Wosik is best known as a street painter in Germany. He enjoys this art form because it allows him to work on large format pictures and to interact with the public. His subjects run from the classical to more contemporary themes, and his work is distinguished by its high quality and love of detail. **www.gregorwosik.de**

INDEX

ACKNOWLEDGMENTS

Author's Acknowledgements

There are numerous street painters who have been there for me throughout the years, as well as while I wrote this book. Rather than list them all, I want to send a collective thank you for being my mentors, my friends, my colleagues, and my inspiration. I would especially like to thank those who helped contribute to this book: Melanie, Genna, Ann, Rod, Michael, Ulla, Gregor, Valentina, Ketty, Juandres, Peter, Selica, Bruno, Marion, Vera, Tomo, Aimee, Emily and, of course, Kurt. I also would like to thank Kathy Koury, the director for I Madonnari, for being supportive and helping me to find the information I needed–and also for giving me a space to paint when I can make it there! Besides street painting friends, I've had numerous teachers who have helped me to be a better artist and a better teacher, but probably the one who I owe the most to for being my art "dad," as well as an incredible and knowledgeable instructor, is Don Lagerberg at CSU Fullerton–you were never more right about construction! Last, but definitely not least, to the family members who have put up with my trips and my chalk dust everywhere, thank you. To my parents, who enjoyed coming to my festivals whenever they could, and loved bragging about me to their friends; to Bob, who always supported me doing the things I loved and gave me the freedom to do them; to my kids– Chanel, Kyle, Cody, Casey, and Clancey–for filling in my backgrounds, for missing me when I'm away, for feeding the animals when I become absent-minded, for putting up with my odd schedule, and for making me laugh, even when I'm too tired to think straight–you are my life. And finally to Amani–thank you for being there for me in every way I ever hoped for, for continuing to inspire my dreams and ambitions, and for being my biggest cheerleader.

Picture credits

The Publisher would like to thank the following for their kind permission to reproduce their work. The Publishers have endeavored to credit all known holders of copyright or reproduction rights for the illustrations in this book.
Key: b = bottom, c = center, l = left, r = right, t = top

Aimee Bonham: 168br; Emily Bonham: 153; Vera Bugatti: 31br, 69tr, 69br; Bruno Fabriani 69bl (photograph Joy Phoenix); Ketty Grossi: 18 l, 19tl, 19bl, 68tr, 79tl, 147bl; Ann Hefferman: 31tl, 78tr, 110br, 111tl, 146, 171 (photograph Nell Campbell), 173 (photograph Nell Campbell); I Madonnari Italian Street Painting Festival and the Children's Creative Project: 171 and 173 photographs Nell Campbell, 172 photograph Michael Brown; Lisa Jones: 171, see also Mills College Walk of Honor; Michael Kirby: 31bl, 43tr, 43br, 78 l, 147tl; Mills College Walk of Honor: Lisa Jones 98, Genna Panzarella 98tl, 99tl, 99br, and Melanie Stimmell Van Latum 98tr; Genna Panzarella: 31tr, 111br, 122-3, 123t, see also Mills College Walk of Honor; Planet Streetpainting: 36, 42tr, 42br, 43 l, 140, 141tr; Joy Phoenix, with the San Rafael ISPF and Youth in Arts: photograph 42bl see also Rod Tryon, photograph 69bl see also Bruno Fabriani; Royal Museums of Fine Arts of Belgium, Brussels: 107b (photograph Julie Kirk-Purcell); Marion Ruthardt: 40br with Gregor Wosik, 41tl with Gregor Wosik, 68br, 69tl; Tomoteru Saito: 18tr, 18br, 68tl, 78br, 135br, 141tl; Valentina Sforzini: 11, 27, 111bl, 111tr, 127; Melanie Stimmell Van Latum: 9, 15c, 19tr, 20, 30, 40tl, 110 l, 134, 135tr, 141bl, 141br, 147r, see also Mills College Walk of Honor; Ulla Taylor: 39t, 41bl, 41tr, 41br, 73br; Selica Tripini: 19br; Rod Tryon: 42bl (photograph Joy Phoenix), 79; Juandres Vera: 40tr, 42tl, 46tr, 79bl; Kurt Wenner: 13 l, 15t, 52, 53; Gregor Wosik: 40br with Marion Ruthardt, 41tl with Marion Ruthardt, 59b, 110tr.
All other pictures: Julie Kirk-Purcell